Balance: Art and Nature

To all artists who believe in freedom

Balance: Art and Nature

John K. Grande

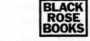

Montréal/New York/London

Black Rose Books No. GG322

National Library of Canada Cataloguing in Publication Data

Grande, John K.
Balance : art and nature / John K. Grande.–Rev.ed.

Includes bibliographical references and index.
Hardcover ISBN: 1-55164-235-2 (bound) Paperback ISBN: 1-55164-234-4 (pbk.)

1. Creation (Literary, artistic, etc.) 2. Art, Modern–20th century--Economic aspects. 3. Art, Modern–20th century--Social aspects. 4. Artists--Psychology. 5. Nature (Aesthetics) I. Title

BH301.E58G73 2003 701 C2003-904155-7

Cover design: Rasa Pavilanis.

Cover Photo: Andy Goldsworthy, Arizona, 1989, courtesy of the artist. Photos on pp.i,9 & 101, by Nils Udo. Photos courtesy of the artist.

Portions of this book have appeared in different versions in: *Adbusters Quarterly*, *Artforum, Canadian Forum, Espace Sculpture, Etc, Sculpture, The Structurist, The Trumpeter, Vice Versa* and *Vie des Arts.*

BLACK ROSE BOOKS

C.P. 1258	Canada	14150
Succ. Place du Parc	2250 Military Road	USA
Montréal, H2X 4A7	Tonawanda, NY	99 Wallis Road

To order books:

In Canada: (phone) 1-800-565-9523 (fax) 1-800-221-9985
email: utpbooks@utpress.utoronto.ca

In United States: (phone) 1-800-283-3572 (fax) 1-651-917-6406

In the UK & Europe: (phone) London 44 (0)20 8986-4854 (fax) 44 (0)20 8533-5821
email: order@centralbooks.com

Our Web Site address: http://www.web.net/blackrosebooks

A publication of the Institute of Policy Alternatives of Montréal (IPAM)

Printed in Canada

The Canada Council | Le Conseil des Arts
for the Arts | du Canada

Contents

Praise for John K. Grande

"Grande defines a future where small-scale societies exist in harmony with their individual bio-regions, and he finds art that articulates this vision. His writing is clear and blessedly free of postmodern jargon." — *Public Art Review*

"Demonstrates that art criticism doesn't have to give readers a headache. His grasp of details—both artistic and political—makes this book convincing, and interesting." — *Books In Canada*

"One doesn't have to agree with everything Grande writes in order to welcome this book's arrival." — *Globe and Mail*

"Ideas are plentiful...Grande is clearly versed and passionate about nature's role in art." — *Quill & Quire*

"Fascinating reading...Grande has assembled an enormous breadth of material and judged it from the perspective of a well-informed heart." — *Montreal Gazette*

"Grande makes an important statement. Despite the various causes artists embrace we still have one common cause: to preserve the earth." — *McGill Daily*

"Reinvigorates my desire to consider contemporary art as a vital form of expression and encourages the reader to see that art in relation to daily life and society at large." — *Canadian Forum*

"Engaging, provocative and thoughtful...Grande cares passionately about art, the environment, and the relationship between them." — *Compass*

also by John K. Grande

INTERTWINING: Artists, Landscape, Issues, Technology

Over forty essays and reviews around the themes of artists, landscape, issues, and technology. Topics include the effects of the internet on museums and education; artists working in and around a nature park; agriculture as art; the artists' response to breast cancer; to animal rights; to violence and children's toys; to art and illness.

"Grande's essays have literary merit and insight that remain vital. When critics do their work well, they increase their readers' understanding of art." — *Hour*

"A readable, engaging book...Grande has taken contemporary art out of the exclusive domain of the artworld demi-gods and given it back to anyone who dips into this collection." — *Canadian Forum*

320 pages, photographs, index
Paperback ISBN: 1-55164-110-0 $24.99
Hardcover ISBN: 1-55164-111-9 $53.99

Introduction

"Which nature? Whose art?" reads the brochure from the Tranekaer International Art and Nature Centre (TICKON). Located on the island of Langeland in Denmark, TICKON is a recently established testing ground for an art dedicated to creating a new relationship between humanity and nature. For artists working towards the betterment of "a world that is vulnerable in some absolute sense,"[1] this relationship is crucial.

For centuries we have assumed that history and art are a series of progressions inimically tied to the economic progress of Western civilization. Our cultural conception of nature, like environmental art itself, has defined nature as "aesthetic real estate" — mere matter to be manipulated, transposed and reformed in order to affirm our superiority over nature. Duchamp once said: "Man invented art. It wouldn't exist without him. Art has no biological source. It's addressed to a taste,"[2] yet who could now deny that art has always been a part of nature?

Art is as necessary to society as the sun is to nature, for it sheds light, to paraphrase Gaugin, on who we are, where we come from and where we are going. It is a point many of today's assemblage artists should remember. By appropriating and manipulating the flotsam and jetsam of industrial society in new and ingenious ways, artists such as Tony Cragg, Bill Woodrow, David Mach and Richard Deacon allude to the malaise of overproduction and consumption. A seemingly reflexive response to utilitarianism and resource exploitation run amok, their work does nothing to reconnect us with nature: it merely reaffirms the syntax of the industrial product.

David Mach's massive installations — *Ploughman's Lunch,* exhibited at the Milton Keynes Shopping Centre in England, and *The Art that Came Apart,* exhibited at the Musée d'art contemporain in Montreal — are the most extreme examples. A kind of temporary performance sculpture, these works were literally built up out of tons of magazines and various consumer products including television sets, a piano, a bulldozer, cars, and a canoe to name but some of the items. This eco-Pop brand of postconsumer art may look more contentious than a Magdalena Abakanowicz or Shigeo Toya, but the effect is hardly as profound or lasting. The inner ear of these altered product statements will always be their materials' original, natural context. Ashley Bickerton deals with these problematic issues by encasing industrial waste, seed pods, trash, dried grasses and earth or, as in a

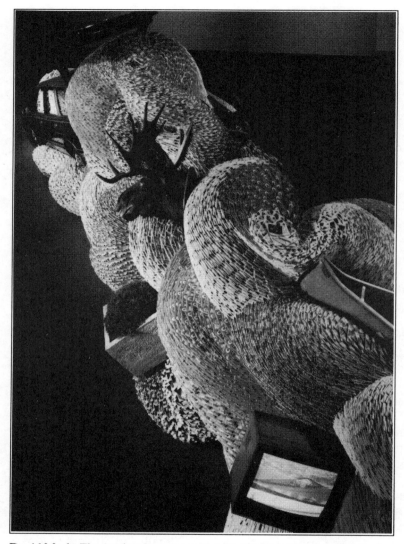

David Mach. *The Art that Came Apart* (detail), 1989.Exhibited at the Musée d'art contemporain de Montréal, Montréal. Photo by Ron Diamond. Photo courtesy of the artist.

work titled *Minimalism's Evil Orthodoxy Monoculture's Totalitarian Esthetic #1* (1989), by juxtaposing soil and crop samples from South America, Asia and Africa. Another Bickerton piece approached the question as it relates specifically to artist's materials: two structurally designed boxes had tiny squares of cadmium yellow and cadmium red painted within them — the toxic components in cadmium were listed on the boxes' sides.

At the other end of the spectrum, responding directly to various aspects of climate, geology, vegetation, even other life forms, today's most prominent environmental artists — David Nash, Karen McKoy, Andy Goldsworthy, Giuliano Mauri, Jane Balsgaard, Lars Viks and Nils Udo among others — express these concerns by creating natural constructions: installing plantings, welding ice assemblages, making dandelion chains, grafting tree forms, arranging patterns of berries and leaves in idyllic backwood settings far from the hue and cry of the urban centres where most of us live. But the question arises, while these works may present themselves as ecologically sensitized, how socially involved is this new vision?

It has been a long time since we idealized landscapes and saw nature as a seemingly inexhaustible reserve as the Romantics did when the first factory smokestacks went up. As environmental artists opposed to the alienation and confused reality of our cities attempt to rediscover nature on its own terms, they proffer a vision of art as a detail of the landscape. Disconnected from the root cause of environmental devastation — a burgeoning civilization and economy based on profit and competition — this brand of environmental art is as exclusive in its purist vision as formalist art. In one of her "mock monuments" titled *Excess Volatility*, Jerilea Zempel responded to these issues from within the urban situation. Zempel dragged a burned out, abandoned Volkswagen bug into Battery Park and clothed it in tree clippings and cuttings donated by the park management service, sheathing its exterior with a skin of pine needles and painting its interior a bright orange. As Zempel comments:

> To me these stripped down, burnt out wrecks are like animal carcasses picked clean by urban predators. I wanted to reclaim one of those vehicles, exaggerate its animalness using another kind of debris from nature rather than culture.[3]

Ephemeral is now fashionable. We attribute ethical values to works of art based on their supposed permanence or impermanence

Jerilea Zempel. *Excess Volatility,* 1989. Abandoned Volkswagon and tree branches. Battery Park. New York. Photo courtesy of the artist.

without considering that human civilization has always been a product of the culture of nature. Goldsworthy inverts the order, finding design as a quality of nature. Though it may seem too simplistic and socially uninvolved, it is an art that achieves a balance between ethics and aesthetics. His works promote an ecological consciousness as premeditated as Duchamp's once was — a land art in microcosm — where the subject has been preselected and nature is considered within a purist context. Yet such designing with nature is a primordial or Jungian social act because it recognizes our own unconscious origins in the forms that exist in nature's holistic state. Contrary to popular opinion, human design and design in nature are not exclusive of, but complemetary to one another. As Goldsworthy comments:

> My approach to the earth began as a reaction against geometry. I used to think it an arrogance imposed upon nature, and still do. But I've also realized that it is arrogance to think man invented geometry. As regards my own work I'd like to think geometry has appeared in it to the same degree I have found it in nature.[4]

Any attempt to discover the dark heart of real creativity must involve a redefinition of human culture within the context of nature. Meanwhile, nature remains oblivious, yet intensely affected by human endeavour. It is now up to us to regenerate our social and environmental landscape, to adapt ourselves to it in more provocative, new and varied ways. It is only by a radical reinterpretation of the terms *nature* and *culture* that art will find new avenues for regeneration. To think, act and create "naturally" is not an easy task in a culture that emphasizes distraction, distortion and decontextualization. It requires the awareness that everything does indeed matter. The solution is neither structural nor syntactic. It involves a basic confidence in perception, intuition and the ritual of exploration of materials with a sense of their potential power and magical properties.

We generally equate idealism with visible change, or we reject it in favour of nihilism. Both of these stances cripple the artist's creative impulse, because they are based in an agenda for, not a feeling of, the inner self. It is as if by abandoning a vision based on individual achievement, we fear we could lose the very core of our being — the ego. There is a slow-moving transformation toward a more holistic state of culture, where resources, communications systems, technology and permaculture will work together. A morality of good and

evil, right and wrong, imbued art and nature with a religious and ideological hierarchy. It is a hierarchy we must now leave behind.

Tennessee artist Kelly Brown's outdoor mazes and passageways made out of branches, leaves and sticks are, for him, like handling the bones of a once living creature — a cathartic experience. Germany's Nils Udo uses the medium of live vegetation to create leaf patterns and organic arrays, designing art *with* and *in* nature. Most recently, he has began working with the human body in nature. Udo sees no apparent contradiction between designing nature and design *in* nature because his works reflect a conscious desire to merge with, rather than stand out from, the surrounding context. Grégoire Ferland's animated assemblage sculptures explore the core of our being, our biological essence by recreating the camouflage character of life forms in their natural habitat where near invisibility is part of the complex and dynamic web of life. Monique Crépault is an artist who comes to the age-old practice of painting in egg tempera on panel from video and theatre. She finds it a medium that allows more reflection, a slowing of time in the process of creation. Peter von Tiesenhausen's ship, tower and pod pieces plaited from willow wands in northern Alberta evoke nostalgic associations of voyage and early settlement but likewise mark a move towards an art of ephemeral integration where nature is no longer a mere subject. While critics such as Arthur C. Danto and Theodor Adorno might tell us nature doesn't have any artworks, the telluric sensitivity of Chris Drury's stone piles and geo-domes of braided wood tell us otherwise. Drury's work concentrates meaning by creating a location of gestation, where the seemingly chaotic flux of nature's energies are seen to have an invisible order. The surfaces of Richard Brown's *Earth Clocks* swell in heavy rain and nature's freeze-thaw cycle cause sections of these compacted walls of earth to fall off with a poetic and natural beauty. Ephemeral artworks usually preclude the natural process of decay, but as shown in 1975, when Reinhard Reitzenstein dug out the entire root system of a mature ironwood tree in the Ottawa Valley to see how its roots travelled through earth around boulders, the tree flowered better than it had for years, owing to the airing of the root system. Last year Reitzenstein installed *The World Tree* (1993) stripped of its bark and covered in beeswax suspended upside down in the Confederation Centre Art Gallery in Charlottetown, Prince Edward Island. There it hangs, offsetting the interior architecture like a ghostly apparition.

To develop a stronger relation to nature, we now have to generate procreative models for human culture and civilization — our future

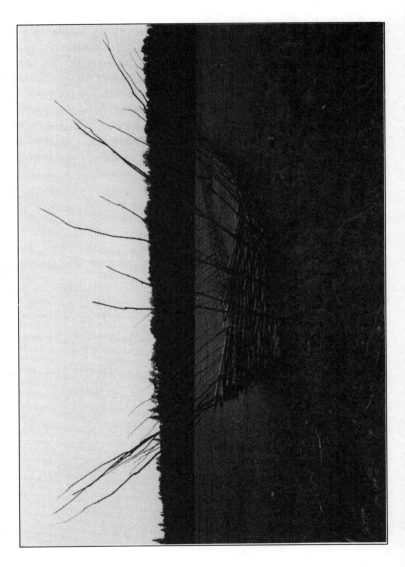

Peter von Tiesenhausen. *Vessel,* 1994. Plaited willow branches. Demmitt, Alberta. Photo by Randy Adams. Photo courtesy of the artist.

depends on it. Reason alone cannot improve our quality of life. As Thomas Berry writes: "We consistently think of the human as primary and the Earth as derivative rather than thinking of the Earth as primary and the human as derivative. This must change."[5] The ebb and flow of energies that are part of the process of life in our biosphere are the procreative core of our desire to transform, enrich, express, improve. We need an art that goes beyond merely treating nature as raw material for an environmental project, that reaffirms the universal experience of being alive and conceives of nature as the end, not the means, of the creative process.

Notes

1. Thomas Berry, "Art in the Ecozoic Era," *Art Journal* (Summer 1992), p. 48.
2. Pierre Cabanne, *Dialogues with Marcel Duchamp* (New York: Da Capo Press, 1987), p. 100.
3. Jerilea Zempel cited in *Festival Landmarks 1990* (Newcastle-upon-Tyne: National Garden Festival, 1990).
4. Andy Goldsworthy, *Hand to Earth; Andy Goldsworthy Sculpture 1976-1990* (Leeds: W.S. Maney & Son, 1990), p. 162.
5. Thomas Berry, "Religion and Cosmology", *Resurgence* , May/June 1994, pp. 16-19.

Part I

Part I

1

Waiting for a Cultural Break
Between the Commercials

Inundated by advertising — what Marshall McLuhan once called "the cave art of the twentieth century"[1] — artists now face a crisis no longer based in forms or styles of expression, but over the very question of what it means to create works of art in non-mechanical, interactive ways. As Ted Rettig, a Toronto-based artist notes:

> Art stands in a metaphysically critical relation to the symbolic dimension of mass media by bringing to awareness an alternative vision of fulfilment of being, through authentic encounters with the self, nature and mystery. Works of art can reaffirm, intuitively broaden and deepen this area of being...I find that the symbolic dimension of mass media leads people away from a direct awareness of reality and from the complexity of their lives. The overwhelming nature of mass media denies the validity of individual being as a response, thereby increasing an ontological dependency. Even for those individuals who see through illusions, the symbolic dimension remains the larger ground for testing their reactions of cynicism.[2]

From billboards to microscreens, this crisis in values is superannuated by the surfeit of syncretic, incantational media imagery that pursues us daily. In the 1994 Schumacher lecture, Jerry Mander suggested our society's resistance to technology is virtually nil:

> Technology is now so pervasive — we are surrounded by it and live within it — we literally do not realize the extent to which we are contained by it. It is so pervasive that it has become effectively invisible, at least to our conscious minds.[3]

The media's sudden visual truncations of an implied greater reality are but a state of mind yet these images affect our daily lives more readily than works of art. Why? Because these fractious phrases

of visual discontinuity are part of the irony inherent in a culture that thrives on consumer values. In seeking a purist, postmodern version of beauty, we deny the integral ethos that is the basis of our classic sense of beauty, which has always implied that any part is the sum of the whole. In a culture where beauty must necessarily exclude ugliness, where oppositions between abstraction and representation exist, yet are blurred in order to sustain a sense of order in disorder, the fragment can not include the whole, yet is perceived as an entirety. The bits of information with which we construct our sense of the world are not archaic fragments attached to a mythological vision based in real, culture-specific experience, nor nostalgic echoes of a Romantic legacy, but instead recant the logic of a visual syntax based in maximal scale production and reproduction systems. The visual fragment represents truth as speed caught for a millisecond, the ghost in the machine.

The modern urban artist will often conceive of his or her work using the language of the media and often feel he or she must compete, either consciously or unconsciously with the banalities of advertising art. Appropriating the latest tools of technology betrays a fearful conformity on the part of some urban artists. It is one of the main weapons in their drive towards recognition — to give meaning to emptiness. Geneviève Cadieux's *The Milky Way* (1992), an oversized billboard-like light box blow up of a pair of red lips that now sits atop Montréal's Musée d'art contemporain does not provide us with any physical, instinctual or intuitive response to a living environment. *The Milky Way* does nothing to engender a better feeling for or understanding of the surrounding environment in which it has been placed. How different is it from billboard advertising and how profoundly does it affect us? Rather than engendering an intuitive response, it boldly reaffirms the vapid power of mass media imagery and mechanical reproduction as an artistic "process." The image is cropped, bears no relation to any context whatsoever, and has been expanded and simplified to mimic the same syntax as chromacolour advertising. Yet such works are supported and encouraged by arts councils, and juries precisely because they do not threaten the status quo.

Suzanne Giroux's *Giverny, le Temps Mauve* (1989) comprised a series of fluctuating images of Claude Monet's famous garden at Giverny. Largely out of focus, these videotaped recordings had no element of workmanship or craft, but simply presented them through windows set into classic moulded picture frames — a supposed filter for soulful expression. This, despite the fact that the picture frame was

usually a later addition to Monet's original presentational intention. Everything is extemporized, minimized but the technology itself. In what way does this kind of art imply a commitment to social change and the betterment of human culture in the city, its local history or the broader context of nature with whose resources we change, alter and construct our city environments?

Environmental deprivation encourages aesthetic deprivation. For the public at large, the human context and credibility of arts culture is lost; it is a face with no eyes. The real message here is that the artist has no message. Aesthetic deprivation thus mirrors environmental deprivation and the human context of culture as a whole is lost. In this respect, the urban arts audience is no different from the artist whose sense of individuality is threatened by the all pervasive effects of the market system in today's capitalistic society. In *The Limits of the City* Murray Bookchin writes:

> Like a fragment of a jigsaw puzzle, the individual is separable from the whole — in fact, he is compelled by the market relationship to fend for himself — but his particularity and separability are meaningless unless he "fits himself into the picture." The urban ego, which once celebrated its many-faceted nature owing to the wealth of experience provided by the city, emerges with the bourgeois city as the most impoverished ego to appear in the course of urban development.[4]

Innocuous, socially inept, at best touristic and at worst absolved of any critical initiative, the official urban arts projects that adorn our public buildings and museums reify the language of the modern-day media and this in turn mimics the combined agendas of the corporate sector and the official arts museum. The commissioned artist will inadvertently ally him or herself to the interests of big business while giving his or her work a semblance of free expression. In 1967, American corporations spent $22 million on the arts while by the end of 1987 the outlay approached $1 billion.[5] Hans Haacke is an artist who since the mid-1970s predicated his artwork on the collusion between big business and the arts institution. Haacke's New York City exhibition of *On Social Grease* (1975) was titled after the following statement by EXXON executive Robert Kingsley: "Exxon's support of the arts serves as a social lubricant, and if business is to continue, it needs a lubricated environment."[6] If this statement sounds Orwellian, it reflects the *realpolitik* of today's corporate attitude towards arts

funding. Haacke's work actually consisted of a series of six photo-engraved magnesium plaques onto which the statements of six national political and corporate figures were incised. The gap between projected aesthetic intention, and corporate prerogative was non-existent. Hans Haacke's obsession with the way institutional arts funding affects artistic production and creates problems of subliminal censorship does not ultimately provide us with any answers to these problems because the focus is on structural problems instead of environmental solutions. Many artists have bought this bill of goods wholesale. Instead of inspiring public confidence in the essential role art can play in expressing contemporary cultural issues, their works exude an air of nonsensical double talk devoid of any sincere feelings or profound reflection. We no longer need an art that fits neatly into an institutional agenda or inadvertently charts its way in and out of museum and corporate collections. Art can provide us with a broader vision, communicate humanity's greater potential, and be a force for social and environmental transformation. If what we are served up as art in our arts institutions and commercial galleries is anything less, it usually mirrors the fatalist, techtopic values of the corporate agenda.

The an-aesthetic of our culture, where Walkmans and video cassette recorders, tinted windows and climate controlled offices encourage sensory deprivation, an experiential mono-reality, is today's reality. Our governments have likewise contributed to this situation. An excerpt from *Choosing a House Design*, a Canadian Mortgage and Housing Corporation booklet makes this clear:

> It is not worth having a large window unless the picture
> will be pleasing. A street aspect may only offer noise,
> gas fumes and traffic. It is, therefore more ad-
> vantageous and restful to locate the living room at the
> rear facing, and tying in with, the family's private gar-
> den where the aspect can be controlled. You then can
> justify having a large window. And you can arrange
> your own picture.[7]

It is a *perceived* culture with which artists must deal. We are now literally barraged with more choices than ever before and, ironically, seem less able to select quality over quantity, to make better personal decisions. Indeed, when faced with a "taste test" between a mechanical reproduction of a work of art and an original print, the average person will actually have difficulty perceiving which is the original, so seldom are his or her perceptive capacities called upon.

Our modern-day vision is a *techtopic* one. We codify and process our responses to images, then we throw them away in preparation for the next. As a result, when we look at a painting, a sculpture, an installation or a video, our patience is minimal: We have become consumers of art, no longer appreciators. Likewise, when looking at a natural forest or landscape, we will generalize its elements visually. Seldom do we actually look at the diversity of camouflaged, co-dependent elements that exist within their specific microcosm — a mirror of the planet's maximally scaled ecosystem. A forest is just a forest and a tree is just a tree. When we look at a tree, no different than the kind of tree our ancestors saw one thousand years ago, we say nature *reproduces* its own forms, when in fact nature *procreates* itself. It is we who invest nature with a purpose as a living object-container, an agent of endless reproduction, instead of seeing its essence as a virtually timeless catalyst of life. The same applies to art, where we conceive all materials objectively as contained or containing. Our aesthetic assumptions reflect the hermetic tautologies of a history based on material progress. Principles of production measure content, symbol or material as evidence of an underlying rationale. We preselect our responses to the eclectic wilderness on an *a priori* basis, simplifying its confusion of details in the same way we have been trained as consumers to do with our minimalist, media-saturated imagism. Our curiosity about the diverse elements that comprise it, or incredulity about its diversity of composite forms, have been deadened. The urban environments in which many of us live, where nature's presence has been reduced to tiny lots and geometrical parks caught between traffic and buildings, are experiential mono-realities, equally real environments whose lack of variation reinforces the sensory deprivation inherent to artificial media stimulation.

Today's aesthetic is a child of technoculture that eulogizes environmental overstimulation. For its overloaded imagery, it resembles a media product as void of any truly natural diversity as the sterilized climatic and vegetal environments in which animals are imported to live, exemplified by such places as Montréal's new Biodome. Constructed in a cement superstructure and replete with part-real, part-artificial landscapes and vegetation made out of poured and modelled concrete — shoreline erosion, cliffs, valleys, grottos and giant tropical forest trees — because, "if real boulders were to be used, the weight on the building's structure would be enormous," the Biodome is intended to "move beyond the individual to develop a "systemic view," a global understanding of the natural laws that

govern the healthy balance of an individual, a community or the planet itself."[8]

The Biodome is the only museum in the world that actually replicates four ecosystems in their entirety (a tropical forest, a Laurentian forest, the marine ecosystem of the St. Lawrence River and the polar world). These reconstructed environments internalize the kernel of the Romantic ethos, presupposing that the act of representation is itself a sublime ideal that somehow surpasses nature. Beneath the ground level floors of the Biodome, a huge equipment room houses reservoirs, pumps, filters and sterilization equipment required for air and water purification systems for each of its climatic microcosms; yet they also generate pollution and, like most of the household refrigerators still in use, actually contribute to ozone depletion. Contained within these hermetic environments are a bat cave, a beaver hut beside a stream (whose interior is monitored by a video camera and shows the beavers' movements within), a river scene with "mist nets" to prevent the terns, kittiwakes and gannets from escaping, and Antarctic and Labrador penguins assembled in the same polar environment to demonstrate the principle of *convergent evolution*. What we do not see are the other support areas: the clinic and quarantine areas for animals, the reproduction rooms, the nursery, the laboratories, the pharmacies, the carpentry, welding and fibreglass workshops that are also part of the production. Built at a cost of $58.2 million and projected to inject almost $44 million (annually) directly into the Montréal and Québec economies, the Biodome is a testament to our humanity's seeming incapacity to enhance the world's life systems where they exist naturally.

The borders between civilization and nature are confounding. They have become permeable, constantly shifting entities and we are no longer certain what nature really is. In the United States ninety-two percent of the lower forty-eight states have been developed. Only eight percent of the mainland United States is undeveloped.[9] As Robert Yaro, senior vice president of the Regional Plan Association in New York City notes:

> The landscape of Connecticut is as artificial as Central Park in New York City. It may not be as contrived, but the landscape of New England is a human creation. Unlike England which is an over-tended garden, New England is an under-tended garden. Early in this century, Massachusetts conducted an inventory of scenic landscapes and found a few remnants of forest in an

otherwise open agricultural landscape. Fifty years later, when I conducted a similar inventory, I found that only ten percent was agricultural and most of the rest was second growth forest. Connecticut is quite similar.[10]

Like the environmentally deprived audiences who visit a postmodern zoo such as the Biodome for a lack of any experience of real nature, today's art-going public is a predominantly urban one, whose vision is simultaneously based on visual-conceptual over-stimulation and a lack of bio-diversity or physical variation in their daily environment. Ironically, their vision of nature does not include their own city environments and involves stereotypes of the pristine wilderness we see in our national parks which can be likened to museums — a kind of archival storage system where the interaction of species remains less disturbed and disrupted than elsewhere.

Helen Mayer Harrison and Newton Harrison are two artists who began working together on themes of ecology and the living environment back in 1970, the year the first celebration of Earth Day took place. In the mid-1970s the Harrisons created *Sacramento Meditations*, a work that already dealt with the issue of global warming. In *Survival Piece No. 2: Notations on the Ecosystems of the Western Salt Works (with the inclusion of brine shrimp)* (1971), the waters in a series of shallow pools designed by the Harrisons gradually changed colour as the shrimp grew, ate the algae and the water's salt content changed. An excerpt from one of the Harrison's nine texts on *Sacramento Meditations* reads:

Therefore, new paradigms will be needed which will lead to new legal and social codes that will permit land and water to be passed on to succeeding generations intact, non-renewable resources managed, and renewable resources not depleted. For if the paradigms that inform the present use and energy practices of our culture (exploit/consume/transform into goods/transform into profit) as typified by our use of the Sacramento-San Joaquin watershed do not undergo modifications slowly (through civil means) or more rapidly (through revolutionary means), then they will surely undergo modification through massive biological revolt as ecosystems simplify in response to increasing stress and become minimally productive.[11]

In what way do synthetic or technology-based expressions imply a commitment to the betterment of nature from whose limited resources all economies and materials derive? An art of arrested holistic development that reifies experiential deprivation and relies excessively on the formal syntax and structures of technology is indeed a weakness. These "egosystems" of expression can now be contrasted with an art whose vision is more subtle, but whose purpose and effect is longer lasting. The main premise of environmentally-based art is a profound respect for our ecosystem. Art can be a form of "experiential nutrition" for its audiences, and encourage us all to appreciate life more fully.

Notes

1. Marshall McLuhan, *Understanding Media*, (Toronto: McGraw-Hill, 1964), p. 226.
2. Ted Rettig, *The Symbolic Dimension and Awareness in Mass Media, Religious Experience and the Fine Arts*, Paper presented to the University Art Association of Canada Conference, November 1985, pp. 3-8.
3. Jerry Mander, The Tyranny of Technology, *Resurgence*, May / June 1994, p. 24.
4. Murray Bookchin, *The Limits of the City*, (Montreal: Black Rose Books, 1986), p. 102.
5. Herbert I. Schiller, *Culture Inc.*, (Toronto: Oxford University Press, 1989), p. 92.
6. Ibid.
7. Central Mortgage and Housing Corporation, *Choosing a House Design*, (Ottawa: CMHC, 1970), p. 17.
8. Press release, The Biodome, Montréal, Québec,1992.
9. Dave Foreman cited in, Michael Pollan, "Only Man's Presence Can Save Nature," *Harpers*, April 1990, p. 43.
10. Robert D. Yaro cited in, Michael Pollan, "Only Man's Presence Can Save Nature," *Harpers*, April 1990, p. 39.
11. Craig Adcock, "Conversational Drift: Helen Mayer Harrison and Newton Harrison," *Art Journal*, (Summer 1992) Vol. 51, No. 2, pp. 40-41.

2

Like a Bird with No Feet

The media myth that market recognition is the only real way of establishing a value for art places many of today's artists at a great disadvantage. Inadvertently denigrating their origins in the process, contemporary artists' obsession with marketing usually precedes any desire to be recognized within one's own specific culture.

As they make the jump to the international market, today's artists have assumed the role of journalists: professional media mongers, hunting down reviewers and feature writers like print-hungry primitives, as if the published article was the only proof of talent. Their shows are analyzed in international art magazines that have become the Biblical barometers of avant-gardism, scrutinized by collectors, curators and dealers throughout the world, seemingly to the exclusion of anything that is left unrecorded in print. The judgements of these publications, which specialize in the cryptic art-speak jargon of never-never land, are tantamount to the tablets on the Mount: their word is *the* Word. And as these artists start to reap the rewards of media recognition, they begin to fetch high prices in Tokyo, New York, Paris and Berlin.

In subjugating their expression to a process of product standardization and valuation by market forces, most successful, career-oriented artists are forced to abandon any real search to identify with their own culture-specific experience in the regions of the world they come from. In so doing, they lose something very precious. This process of de-identification of the artist belittles any intrinsic value or holistic experience an artist's expression could potentially offer to the world. Works of art, as well as the artists, become interchangeable. In part, this divestment of integrity explains the fatally coded, anomalous messages: the stone-washed self-conscious forms of today's art. Many of these artists are only too willing to make clean, altruistic statements about the problems that have beset the world — pollution, overpopulation, war and famine — by incorporating media documentation, relics and artifacts from oppressed regions and cultures of the world. It gets them into important shows and sells their work to museums.

Vancouverite Jeff Wall's large-scale photographic light-box pieces have jumped in value from around $75,000 to $350,000 in two years,

becoming some of the hottest avant-garde trinkets sought out by the international museological industry. Berlin-based Vancouverite painter Attila Richard Lukacs' works now sell in the $40,000 to $100,000 range to collectors worldwide such as Elton John. Jana Sterbak of "meat dress" fame, in a show titled *Declaration* (1994) at Montréal's Musée d'art contemporain, simply presented a video of a stuttering man repeating segments from the American Declaration of Independence. In front of the piece, a designer chair typified this artist's vacuous cynicism and fixation with controversy for and of itself. Spoon-feeding the media may be some artists' idea of creativity and it does catch a lot of reviews and interviews, but one did not really even have to see the show to catch the gist of Sterbak's message. Conceived and executed in an overly simplistic manner, *Declaration* works on the lowest of levels, that of media manipulation and the pallid politicization of the work of art in a museum forum that itself is far from the broader public's interest. Geneviève Cadieux, whose photo blow-ups of microscopic facial and bodily details have received considerable international acclaim, plays on the *clair-obscure* platitude that art is anything you, the public, do not understand.

Other artists have taken on the oppression of minorities, the third world, and political issues as a *cause célèbre* and it gets them grants, yet they are terrified of taking any direct action that might improve the ecological or social problems occurring in their own backyards, nor will they send their grant cheques to Africa or Bosnia. In an installation at the 1989 Les *Cent jours d'art contemporain* at the *Centre international d'art contemporain* (C.I.A.C.) in Montréal, Dominique Blain's self-styled polemic focused on the art system itself. Sandbags were arranged around three sides of the installation much like those erected by soldiers in World War I to protect official monuments. Looking into this space the viewer could see a large photo of dead bodies fragmented into four parts covering the floor of the exhibition space. While this work was obviously pointing to the higher value attributed to official art works than to human life itself, it also inadvertently implied there was a greater value to exhibiting socially controversial art in the esoteric forum of the gallery venue than elsewhere.

As with American artist Jenny Holzer's electronic billboard truisms, Blain's work uses propagandistic effects as art. We are never sure where the art begins and the propaganda ends, yet the venue already weakens the artist's credibility as well. Though social statements by artists may be under attack in these conservative times, rather than replicating the language of propaganda and politics, the

most powerful counter-measure may be for it to explore other more creative and less didactic forums for exhibition.

MISSA (Mission), Blain's three-part installation at C.I.A.C. in 1992, continued to play with formal, media-generated imagery using the same unrepentant candour of her earlier works. In the first installation room, one was simply presented with an old office chair, spotlit in an otherwise empty space, in which one could sit between a pair of speakers suspended from the ceiling at ear level and listen to the sounds of a crowd chanting unintelligible slogans. The effect was innocuous, accessible, and annoying; as cloying and monotonous as media politics themselves. Blain's second installation consisted of rows of fifty-six perfectly aligned pairs of military boots polished shiny black, one from each pair hanging from black strings, seemingly marching nowhere and everywhere. The third room contained an Iwo Jima type flag temporarily supported by sand bags, with the word "CREDO" emblazoned on it. A giant fan in the foreground caused the flag to flap to and fro. If artists wish to go beyond merely perpetuating these same blinkered myths to express life's inherent uncertainties, they have to use art as more than a pretext for confirming facile analyses of ideological hegemony. Socially relevant art is not necessarily ecologically relevant. A gap exists between the "I-ness" of formalist expression and the more poignant, intuitive side of expression. The latter is ecologically pertinent and cannot be contained by traditional or avant-gardist historical imperatives.

Consequently, as internationalism has evolved during our conservative epoch, it has sought to cover up all tracks of cultural specificity, elevating the power of the market over all artists, regardless of national or regional origin. Some artists collude in this process as part of an ongoing search for a paternalistic approval. They will try their utmost to remove all marks of their regional and national identities from their art, masking it with the latest didactic, conceptual metaphors of late materialism's ongoing angst. But some artists are asking new questions about the problems that beset the planet, wondering if internationalism has not itself begun to manifest the exploitative characteristics of an economic system that needs to be reformed from the bottom up. Liz Magor, a native of Winnipeg who represented Canada at the Venice Biennale in 1984 and the Documenta exhibition in Kassel, Germany in 1987 put it this way:

> Periodically, I think it would be better to stop making art than to continue to be part of such a compromised ac-

tivity. I see it as compromised by various things: the market, peoples' expectations, political correctness.[1]

Internationalism in the visual arts has lost its human face. Still, many of today's most interesting artists are keeping at arm's length from the machinations of the international art market. Their concern lies with establishing new connections between our humanity and the biosystem on which our future depends. Georganna Pearce Malloff is an artist who tested the waters of the big city scramble in arts careerism and is now the director of the *Freshwater Bay Sculpture Park* (F.B.S.P.), a 100 acre natural environment located twelve miles southeast of Alert Bay on the Northeast coast of Vancouver Island, accessible only by boat or seaplane. Located in a wilderness area, the F.B.S.P. is dedicated to encouraging sculptors to create installation works that are directly responsive to the ecology and natural features of the region. Earlier in her career, Malloff exhibited her intricate carvings, *Cosmic Maypoles* and *Creation Poles*, with their intertwining of natural, wildlife and abstract relief elements outdoors at various sites. The individual elements within were considered as important as the unified collective design. A seventy-five-foot pole was created for the United Nations Conference on Habitat in Vancouver in 1976 and *Cosmic Pole II* for the Harbourfront Contemporary Art Gallery in Toronto in 1980. Malloff commented on her work:

> After about fifteen years of trying to be an international artist — I could see the futility of it. I worked at a grass roots, intuitive, networking level and found my works were antithetical to big institutions. But, nonetheless, I was losing my creativity — my soul — as the process became too self-conscious. In the spotlights it is hard to work in that deep intuitive state of mind from which true creativity comes. With my *Cosmic* or *Creation Maypoles*, I refused to imitate an Indian totem and came up with something universal, in the sense that it related to creation myths from many countries. "Cosmic" in the sense of spiritual universe — connecting aspiration — or the understanding of the flow of human energies, the desire to connect with higher consciousness. Each project reflected the community groups and different structural systems I was working with. I am now trying to create a place where "emerging" artists (before they are packaged by any art market) can play, experiment,

interchange with each other in a wilderness area. We want to resist becoming an institution so spontaneity and discovery can truly happen. The world is so intent on becoming cosmopolitan that we are sometimes afraid to touch the earth even when sleeping.[2]

Universal concerns with the environment, a resurgence of interest in mythology, and the need to replace outdated patriarchal models of society, are all coming into play as artists seek to nurture new forms for their art. Even art's own history is being rejected outright by feminist artists whose vision is not to fill their fathers' shoes, but to invent an entirely new kind of footwear. While some of this work tends towards the didactic with its force-fed lessons in the ABCs of social conscience, Liz Magor's genial mock reconstruction of a room in a generic, Victorian colonial mansion (exhibited in Montréal's new Musée d'art contemporain's blockbuster opening show *Pour la Suite du Monde* in 1992) was a witty period piece, complete with partially rolled up carpet and synthetic recreations of accumulated dust. Two over-life-sized beavers (one of Canada's national symbols of industry) sat ignominiously upright in mahogany chairs covered over in plastic, as if history was on hold. In the same installation a series of before-and-after photo shots of working-class Irish and Scottish immigrants portrayed how little their economic plight had changed after settling in the New World.

The hazards of so-called professional arts careerism are now great. Many artists will spend four days per week on bureaucratic details — arranging shows, negotiating contracts, and giving interviews — rather than on their art. As their latest creations are being shipped from here to there, the artspeak of their work holds little interest for their neighbours back home, who would probably breathe a sigh of relief upon leaving their exhibitions. A further irony is that in New York, Paris, Berlin and Tokyo, these same works will be considered the ultimate reflection of their place of origin. But, as the instant artifacts they create become the latest places to park money, many of these artists perceive themselves to be in a double bind, eulogized and colonized at the same time. As Margaret Atwood states in *Survival*,

> A person who is "here" but would rather be somewhere else is an exile or a prisoner; a person who is "here" but thinks he is somewhere else is insane. But when you are here and don't know where you are because you've

misplaced your landmarks or bearing, then you need
not be an exile or a madman: you are simply lost.[3]

Displacement through internationalism distorts creative effort. Its ef-
fects are now being felt throughout the world. The internationally
recognized artist is like a bird with no feet, who must circle endlessly
in the air, and can never land.

The dismantling of the Berlin Wall, the reunification of the two
Germanies, Perestroika in Russia and its consequent break-up, and
the resurgence of micronationalism in Eastern Europe, are all part of
the vast social, political and economic restructuring going on in the
world. These changes are pointing to currents that are completely dif-
ferent than those appearing on the surface of the New World Order.
Regional economies, linked to a greater world economy, seem to be
replacing the megastructures of the past. For this reason, internation-
al postmodern art is now passing the way of the Edsel because it
avoids any future vision and seeks to sever ties to regional culture. If
the cultural mix appears to be taking place on the surface, it largely
results in the homogenization of world cultures, not a mutual respect
for cultural differences. Cultural diversity based on a respect for the
specificity of each group's bioregional needs seem a better way to en-
sure freedom of choice than an economic totalitarianism based on
corporate profiteering. The demise of one ideology — communism —
also signifies a re-evaluation of another — the West's democratic
traditions.

Our legacy of economic progress has created a quantitative,
materialist history of art, a history perceived as a successive layering
of movements and eras on top of one another in a kind of pyramid of
time. The ideology of avant-gardism, with its deification of the in-
dividual artist, promotes "egosystems" of expression that nurture a
Pilgrim's Progress vision of cultural history. It blinds us from any real
insights into the inclusive relation between human culture and the
culture of nature. In *Dreaming with Open Eyes*, Michael Tucker writes:

> The cult of avant-gardism betrays the West's ridiculous
> obsession with the ceaseless movement of history: to be
> forever ahead of the game on the plane of art history
> and journalism is to be forever removed from the sour-
> ces of genuine, lasting creativity. There must be a return
> to the symbolism of cosmos; a revivification of archaic
> principles of creativity, drawn from the deepest layers
> of an integrated psyche.[4]

We generalize and simplify nature, link it directly to an expansionist illusion that has been our model of history. *New art* is deemed socially relevant by the *culturati* that govern our arts institutions because it represents a break from the artistic traditions that immediately preceded it and thus encourages a market demand for its very novelty. There is a coded *connaissance* of the past traditions from which *new art* is supposedly distinct. This tautological concept of the evolution of art encourages the notion of transgression, of a steady stylistic progression that looks askance to check historical precedent in order to ensure its own implicit originality.

The demise of avant-gardism in the West, hailed by critics and artists alike, is taking place. Yet it is only recognized as a hypothetical idea, not a reality, by arts aficionados. Even as it is taking place, it is rejected outright by the institutional arts community because it would make a mockery of twentieth- century art's entire *raison d'être*, its modernist prerogative based on linear progress. The mutually exclusive ideologies of capitalism and communism are now coalescing. They no longer exist in a direct, dualistic opposition to one another. A homologous internationalism continues to sweep like a tide across centre stage. Ecological reform as a process, not simply a product modification, has still not been brought into the equation. This is because it calls into question the very basis of economics' dynastic structural ethos. Our humanity's unchallenged dominion over our planet's renewable and non-renewable resources must surely end. It will more certainly affect our future survival than any political or economic agendas of expansion, no matter how attractive they may appear to be.

Economies of scale will ultimately be limited by the availability of natural resources. It may not be an easy choice but we have a chance to safeguard the planet's other species and renewable resources if we recognize quality of life to be a more lasting value than economic production and consumption quotas. The same applies to cultures of scale. Interrelated yet linked as a whole, the diversity of the world's human cultures are independent, yet integrated. They are the most capable of maintaining the bioregional cultural diversity we now possess because they have the greatest knowledge of their respective local ecologies. As these microcultures are manageable, both in terms of scale and resources, they are capable of regenerating and controlling their use and regeneration of both human and natural resources. The cultures of the world are not just superfluous baubles on the world tree of mass consumption and resource exploitation, but the very lifeline that can ensure a greater responsibility for resource

regeneration. It seems highly unlikely that the peoples of the world really want to live through the authoritarian dictum of a New World Order that fails to encourage a sense of cultural and ecological responsibility into its elegantly charted production and exchange tables. The Earth Charter, prepared by various non-governmental organizations that gathered together at Rio de Janeiro in June 1992, recognized the revitalizing potential of bioregionalism in the world without reverting to the pat nationalist nostalgia of the past. Section Four of the Earth Charter's principles adopted June 10, 1992 reads:

> We recognize that national barriers do not generally conform to Earth's ecological realities. National sovereignty does not mean sanctuary from our collective responsibility to protect and restore Earth's ecosystems. Trade practices and transnational corporations must not cause environmental degradation and should be controlled in order to achieve social justice, equitable trade and solidarity with ecological principles.[5]

The generalized ideologies of the past, so intensely reliant on a dualist perception of the human will to rationalize experience, are now less convincing than they used to be. This was made evident in the exhibition of *Free Worlds: Metaphors and Realities in Contemporary Hungarian Art* (1992), held at the Art Gallery of Ontario. Lazlo Féher's paintings recall the Romantic realist idealizations seen in Communist paintings and monuments. They portray the empty, oblique city scenes that typified the decades of Communist rule. These images have unreal figures in outline only, old men and youngsters, the innocents whose collective will eventually gave Hungary its current state of freedom. Sandor Pinczehelyi's collaged symbols and images have a post-Pop flair that plays off the redundant icons of Western consumer culture (such as Coca Cola lettering) with equally redundant Communist symbols (such as the Red Star). One spring morning about twenty years ago, Pinczehelyi laid out a five-pointed star of cobblestones and by degrees filled it up with more stones, even beyond its original borders. It was then that he arrived at the conviction that he could use signs and symbols that were part of his immediate cultural environment:

> This seemed to be a tremendous force but I was certain that answers could be created through irony and by reversing meaning in photographs, drawings, paint-

ings and installations. Andy Warhol did works with the hammer and sickle in 1974; I was already using the hammer and sickle in the early 1970s. For Warhol, the hammer and sickle meant totally different things than for me in the Hungarian context.[6]

Gabor Bachman's *Free World* maquette and photos of Budapest installations are architectural and classical ideotypes, succinctly versed in the constructivist tradition. The sheer scale and engineered sense of finite illusionism in Bachman's works make them reluctant metaphors that bear witness to the problems inherent to any generalized ideology, either the free world's *land of plenty*, or communism's structuralism. In Hungary, the arts have, until recently, evidenced the populist culture of resistance that existed in opposition to communism. The Moscow-directed bureaucracies that tried to control the Hungarian peoples' natural identification with their own culture did so in three ways, known as the three T's: *Tamogatni* (to support), *Turni* (to tolerate) and *Tiltani* (to ban). This manipulation, intimidation and outright control, worked only so long as Hungary remained isolated from the outside world. By the mid-sixties, despite its marginal official position, avant-gardism was a significant, unofficially recognized counterforce to State ideology. In the 1970s, as trade ties with the West strengthened out of sheer necessity, unofficial art flourished, supported by trade unions and State companies. As Pinczehelyi comments:

> It is a very interesting and ironic situation that the death of the avant-garde was announced in the West at the same time as Hungarian artists were still struggling with their total isolation from the system and with the total division between Eastern and Western systems. The whole idea was like a farce for them. If in the West, the death of the avant-garde occurred because of indifference, because it finally got to be an official art and familiarity killed it in a way, in Hungary it was never allowed to be born so there was nothing to kill. The struggle was always there to create progressive work, to stay in tune with one's culture and modern environment, so it was never a question in Hungary.[7]

As no strong market exists for their work at home, Hungary's artists now seek to embrace the fruits of our arts market system, naively

adhering to old fashioned notions of avant-gardism, of a historical tautology of art. Yet while avant-gardism in the West is fragmenting and European and North American art galleries have accepted Hungarian artists for exhibitions, their work is still considered marginal; peripheral from the big name market activity orchestrated in New York, Paris, Tokyo and London.

In North America, formal culture is still seen as something to be promoted; basically, marginal to the broader spectrum of social activities. In the sixties, Jim Dine was an American artist who occupied the centre stage of the Western avant-garde scene. It was at this time that he created a *Car Crash Happening* at the Reuben Gallery in New York, incorporating rolls of linoleum painted white, which lined the gallery walls and had huge red crosses of wood suspended above a scene of the mangled remnants of limousines and crash victims. In a recent show at the Pace Gallery in New York (1992), Dine presented works that no longer challenged, but instead endorsed an establishment, art market point of view. These recent sculptures readily identified with the nostalgia of the American Dream, the junk piles and castaway curios of Americana that litter the roadside landscape. His once ephemeral icons and memorable rough hewn wood carvings were sanctified to become bronze cast constructions akin to Joseph Cornell's box assemblages, but extended outwards. *Wheat Fields* (1989), the most emphatic of Dine's new found alchemical statements, assembled rusted farm machinery, discarded tools and household objects along a sixteen foot wooden beam, along with a carved skull-like head. The entire piece was cast in bronze. All of the individual elements were then painstakingly painted over to give them their original look, their permanence disguised. The work eulogized America's past cultural regionalism, its homespun self-reliance that preceded today's industrial gigantism, economies of scale and mass production.

Like so many of his sixties counterparts, Dine has abandoned his allegiance to emphatic social statement in an effort to re-establish a continuity with America's past cultural traditions by presenting nostalgic reflections on capitalism's cultural roots; but his choice of bronze as a medium has everything to do with the sale price, not the creative process of expression.

The boundaries between nature and the civilized world are constantly shifting, bringing the very notion of a "true nature" into question and abstracting the basis of cause and effect in a world undergoing vast environmental disruption. Today's landscape is certainly not a pristine wilderness immune to human intervention nor a

boundless, inexhaustible reserve. In trying to denounce the great gap between humanity and nature many artists have *framed nature* as readily as any industrial giant exploits it. The result is a lifeless form of art that defines and describes the idea of exploitation without offering any creative solutions. These fatalistic forms of expression are part of our old-fashioned legacy of modernism, of an art whose vision is entangled in a nostalgic vision of the future. To recognize our place in the picture of life, we have to be responsible for the ambiguities and uncertainties of true feeling. These cause us to question our basis of identity in relation to the diagrammatic systems of which we find ourselves a part. Any transitional attempts at maintaining outmoded codes of aesthetics are flagrantly short-sighted. Like lost souls in a snow storm, we move forward step by step, seemingly unable to see where we are going, only to find we have arrived where we began. While moral, ethical or social questions are well described in today's art: the art is shallow, a literal presentation of material without an intrinsic identification with its material constituents. William Shakespeare described the process of art in *A Winter's Tale*, when he wrote:

> *Yet nature made better by no mean — but nature*
> *makes that mean — which you say adds to nature, is*
> *an art — that nature makes...This is an art/which*
> *does mend nature — change it rather; but —*
> *The art itself is nature.*[8]

Aesthetic narcissism, the egotistical view that what we create is somehow immortal, eternal and more significant than life itself, reinforces our division from nature and relegates expression to the role of dogma. Hard as it is to accept, nature is as much a part of art as we, and we are a part of nature. Any attempt to maintain codes of aesthetic narcissism, part of the necessary exhaustion of identity in a consumer-based society, will ultimately fail. It propagates the naive view that we are somehow immortal, gods of our own creation. In this walk through the dogmatic, the literal character of today's art forms fundamentally bores us because it is tied to our historical legacy of material progress.

Our society's world-view, its history and art, relates directly to the economic context on which its evolution has been predicated. Aesthetic traditions have defined content by measuring subject, symbol or material evidence, but their vision of the progress of art contradict our economic definitions of progress. Traditional and avant-

gardist forms of art (postmodernism included), with their reliance on
a chronological evolutionary legacy of expression, likewise reinforce
cultural models diametrically opposed to nature. They embody no-
tions of individualism that conceive their significance in relation to
their relative context within a formal history. By presuming the
artist's role to be superior to that of nature, we have committed a sub-
lime oversight that must change if our planet's bioculture is to sur-
vive.

The history of Western culture is inimically tied to economic
progress. Prototypes from the past mislead us in our vision of how art-
ists can create expressive works in the future. The frenetic anxiety in
today's art world is associated with the idea that we might as well cash
in now, because we do not know what tomorrow will bring. The mes-
sage has become more important than the medium. This crisis of ex-
pression is not always evident, buried as it is beneath a barrage of
books (themselves now just "products") that reify our Cartesian, quan-
tifiable view of art and history. By manipulating nature through art we
have treated it not as an equal partner, the fundamental facet of any
economy and a true source for expression, but instead as something to
be framed. Nature becomes a device to be used and one of its main
purposes is to have a name attached to it. Seen in environmental terms,
the artistic process is indivisible from nature because it involves work-
ing with materials. Our entire world — the fax machines, the stone
and cement our buildings are made of, the paint and canvas an artist
uses — all ultimately derive from and are materials in nature. James
Lovelock's Gaia hypothesis views the world of materials in a similar
manner but without an emphasis on creativity:

> The Gaia hypothesis sees the evolution of the species of
> living organisms so closely coupled with the Western
> evolution of their physical and chemical environment
> that together they constitute a single and indivisible
> evolutionary process.[9]

In a media-charged world where who we are and what we are is
considered irrelevant because knowledge of self has no marketable
value, evidence reigns supreme. Mass market advertising and com-
munications imagery increasingly infiltrate our conscious thoughts
and actions in the world around us. If we allow ourselves to succumb,
the danger of losing our instinct to feel what is actually around us in-
creases. To communicate thus becomes to consume. The contem-
porary artwork held in the highest regard by the media and museums

these days usually displays no instinct for cultural survival and is lost in the collector lane of hyper-syncretic metaphors and plastic fables of cultural anomie. The New World Order's so-called internationalism is displacement through devaluation, exchange without recompense to integral value or resourcefulness. It is a fatalist nightmare whose effects are now being felt throughout the world. The same phenomenon has occurred among landscape designers and architects. Alexander Wilson describes the effects of internationalism on regional architects in *The Culture of Nature*:

> North American modernism has other roots as well. It borrowed from Japanese and Moslem gardens, as well as from Latin America. Roberto Burle Marx, a Brazilian, introduced flowing biomorphic patterns into his landscape projects, which rely on complex pavings of many different materials and a sculptural use of native plants. Luis Barragan used the basic, almost primal forms of water, earth, walls and trees in his work in and around Mexico City.
>
> The most obvious characteristic of all this work ... is its emphasis on form. But it is form as it is derived from local cultures and topographies, a sensitivity to region that often carries over to the use of native plants. The tension between modernism and regionalism in fact is a recurring theme in twentieth-century landscape design. Modernist aesthetics generally have ransacked and colonized non-European cultures in a search for authentic expression. Sadly, the formulation of the "international style" — with its parallel in the standardization of building techniques and industrial processes — means that many of our built landscapes today are indistinguishable from one another.[10]

Art from the older Western nations, the newly created East Block nations, the third world and primitive cultures is equalized through appropriation into the mainstream market. As the rate of this appropriation increases, the more fragile cultures of smaller nations and regions are flattened out and steamrolled by the central markets of the more powerful nations. The profound depths of intrinsic cultural value are consumed and depleted to demonstrate that economy is indeed "lord of culture." The power of postmodernism, the main market's didactic namesake cousin is, like economics, just the packag-

ing that surrounds and obscures the real value that lies within, name-
ly intrinsic culture. Internationalism is a dilution or distortion of
original culture.

The success of some artists is essentially a failing, the subjugation
of cultural origins in the face of the devastating effects of global scale
economies that parallel a new spirit of conservatism throughout the
Western world. This spirit is no less present in the business of art than
it is in the business of business. In New York, where the spiritual ex-
haustion of America's own *commodification* of art has achieved out-
rageous proportions, a succession of regional movements have been
ingested by the main market. *Arte Povera* from Italy, which used dis-
carded materials as the basis for its art and was originally a reaction to
the rampant elitism of the art world, found itself integrated into the
New York market. Then Germany's neoexpressionists, who had, at
the outset, sought to maintain their cultural specificity by avoiding
the American market, found themselves devoured in the early
eighties. They were soon ensconced in a series of exhibitions, includ-
ing the Museum of Modern Art's *Anselm Kiefer* show in 1989. Now,
Spanish, Australian aboriginal, Russian post-Perestroika, Native,
Inuit, Mexican and Central American art forms are undergoing ab-
sorption. The voracious appetite of business investors devours the
latest products of avant-gardism. This results in the consequent
demise of each ingested "movement." Modern art has become a vast
clearing house in a seasonal fashion show where New York gallery
labels can jump the prices tenfold. The fusion of art and money have
become so strong that the engine driving internationalism is quite
simply greed. The great art centres of the West continue to exhibit a
kind of Darwinian selectivity, a single crop aesthetic rotation scheme
designed to reduce any potentially beneficial diversity of expression
to a minimum.

While international acceptance plays an important part in many
artists' careers and encourages higher prices, it may not be as accurate
a barometer of quality as we tend to think. As Canadian-born
economist John Kenneth Galbraith stated:

> Some part of the art market, perhaps a large part, is now
> a manifestation of the classical character of inflation on
> the speculative level. That is to say prices have gone up
> for whatever reason. This causes other people to think
> they're going up more, and so they buy on the expecta-
> tion and that sends the prices up...The answer there-
> fore is, yes, these prices (in the tens of millions), there's

no question, represent in part a flight from reality that characterizes all speculation...People who buy art as an investment or capital gain are doomed to see dollar signs rather than beauty or interest.[11]

Notes

1. Liz Magor, quoted in, Gillian McKay, "Liz Magor," *Canadian Art*, Fall 1990, p. 83.
2. Georganna Pearce Malloff in correspondence with John Grande, February 23rd, 1994.
3. Margaret Atwood, *Survival*, (Toronto: Anansi, 1972), p. 18.
4. Michael Tucker, *Dreaming with Open Eyes: The Shamanic Spirit in 20th Century Art and Culture*, (San Francisco: Aquarian Harper, 1992), p. 65.
5. *The Earth Charter: Stated Principles*, Final Version, adopted June 10th, 1992, Rio de Janeiro, np.
6. Sandor Pinczehelyi interviewed by John Grande, "Time Gaps and Culture Zones," *Vice Versa*, No.40, Feb./March 1993, pp. 46-47.
7. Ibid.
8. William Shakespeare, *The Winter's Tale*, (Baltimore: Penguin Books, 1956), IV, pp. 89-97.
9. James E. Lovelock, *Gaia: A New Look at Life on Earth*, (New York: Oxford University Press, 1979), p. 57.
10. Alexander Wilson, *The Culture of Nature: North American Landscape from Disney to the Exxon Valdez*, (Toronto: Between the Lines, 1991), p. 103.
11. John Kenneth Galbraith interviewed by Alexis Gregory in, "Art as Money," *The International Journal of Art*, Oct. 1990. p. 59.

3

Nature is the Art of which We are a Part

The 1992 Earth Summit in Rio de Janeiro clearly demonstrated that the main players in the world economy are in no way about to reform the systems of resource exploitation that have led to our planet's ecological malaise. As artists witness the effects of environmental abuse on the product and process of art, many are realizing that the international arts scene is now showing the ramifications of an economic system that itself requires radical transformation. For many artists beset by all this evidence of necessary irresponsibility, the very assumptions we have held about our own history, about the *de rigueur* formalism of the international art world's legacy, must now be challenged. The fusion of art and money has become so strong that it resembles a floating crap game in which national cultural bureaucracies willingly co-operate while dealers and art brokers collude at arm's length. Internationalism manipulates nationalism, as nationalism manipulates nature. The very notion of advancing a gross national product, while diminishing the gross Earth product is ridiculous. The same applies to the international marketing of art, which while adversely diminishing cultural values, turns them inside out.

Just as economies must be redesigned to create systems that will preserve the Earth's integral ecology, so the arts system must be de-economized, relocalized and strengthened at its roots if it is to retain any meaning. We are moving towards a world where bioregions and microcultures are re-emerging. As diverse as nature itself, humanity's regional cultures are beginning to work together in an intra-cultural, intra-national way. Sustaining a maximum level of cultural diversity through management at the local level is the best way to manage nature's ecosystems and encourage bioregional diversity.

Many gifted artists of the modern era have accepted that the artworks they create have absolutely nothing to do with the art market. From the artist's viewpoint, going for a walk is economy; from the economist's, industry is culture. These two approaches have always been at loggerheads. Within our own cultural heritage, as elsewhere, the visionary artist has never created for purely economic reasons. Indeed, many of the brightest lights in the history of modern art, such as William Blake, Paul Gaugin, Vincent van Gogh, Edvard Munch, Natalya Gontcharova, Albert Pinkham Ryder, Ralph

Blakelock, Emily Carr and Frida Kahlo created works of art for intrinsic or prophetic reasons, without a thought of personal gain or the vicissitudes of market taste. It is a sublime irony that it is precisely these artists' works that have generated an entire museological industry and form the core of today's blockbuster historical shows. Their major canvasses all attain prices in excess of $100,000 and are the subject of the greatest scrutiny by the international museological industry and arts brokers; precisely because of the spiritual and lasting values these artists projected into their art. As *Time* Magazine's critic *par excellence*, Robert Hughes, stated so succinctly in an article titled *Art and Money*: "What strip mining is to nature, the art market has become to culture."[1]

By having an economic value placed on it, the essence of art — its interactive capacity to communicate the ephemeral through materials — is devalued. Instead of furthering the holistic value of experience, it becomes a mere product, bought and sold. For the current price of a Van Gogh or a Corot landscape, millions of real trees could be planted, more than could ever be represented in one painting. For this reason, younger artists are justifiably confused. They are offered professional careerism based on economic rewards and little else. This entangles them in the complex web of a material-for-capital exchange system that is completely at odds with the true spirit of creativity. It reaffirms the least imaginative of all dreams — that of materialism. The nineteenth-century critic John Ruskin wrote of this in *The Political Economy of Art*:

> A real painter will work for you exquisitely, if you give him…bread and water and salt; and a bad painter will work badly and hastily, though you give him a palace to live in, and a princedom to live upon…I believe that there is no chance of art's truly flourishing in any country, until you make it a simple and plain business, providing its masters with an easy competence, but rarely with anything more.[2]

While the modern-day art museum itself is now in danger of becoming a passive leisure industry devoted to the consumption of images rather than the appreciation of human and worldly values, the true meaning of art has never been less certain.

In seeking to bridge the great gap between the environment and humanity, many artists are now maintaining a guarded distance from the machinations of the market as they try to move beyond traditional

forms of expression. Their concern lies with establishing new connections between humanity and the biosystem on which our future depends. Universal concerns with the environment, a resurgence of interest in mythology, and attempts at rediscovering a basic self-sufficiency through the recognition of the value of bioregional culture are all part of this new non-movement. The need to replace outdated patriarchal models of society is equally being recognized. In nurturing new approaches to the creative process, many artists will reject the history of art outright. For these artists, culture is not perceived as a mutable membrane to be permeated by mega-corporations, but instead can determine the very shape of what an economy could be.

The diverse spectrum of bioregional elements that are a part of our experience of the world around us — climate, geography, geology, other life forms — are now an inviolable part of, not distinct from, the creative process. In developing a nature-specific dialogue that is interactive, rooted in actual experience in a given place and time, and giving these elements an equal voice in the creative process, we are ultimately respecting our integral connectedness to the environment. The inflexible stereotypes of art history and outmoded notions of avant-gardism could be replaced by a searching inquiry — one in which the maps of art's legacy can no longer be a guiding principle. A synchronous development is occurring throughout the world at the same time, almost despite the media's sublimely counter-productive message; this new imperative defies the classic stereotypes of an art based in formal language. As an approach, it no longer recognizes central market forces as all-important, but instead as demeaning. This art takes its cue from specificity itself, an intense realization of the importance of nature where it exists, in each and every bioregion of the world. Its mutualist role uses art's capacity to communicate through materials as a centring device that can help us reconnect with our place in the natural world. Our expendable taste for novelty is being rejected. Some of us have begun to realize that we are a part of the continual interaction, exchange and transformation of energies that is nature: nature has become the main substance for a new art as nature. There is an essential freedom that comes when one identifies with the life process itself as art. It is the one chance we have to ensure a viable art of the future. Nature is the art of which we are a part.

Notes

1. Robert Hughes, "Art & Money," *Time Magazine*, 27 Nov. 1989, p. 79.
2. John Ruskin, *The Political Economy of Art*, (London: Smith, Elder & Co., 1857), p. 75.

4

Ephemeral Inspiration, Concrete History

The words *ecology* and *economics* derive from the same Greek word, *oikos*, which means household or home. Ecology (*logos* meaning study) is the study of the home, and economics (*nomics* meaning management) is home management.[1] The forces of economies and their consequent exploitation of the environment in this period of late capitalism have done nothing to enhance the management of our true home, the planet Earth. Instead, nature and life itself have been relegated into a small corner of our experience. Most of today's art expresses the disruption of the self by the forces of our consumer-based ephemeraculture. It denies the process of living within a permaculture and perceives expression in relation to the ephemeral dictums of material growth.

In a recent article titled *Art in the Ecozoic Era*, Thomas Berry, author of *The Dream of the Earth*, suggests that the new era our civilization is moving into should be referred to as an *ecozoic*, rather than an *ecological* one.[2] While ecology merely refers to an understanding of our life systems and their integral relations, Berry suggests the term *ecozoic* (the suffix *zoic* being derived from the Greek *zoe* meaning life) simultaneously conveys the feeling of an immediate, biological reality and of a historical realism.

The word *nature* derives from the Latin *nasci*, meaning "to be born." The demise of an art that considers people's place within a natural environment had its roots in the early industrialism of the eighteenth century. It was at this time that humanity's relation to the diurnal, biological forces of life became estranged, subsumed by mechanization and markets for the exchange of material products. The purpose of the new economic structures that were being put into place in the new industrial era was pure profit, maximal resource extraction and the assembling of vast stores of capital. Percy Bysshe Shelley recognized the effects of the economic force behind early science as early as 1821 when he wrote in *A Defence of Poetry*:

> We want the creative faculty to imagine that which we know; we want the generous impulse to act that which we imagine; we want the poetry of life: our calculations have outrun conception; we have eaten more than we

can digest. The cultivation of those sciences which have enlarged the limits of the empire of man over the external world, has, for want of the poetical faculty, proportionally circumscribed those of the internal world; and man, having enslaved the elements, remains himself a slave. To what but a cultivation of the mechanical arts in a degree disproportioned to the presence of the creative faculty, which is the basis of all knowledge, is to be attributed the abuse of all invention for abridging and combining labour, to the exasperation of the inequality of mankind? From what other cause has it arisen that the discoveries which should have lightened, have added a weight to the curse imposed on Adam?[3]

Art and science were closely related prior to industrialism, both in theory and practice. Isaac Newton's study of alchemy and the occult were, for him, considered part of his scientific investigations. As for John Constable, scientific notes on cloud formations were a part of his artistic research into painting. At the pre-conscious stage — the point prior to and during any discovery — the arts and science remain very similar even to this day. Niels Bohr, the Danish atomic physicist, states:

When it comes to atoms, language can only be used as in poetry. The poet, too, is not nearly so concerned with descriptive facts as with creating images and establishing mental connections.[4]

Art could play a leading role in the future of our society if our artists accepted the importance of studying nature, and recognized their own place within an ecosystem. The great gap between the arts and science still does not essentially exist. Like the arts, scientific discovery at its best is based in recognizing the immense number of variables extant in nature — which our unconscious taps into when involved in any creative endeavour. Technology — which we often categorize as science — is an altogether different thing — a facet of scientific discovery inimically linked to the production process. If the arts are to be truly relevant to the development of a future vision, we must leave behind the "egosystems" of expression and base our art in a profound respect for the ecosystem. The barrage of materialist metaphors, didactic statements and affirmative narcissisms that we see in today's art are a fragmentary idiom that resembles the dissem-

bling of the personal and social identity in our society. It is a direct result of our wholesale identification with consumerism, the innocuous values of a culture arranged around artificially instilled techno-regions. These techno-regions restrict our contact with any immediate, physical reality that exists in our bioregions: climate, other species, geology, land, water and specific resources. Capitalism perpetuates exchange economies that create hierarchies of mass consumption. In so doing, it creates a set of artificial values and needs that extend an omnipresent feeling of emptiness, of existing in a cultural vacuum. The West's modernist legacy, with its endless fracturing of past "movements," is a kind of planned obsolescence resembling that which we find in all consumer sectors of society. Novelty is considered to be of great value. The past, however recent, is perceived as irredeemably irrelevant, something to be replaced. This attitude leaves us looking for creative sources in something that is somewhere else than within ourselves.

As we approach the end of the second millennium, we must rethink the role of art in society. In an era where we are no longer sure what inspiration really is, we must question what a response to art actually is. Traditionally, when inspired by a work of art, the viewer had a feeling of empowerment, a manipulative control over his or her senses. Inspiration suggested a kind of quantum leap of faith as to what we were experiencing instead of a gradual, slow moving transformation from a limited to a more holistic state. Nietzsche explained the revelatory nature of his definition of inspiration when he explained, after writing *Thus Spake Zarathustra* that:

> The notion of revelation describes the condition quite simply; by which I mean that something profoundly convulsive and disturbing suddenly becomes visible and audible with indescribable definiteness and exactness. One hears — one does not seek; one takes, one does not ask who gives: a thought suddenly flashes up like lightning, inevitably, without hesitation.[5]

Nietzsche's definition seems the very basis of our old dualistic conception of what art and our world once were. It was this notion of good and evil, of right and wrong, imbued with hierarchical religious and political overtones, that formed the world vision we now seem to be leaving behind. This assumption remains implicit in the last works of postmodernism. In American artist Jenny Holzer's electronic billboards for example, politically rigid, de-poeticized statements

move across the screen just long enough that we can read them and then disappear. Her hermetically sealed syntax propagandizes the propagandistic syntax of production. This language (for that is what it is supposed to be) is not at all intuitive, but instead describes the decline of language as an embodiment of myth and metaphor. Holzer's work exposes humanity's blind spot, its belief that we are expressing our conscious will, when in fact we are merely verbalizing a collective state of anomie. Her work suggests ideas may no longer have the same relevance they once did. Social communication defers to the material medium which defers to production. The sheer volume of diagnostic writing produced on any subject — art included — inadvertently devalues the human content and social process by which ideas are naturally communicated and its original purpose becomes extemporized. The artistic production comes to represent neither the medium nor the message. Joseph Beuys' vision of "the threshold between the traditional concept of art, the end of modernism, the end of all traditions, and the anthropological concept of art, the expanded concept of art, social art as the pre-condition for all capability"[6] itself now seems redundant. Our future vision has now surpassed any ideational, philosophical, anthropological or social definitions. Material is simply material, ideas are simply ideas and "never the twain shall meet."[7] A new basis for artistic expression must be found that involves ephemeral integration. Its meaning will be defined by the material and physical limits of life within the context of the culture of nature.

Asian art, on the other hand, has traditionally been engaged in a vastly different cultural world-view. Guided by the Shinto and Buddhist religions, Japan's artists, even today, prefer to be apolitical, to reject challenges to conformity, and see the universe in different terms. Western culture's generically dualist world-view implies a hierarchical order of being. An omnipotent God is dominant over man, man is dominant over nature and transcendence is possible only after death. Shinto and Buddhist philosophies view the spiritual universe as a single indivisible manifestation of matter and spirit. Nature and divinity are united. Japan's artists continue to perceive their social role in these terms, even if they will not consciously recognize it. Seldom, if ever, will they call themselves artists. Their role is private, not public. The notion that a work of art will last in perpetuity is also not a presupposition they will naturally assume. In painting, their public status advances only with the passing away of their elder masters. A master chosen by the nation is actually referred to as a "human treasure." If, at sixty years old he or she makes a calligraphic

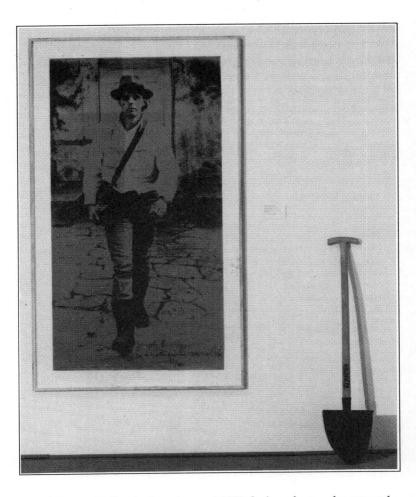

Joseph Beuys. *La Revoluzione siamo noi,* 1972. Serigraph on polyester and written text. 191 x 102 cm. Private Collection. Photo courtesy of Centre international d'art contemporain, Montréal.

drawing in one-tenth of a second, he or she will say: "This is sixty years and one-tenth of a second old." Contemporary Japanese artists tend to work with materials in a way that does not preclude their cultural traditions, as in the West. Modernity is seen as a continuation of, not a breaking off from, past traditions. In this way, modernity seems less a schism, but instead, an extension of cohesive traditions.

Notes

1. David Suzuki, *Inventing the Future*, (Toronto: Stoddard, 1989), pp. 113-114.
2. Thomas Berry, "Art in the Ecozoic Era," *Art Journal*, Vol. 51, no. 2, (Summer 1992), p. 46.
3. Percy Bysshe Shelley, *A Defense of Poetry*, (London: Porcupine Press, 1948), pp. 44-45.
4. Niels Bohr cited in, W. Hersenberg, *Physics and Beyond*, (New York: Harper, 1971), p.41.
5. Friedrich Nietzsche, *Ecce Homo*, trans. Clifton P. Fadiman, in *The Philosophy of Nietzsche*, (New York: Modern Library, 1927), p. 896.
6. Heiner Stachelhaus, *Joseph Beuys*, (New York: Abbeville Press, 1991), pp. 67-68.
7. Rudyard Kipling, *The Ballad of East and West*, cited in *Collins Gem Dictionary of Quotations*, (Glasgow: Wm. Collins & Sons, 1985), p. 186.

5

Stolen Subjects and Exhausted Spirits:
Appropriation Without Representation

When Benin artist Cyprien Tokoudagba slew a chicken to ensure that the magical spirits would not be angered by his inclusion of cult statues in an international exhibition of art at the *Centre culturel Georges Pompidou*, his superstitious act revealed more respect for the sacred role of art's spiritual message than that of any of his Western colleagues. Ironically, Benin art was the first African art to attract widespread attention in Europe at the turn of the century. As a sacred and symbolic representation of life, Benin artists, traditionally dripped blood onto altar furniture.[1]

Les Magiciens de la Terre held in 1989, was a vast, ambitious, curatorial undertaking that sought to break new ground by presenting works by third-world artists alongside those of the West. Its organizers literally covered the globe to find exemplary works from such countries as Zaire, China, Madagascar, Pakistan, Mexico, Tibet and South Africa. The works from these countries, earthbound and culture specific, exercised a superlative kind of generic magic. Their ongoing explorations of myth and metaphor gave cathartic evidence that art can still be based in an unconscious, imaginative response to actual environment and holistic reality. If there was any real doubt as to who was really calling the shots in the game of planetary cultural sovereignty, such heavyweight internationals as Christian Boltanski, Sigmar Polke, Francesco Clemente, Nancy Spero and Mario Merz (who constructed a suitably primitive straw hut for the show) were featured contributors.

Holistic art existed in all cultures, including our own at one time. It expressed a basic connection to the universe in general, and to nature in particular. Ironically, these fragile, ephemeral works of art were not seen as having a specific economic value. Like talismans or emblems of nature, they held great symbolic and spiritual value.

Western artists can now appropriate any spiritual notions and forms from non-Western sources at will, neatly fitting them into the West's once national, now internationalized, historically correct tautology of avant-gardist individualism. The irony is that this process of transcultural osmosis reflects the decline of integral social culture in the West; its origins, and in the process, the same in-

dividualist rationale fragments. Ideas become interchangeable, diverse cultures become homogenized and the myths and meanings of holistic art are largely lost. The process I am describing is most visible in our museums, the organs of official culture. At the same time, Western artists will plagiarize third-world, tribal and extra-national styles (using products, technological gadgets and word text in conjunction with these appropriations) to make essentially mediatic or rational statements against economic colonialism. In so doing, they actually reinforce the cultural and economic biases inherent in both Western art and the new corporate world order. The most noticeable characteristic in all of this cross-cultural synthesizing of images is an all pervasive syntax based on the idea of, and not the mutable experience of working with and through materials in art. Our didactic, postmodern nomenclature conceives of art as a *conscience finale*, a kind of spiritual endpoint or aesthetic *memento morae*. The abyss of cultural extinction is approached not with a bang, but with careful cachets of consumerism. Concocted like the latest brand of shampoo, this art's mercurial essence combines expressions of a spiritually void technoculture of progress with appropriations from other cultures and other times.

French artist Jean-Pierre Raynaud's *Stele + Crâne Néolithique* (1985) — a work that enclosed an actual human skull dating from 5,000 B.C. in a museum casing — was an extreme example of this. If Raynaud's intention was to make an ironic comment on how time and globalizing influences change the value and meaning of cultural and ethnographic objects, the final effect was cynically calculating, politically aseptic and devoid of any intimacy.

By temporarily including examples from the remnants of holistic, third-world cultures in one of the West's flagship museums, the Pompidou Centre's curators ingeniously safeguarded the West's hegemony over art. The real basis of this "greater significance" is pure and simple economic leverage. As with so many exhibitions of third-world or tribal art in North America and Europe, the participating artists whose non-marketable religious art was exhibited in *Les Magiciens de la Terre* will ultimately feel exploited by the political expediency of these arts bureaucracy's curatorial policies.

Aesthetic solidarity with our planet's economically bankrupt nations continues to be a one-way love affair. Any response to, or appropriation of, primitive cues edifies our "official" artists' abiding pseudo-conscience and equally ensures them a rapid rise up the ladder to commercial success.

Ever since the day Pablo Picasso wandered into the *Palais de Trocadero* in Paris and discovered African ceremonial masks, the appropriation of primitive, exotic images has been *sine qua non* in twentieth-century art. Der Blaue Reiter, Maurice de Vlaminck, André Dérain, Paul Gaugin and Le Douanier Rousseau likewise learned from the language of the exotic. Picasso's ground-breaking *Les Demoiselles D'Avignon* (1907), with its angular, African-looking female faces, adopted the primitive style of a marginal culture in order to deform the conventional Renaissance perspective. The violent, abstract fury of Cubism destroyed any lingering notion of continuous sequential representation, furthering the "visionary" schism between humanity and nature. As José Argüelles notes, the abstract expressionist painter Jackson Pollock

> invoked the Indian sand painters of the American Southwest to justify his laying the canvas on the ground and working on it from all sides. But for the sand painters, whose canvas is the earth, Pollock's consideration is meaningless. Pollock's canvas was intended to be put on a wall and admired, whereas the sand painters' work remained on the ground and by tradition was erased after its ritual healing function had been completed.[2]

Kate Kennedy White's film *Market of Dreams* (1990), documents the changes taking place in traditional sand painting among the Aborigines of Australia's western desert as a result of market interest. A transient art form that existed for thousands of years, Aboriginal sand paintings are mythological maps made with circles and dots and lines, and sometimes animal and human figures. They manifest the invisible pathways — songlines — that are an integral part of tribal and personal history, while also representing sacred and spiritual ownership of a given landscape. Sand painting became the Western Desert Acrylic Movement in the early seventies — as a result of collectors' demand for aboriginal work in Australia and overseas. *Market of Dreams* shows Aborigines acting out a sand painting for TV cameras, painting a BMW like the holistic messengers of an automobile publicity campaign. At a *vernissage* of his work in New York, one Aborigine stands timidly off to one side and says he does not understand why only his name has been put on these creations. A Los Angeles real estate developer comments, "I liked the land so much (in these paintings) that I had to buy it." A New Yorker unabashedly

says, "Do they hang them in their homes?" An Aborigine decorates his running shoes with the same benign sense of abandon as he would an acrylic on canvas, simply smiles and says, "You look after the dreaming and it looks after you."[3]

Usually unsigned — because its cultural function was collective — primitive art now finds itself elevated from indeterminate ethnological artefact to high art — something to be placed in museums like the Smithsonian. Native demands to have their sacred objects — which were largely stolen, traded, or bought for paltry sums in the first place — returned to their tribes, are largely ignored (just as the Parthenon's *Elgin Marbles* that now sit in the British Museum in London once were).

Cultural appropriation mirrors acts of expropriation in the economic sector. It reflects a desire to acquire, without any specific experience of what it is like to live or to have another culture's experiential world-view. Gaugin's escape to Polynesia was largely a spiritual odyssey, a return to primitivism and rejection of his stultifying life as a stockbroker in Europe. His primitive colourful paintings were the result of a lived experience in Polynesia but significantly acculturated to be different both in style and spirit from indigenous Polynesian carving. Symbols and imagery have been absorbed into various cultures by other cultures for millennia, but appropriation these days often simply reflects a lack of any creative imagination. As Western artists turn to foreign tribal and primitive imagery in rejecting the incredibly complex cultural realities of living in consumer techtopia, they will usually reject the pagan, or spiritual references from within their own cultural history. The notion that appropriating the foreign or exotic is necessary to render expression spiritually "loaded" is a sad commentary on many North American and European artists' lack of confidence in, or interest in, the origins of their own tribal heritage. Celtic, Druidic, Viking, Teutonic, and other European cultures' pagan myths, tales, rituals and spoken traditions are as fascinating as any. Learning about them can encourage the development of a real social conscience — a discourse vis-à-vis one's own historic collective identity. The implicit fatalism of borrowing benign spiritual symbols from other places and other times unintentionally reinforces the malaise of the *techtopia* in which we live. The exotic becomes a device to hide behind, to disguise uncertain fears over the future of our own civilization.

Richard Purdy has attempted to reconstruct a fictional mythology by manipulating the combined legacies of both Western and Asian cultural history in his art. Winding its way through *Galerie Christiane*

Turkey Tolson Tjupurrula with a work in progress during the filming of Market of Dreams in Central Australia. Photo courtesy of Kate Kennedy White: Market of Dreams.

Chassay, suspended and spot-lit like some kind of neomythical snake, Richard Purdy's *Progeria Longevis* (1989) comprised a 365-foot scroll of handmade paper whose copious illustrations in gouache formed a metaphorical chain of being. The meticulously fabricated fake documents — cartoon-like depictions in this work — gave, for the most part, a greater sense of authenticity than the actual historical documents which they sought to resemble. The records and images on the scroll followed the life of a central fictional figure born in Venice in 992 A.D. who acquires a rare disease caused by a pituitary hyperfunction that reinforces the human immune system (the inverse of AIDS). Like Virginia Woolf's Orlando, he assumes numerous identities (208 in all), both male and female, during his 1,000 year life, of which only three are known — those of Ordelafio Falier Doge (1090-1106), Theophrastus Paracelsus (1530-41) and Carlo Adam Jerusalem Corlet, his last incarnation. This mysterious figure traverses cultures and historic epochs at will. He meets Dante and Leonardo, performs as a troubadour, marches with Tambourlaine to Russia, fights in the crusades and survives the plague years. While staying in a Tibetan monastery he overcomes his greatest hindrance, his accumulated memory, and learns the ability to forget. Towards the end of his life, he travels to North America, survives the sinking of the Titanic and, after a stay in New York City, spends his last days in a nursing home on the west coast. After he falls into senility, he begins to speak Middle English and other extinct languages. The old man is quite incapable of using modern devices such as telephones and record players. His clumsiness is a curious paraphrase for how technology has changed the way we view history and everyday life. We rely on mimeographic and mimetic visual and aural recording and transmissions systems, substituting them for spoken communication. As a result, we have begun to lose our capacity for invention and the ability to tell stories or recount personal experiences. Corlet finally dies in 1992 while watching *The Price is Right* on television.

A recent example of the effects of technology on native oral history involves the Dene nation who live in the remote Mackenzie Valley of the Northwest Territories. The Canadian government recently pushed these communities to accept free satellite dishes and television sets, which fifteen of the twenty-six communities did. Native storytelling, the main nightly activity before television was introduced, has now virtually died out. *Dallas, The Edge of Night* and other U.S. television reruns now dominate their lives. The Dene nation's community ethos is dying. The consumer values beamed by satellite into their homes in the Mackenzie River Valley of the Northwest Ter-

ritories have affected their collective mindset more dramatically than thousands of years of physical hardship.[4]

West-coast painter Jack Shadbolt is a long standing artist of considerable reputation who has chosen regionalism despite the attraction to internationalism throughout his career. His example helped to evolve the arts scene in British Columbia. Shadbolt adopted the imagery of native art, in a sense to build a bridge between a largely undeveloped modern art scene in British Columbia and indigenous native cultures that had a wealth of indigenous cultural history to share. For Shadbolt, it was an escape from the "behind the times" European style paradigm that dominated Western Canada's fledgling arts scene in the 1940s and 1950s. Shadbolt's semi-abstract, quasi-native canvasses, unlike most native artists' work until very recently, have made him a comfortable living as a professional painter. One wonders why the west-coast art market more readily responds to Shadbolt's modernist adaptations than to the real thing. Native art is usually stereotyped as craft by traditional collectors of modern art, something rated well below Euro-American modernist work. Shadbolt's shamanic modernism never left art history's narrow aesthetic formulae behind entirely.

Real appropriation is usually closer to direct copying and it can be done very well, but one can usually feel it in the resulting art. It is a more insidious kind of borrowing and can involve the outright lifting of tribal imagery by writers, artists, and more often corporations, for commercial profit. A notorious example was a Japanese manufacturer's pirating of a traditional west-coast Kwakiutl design and the subsequent mass production of hand-knitted Kwakiutl sweaters, resulting in a $250 million market in the Asian pacific-rim countries. The symptoms of appropriation can also be seen in a more popular sense, as in the instant identity bumper sticker, corporate logo and T-shirt symbol mania of the West. Australian aboriginal artist John Bulun-Bulun had his painting *Sacred Waterhole* (1980) reproduced without permission by a T-shirt manufacturer. In the resulting precedent-setting case of copyright infringement, Australia's federal court awarded Bulun-Bulun damages of $135,000.[5] This phenomenon is also linked to the rise of the urban artist, who relies on a state of alienation and considers the theme of disconnectedness the only fertile ground for escapist expression. Jerry Mander writes:

> Separated from our roots, from the organic body of which we are a part, from the sources of life, from the rhythms of the planet, from a sense of the sacred

rhythms of the planet, from a sense of the sacred relationship between human beings and the rest of life, living in our concrete artificial environments, we have effectively become like the astronauts in space: afloat, unconscious, uprooted, adrift, living in our own abstract homocentric reality, utterly dependent on technology for sustenance, survival and knowledge.[6]

The comparative isolation and inveterate escapism of the urban studio is a passport to appropriation without association. The historian Arnold Toynbee clearly identified the ongoing evolution of this trend when he commented that:

In repudiating our own native Western traditions of art and thereby reducing our aesthetic faculties to a state of inanition and sterility in which they seize upon the exotic and primitive art as though this were manna in the wilderness, we are confessing before all men that we are forfeiting our spiritual birthright. Our abandonment of our traditional artistic technique is manifesting the consequence of some kind of spiritual breakdown in our western civilization.[7]

The idea that time has no continuity is strongly imbedded in today's avant-gardist experiments. The present is seen as unrelated to the past. Technoculture renders the past, the present and the future equally accessible. It is the latest form of colonialism and much more insidious. In the recent film *Baraka* the audience is provided with an endless array of fractious, idealized images; many of these from primitive cultures and idyllic settings from all over the world. Far from engendering feelings of cultural permanence, of being at one with where we are, a virtual onslaught of the visual capital of distraction, decontextualization and dislocation passes before our eyes.

Some artists feel electronic mail (E-mail) art recaptures a lost sense of immediate experience in new and interesting ways. In an event staged at the Vancouver Art Gallery (V.A.G.) by E-Mail artist Bill Bartlett, instant images produced by natives of the South Pacific Island of Raratonga were beamed off satellites. These images were then instantly flashed on a monitor at the V.A.G., projecting scenes of life in the Cooke Islands that occurred milliseconds before, while gallery patrons produced images for viewers at the other end. The interactivity in this form of art is both immaterial and indivisible from time

and space. E-Mail can be produced anywhere, challenging not only geographical factors, but notions of "high" and "low" culture as well as the gallery context as the only venue for art. E-Mail art keeps the simple cause and effect of history at arm's length and as a result, if this can truly be called art, the present becomes an instant, somewhat nebulous museum of passive imagery. How does E-Mail art really improve the conditions of life on the planet at the primal level and who determines who has access to the technology? The computer revolution and the promised electronic highway, while they can facilitate communication between the cultures of the world, also reduce linguistic, cultural and environmental differences so that they become synonymous bits and bytes of information. Far from "empowering individuals" as Jerry Mander states:

> Computers have made possible the existence of the transnational, global-scale corporation itself, with its dire consequences for the natural world, the last pockets of resources, the last remaining wilderness areas and the native people who live within them. That result is left out of the corporate ads.[8]

Irene Whittome's *Musée des Traces* (1990), presented at the Art Gallery of Ontario, reconstructed a personal museum of memory. This modern-day ethnographic project appropriated urban industrial and natural artefacts: a giant sea turtle's shell, photos, an antique Pathé film projector, even the artist's own previous works. It marked Whittome's first step away from a direct artistic experience evidenced in *The White Museum II* (1975) now in the collection of the Art Gallery of Ontario. The structure of language is the ultimate preserve of a culture's mindset. Most recently, the reproduction and accumulation of knowledge is conceived of as future-oriented while in point of fact, it has to do with the past. It reflects a nostalgia for evidence in which reality supersedes physical or material experience. The inherent structures of information gathering systems, like the basis of language — paragraphs, sentences, words, and even letters — had their origins in graphemes which were little more than pictographs, visual symbols incapable of being broken down into smaller structural units because they were a direct reflection of experience. Irene Whittome's *Ozeanische Kunst* (1990), exhibited at the Sam Lallouz Gallery in Montréal incorporated a series of thirty-three black and white photos of Oceanic masks and sculpture that looked like archival records from an ethnology museum. The brightly coloured, gestural lines Whit-

tome layered onto these photographic reproductions of "soulful" primitive carvings resemble graphemes, orthographic symbols that correspond to phonetic sound fragments found in early written languages from Mesopotamia. By emphasizing the gap between modern and primitive art in a single work, Whittome makes us aware that Western art has incessantly appropriated elements of past styles, earlier movements and other cultures.

In other eras, styles, craft techniques and symbols were adopted out of direct cultural exchange and became part of the ongoing transformations in indigenous regional cultures of the world. These days, images are swopped, cropped and appropriated at an increasingly rapid rate without any real knowledge of their content or meaning. They become merely the Brechtian metope on the architectural facade, the crown on the head of our history's economic barbarism and colonial expansion. Primitive art's sense of the living continuum of time is juxtaposed with our own society's progressive, linear sense of progress where industrial expansion *equals* time. The environmental continuity and context of art are seen as a necessary evil to be overcome, adapted and integrated.

In a show titled *Masters of the Arctic; Art in Service of the Earth* (1990), the Canadian Museum of Civilization in Hull revealed the flip side of the West's appropriation of exotic primitive images in a transpolar show of Inuit art. Inuit artists from the circumpolar nations presented smoothly polished images of seals, polar bears, whales and hunters, many of these made from imported Arizona pipestone and Brazilian soapstone. While ancient trade in stone for making arrowheads or other objects, tobacco and even salt, existed among native tribes for thousands of years, it was part of a long established tradition of cultural exchange. The importing of stones for the large-scale production and sale of quasi-native work in international markets, marks a further step away from cultural self-reliance.

The market demand for such works is real: a California-based company's advertisement in one of the world's major art magazines reads: "An import company is interested in developing a line of polished soapstone sculptures and carvings in sizes from 12 to 18 inches, in abstract, figurative and animal forms." By struggling to modernize their expression and produce at an increasingly rapid rate for southern markets, their works have become increasingly standardized, depleted of any soulful primitivism.

The dilemma of appropriation now works in two directions. It infiltrates primitive and third-world cultures as they adopt Western values and try to raise their standard of living in order to obtain the

technological advantages we have. It permeates our advanced cultures as we seek to fill the great gap between technoculture and holistic experience — the simple feeling of living in a culture with collective, spiritual values. The whole question of identity, of what constitutes the basis of meaningful expression, is seldom raised and seems an afterthought.

Notes

1. Harold Osborne, ed., *The Oxford Companion to Art*, (Oxford: Clarendon Press, 1984), p. 127

2. José A. Argüelles, *The Transformative Vision: Reflections on the Nature and History of Expression* , (Boulder: Shambhala, 1975), p. 261.

3. Kate Kennedy White, *Market of Dreams*, 1990.

4. Jerry Mander, "The Tyranny of Television," *Resurgence*, #165, July/August 1994, pp. 5-8.

5. Jo-Anne Birnie Danzker, "Cultural Convergence: or, Should Artists Appropriate Native Imagery?," *Canadian Art*, Fall 1990, p. 23.

6. Jerry Mander, "Tyranny of Technology," *Resurgence*, #164, May/June 1994, p. 22.

7. Arnold Toynbee, A Study in History, IV, (London: Oxford University Press, 1961), p. 52.

8. Jerry Mander, "Tyranny of Technology," *Resurgence*, #164, May/June 1994, p. 24.

6

Duelling with Dualism: Descartes, Rodin, Picasso, Duchamp et al.

Our historical perspective on art is rational and Cartesian. Its equations for experience have neatly quantified creative expression into a series of linear "isms." Aesthetic traditions have defined expression by measuring content, symbol and material, but their view of art as a systematic progression has always been directly related to our civilization's economic evolution. An artwork's relevance is thus usually based on its place within the historical continuum. Both traditional and avant-gardist aesthetic values have reinforced cultural models that are based in economic expansion and perceive nature as something separate from human culture.

When the first factory smokestacks went up in the early nineteenth century, the Romantics created Arcadian landscape scenes that eulogized the boundless inexhaustible reserves of nature. Beginning in the late eighteenth century, the Romantic artists' recreation of a scene from nature was considered of greater value than nature itself. These sublime vistas inadvertently reinforced humanity's spiritual dominion over nature and nature became a state of mind. At the same time, as society perceived the earth as a kind of living, breathing organism supervised by God, a contradictory model envisioning the natural world as a pseudo-mechanism with gears, levers, bolts and wheels was emerging. These two essentially opposed philosophical views existed in tandem and confused humanity's perception of its place in nature.

While maintaining close bonds with a nature-based vision from a recent feudal past, the Romantic painter's vision of the landscape was no less an escape from reality than the art of our era. Logical positivism was beginning to take hold. Works of beauty were created for patrons of Church and State. For both artist and patron the act of recreating nature affirmed humanity's "spiritual" title to its boundless reserves. The act of recreating a landscape scene, a "window on the world," was an idealized one. Visions of the sublime and the beautiful coalesced, yet as a visionary ideal these testified to a growing need to establish exclusive cultural references and create a distinction between culture and nature. Modern-day advertising idealizes its subjects as the Romantics did, but the generator behind this effect

is now based on the technology of reproduction instead of a Judeo-Christian world-view. Some would say that Romanticism, with its worship of nature, was part of a natural evolution leading from the industrial age to the electronic. This fallacious viewpoint results from our linear, rear-view perspective on the history of art. It is accurate only if seen from a progressive stance, one that essentially parallels the economic model of our civilization's progress in which humankind exploits nature to its own advantage. It is more likely that the Romantics were responding to nature as it became more distant from human consciousness and working life became alienated from the natural rhythms and cycle of life. Goethe clearly expressed this view of how art applied to a living environment when he wrote: "Through studying Nature's process of creation, man can become worthy of participating spiritually in her production."[1]

All this occurred while the industrial age was gaining force, divesting European culture of its indigenous signposts. In the process, primitive art (usually unsigned because of its cultural function), and perceived not in economic terms but as a tribal affirmation of beingness, found itself elevated from the status of indeterminate ethnological artefact to high art — something to be placed in a museum.

In the nineteenth century, artists such as Rodin viewed the raw materials they used for their art much as economists do, as material to be acquired, manipulated and reformed to create suitably beatific eulogies to humanity's self-image, not as elements with a potential voice of their own or having any relation to an environmental context. This Platonic attitude towards materials, dating back to the early days of Greek sculpture, has continued to the present day and now finds its apogee in the current tendency among some artists to use great volumes of materials in an attempt to somehow make their expression more meaningful.

Throughout history, many artists have acted like industrialists in miniature, gathering materials, using their technical expertise and creative energy to reinforce society's superior attitude to nature. The contemporary French sculptor Jean-Pierre Raynaud's aseptic, white-tiled assemblages and gauntly impersonal psycho-objects are an example of how depersonalized the monumental art of our times can be. A world-worn cleanliness and macabre, near pathological sense of anomie permeated Raynaud's *House Project* from the early seventies — a house he constructed and lived in as the consummate psycho-object, whose entire interior and exterior were covered with white tiles, and since destroyed. One of Raynaud's collage pieces titled *Mur sens*

interdit (1970) had a vertical measuring gauge on its left border to off-set a photo of an incarcerated madman, while lines of red and white "No Entry" signs furthered the overall feeling of exclusion. Raynaud's "embalming" of a fifteen-story apartment building, the first ever "lived in" public sculpture in the world at les Minguettes, a suburb of Lyon plagued by social problems, involved covering the entire exterior of this building, including its doors and windows, with over 11,000 square yards of white tiling. Raynaud never really considered what the local resident's reactions to his monument to monumentality would be.

Materials are often used by artists to represent civilization's accomplishments with little regard for nature. Over a century ago, in 1891, when Monet was forced to actually buy a row of poplars from the town of Limitz in order to continue painting them, mainstream art still captured, isolated and defined the subject on the basis of formal style. In seeking to free painting from a preoccupation with form by focusing on the purely psycho-physical effects of light, the Impressionist breakthrough began the revolution of the mind over the eye. As José Argüelles comments: "For Monet before a tree was a tree, that is, a preconceived form, it was a very particular retinal irritation. Only afterward would he say he had seen a tree."[2] Can an art based in realism and representation ever truly enact or recreate a psychophysical representation of the momentary vision? The poet Jules Laforgue was aware of this and in an 1883 essay on impressionism wrote, "Impressionism — the response of a certain unique sensibility to a moment which can never be reproduced."[3] When artists such as Edvard Munch or Vincent Van Gogh sought to express a more universal subjective kind of painterly expression unhampered by the quasi-scientific impressionist technique, they found that they were faced with an overwhelming feeling of anomie, marginalized from the main currents witnessed in the *fin-de-siècle* salons. In the case of Munch, his art expressed neuroses born of a radical religious background. His art paralleled the development of Freudian psychology with its mechanistic and structural approach to diagnosing the human unconscious. In attempting to develop a mechanistic approach to the workings of the mind, Freudian psychology paralleled the emerging industrial society's break with the bonds to nature.

With the benefit of hindsight, we can now see that the increasing gap between art of the twentieth century and nature was linked to ongoing advances in technology. Picasso's splitting up of space and flattening of perspective was directly influenced by the increasingly severe break with a continuous view of nature, based on external ob-

servation and experience of the infinite variety of living elements in the world around us resulting from industrial progress. The multi-faceted, fragmentary Cubist perspective which condensed three dimensions into two, was a reflection of the disintegration of an integral view of nature, of the widening gap between humanity and its life-support system — the Gaia organism of planet earth. In 1992, T. S. Eliot wrote:

> *On Margate Sands*
> *I can connect*
> *Nothing with nothing*[4]

This excerpt from his poem "The Wasteland," now seems as much a eulogy to our alienation from nature as any verse written in this century. It is an ode to the desiccation of the human spirit amid the devastating effects of modernism.

Constantin Brancusi is one of this century's sculptors whose works seem to have stood the test of time better than most. Rodin's sculptures became increasingly generalized, aggressive and public in the official sense as commercial demand compelled him to produce enlargements, reductions, and transpositions into marble and multiple castings of the most popular pieces. Brancusi's works, on the other hand, depended on craftsmanship and practicality as much as a sense of aesthetics. Stemming from a childhood in Romania where the economic backwardness of the region obliged the peasants to make the best use of available materials, in particular wood and stone, Brancusi's art, for its textural and spiritual primitivism, ultimately had more in common with Gaugin's early wood carvings than Rodin's monumental bronzes. Brancusi's *Endless Column* (1928) at Tîrgu Jiu in Romania, whose modules are scaled to human proportions, ascend skywards, repeating the same form to a height of ninety-six feet, three inches. We can as readily identify with Brancusi's "truth to materials" in an age of ecology as at any time in this century.

Surrealism drew from a vast array of visual metaphors and object-oriented representations culled from the so-called "unconscious." Salvador Dali's paranormal paintings of the Arcadian landscape of the supposed unconscious mind were ultimately as conscious and premeditated as art can be, yet Dali's melting clocks, crutches, and ants ultimately used the conventional metaphors of Freudian psychology and religion for their effect.

Dali's sense of the spectacle included walking his pet ocelot around on a leash to advertise his baroque imagination. That animal

was also a symbol of Dali's sense of the extravagance of art, of Wildean fashion looking for an audience. For a show at Gallery 303 in New York this July, Canadian artist Bill Burns played on the way animals or their furs are used as commercial fashion and prestige symbols. His work hinted at the way wild creatures are exploited so as to assuage our feelings of social alienation, how ultimately uncivilized our stereotypes of animals really are. We personalize and romanticize wild animals while they are being slaughtered around the world, either indirectly through the destruction of their natural habitats or directly when they are killed for their furs, genetic manipulation and medical studies. For the show Burns' created his own fashion line of superbly crafted couturier-like protective clothing and life-saving devices for wild animals in miniature — knee pads, life-jackets, hard hats, work gloves, etc. Some of them were "modelled" by stuffed animals set in front of fake natural habitats like those one might see on billboards or in magazine ads. These included a pheasant wearing safety goggles, an otter with a respirator mask and a ferret with a dust mask.

Marcel Duchamp's signed ready-mades sought to broaden our definition of art. However, with the benefit of hindsight, we can see they were also an intellectual's dispassionate endorsement of the manufactured product as art. The syntax of production in the form of actual manufactured products had unambiguously entered the arena of material expression. A symbol of art's deferral to the forces of production, Duchamp's ready-mades abandoned the creative element of discovery that comes with working and transforming materials in favour of benign acceptance of what had not until then been art — the manufactured product. The issue of humanity's dependence on nature was not only avoided, but it was also aggressively countered in order to legitimate a process of art that had lost its hold on the "social" course of life in the early twentieth century. The anthropologist Claude Lévi-Strauss commented on how banal the artistic vogue of appropriating "ready-made" manufactured product seems when contrasted with the diversity of materials in nature:

> Yes, but from this point of view, nature is so much richer than culture; one very quickly exhausts the range of manufactured products as compared with the fantastic diversity of the animal, vegetal and mineral worlds...in short, the novel character of the "ready-made" presents a kind of last resort, before the return to the main source.[5]

Bill Burns. *Otter with Respirator,* 1994. 303 Gallery, New York. Photo by
Paul Litherland. Taxidermy otter, paper, plaster and photocopies. Photo
courtesy of the artist.

"Man invented art. It wouldn't exist without him. Art has no biological source. It's addressed to a taste,"[6] Duchamp once said. Yet who could deny that art has always been a part of nature? Duchamp's oversight made no account for the fact that all materials an artist uses — either synthetic or natural — are derived from an ecosystem, and secondly, that we ourselves are biological entities as much as conscious beings. J. Baird Caldecott summed up the basic biological similarities between humans and nature with this explanation:

> To anyone not hopelessly prejudiced by the metaphysical apartheid of Christianity and Western thought generally, human beings closely resemble in anatomy, physiology and behaviour other forms of life. The variety of organic forms themselves are closely related, and the organic world, in turn, is continuous with the whole of nature. Virtually all things might be supposed, without the least strain upon credence, like ourselves, to be "alive," that is, conscious, aware, or possessed of spirit.[7]

Duchamp's signed ready-mades were an attempt to make the manufactured product literally a part of the artistic vocabulary. While appearing to broaden our definitions of what art could be, his ready-mades were a complete deferral by an essentially intellectual artist to the forces of industrial production. In the eyes of formal art history, Duchamp succeeded. There have been hybrids, clones and probably even imitations of Duchamp's original idea. Remember, the ready-made was mainly an *idea* about art.

The Italian Futurists — ideologues supreme — went further to embrace the growth of industrialism wholeheartedly. The machine ethic was considered the answer to humanity's woes. The Futurists' fascination with the modern city, its netherworld of artificial and structural innovation, seemed to be blinded to humanity's biological and unconscious needs. Mythology was certainly not their forte. The de Stijl (1917-28) and Bauhaus (1919-33) movements in art and architecture evolved and flourished after the World War I. These artists envisioned the society of the future in an anthropocentric way. Nature was a source for design, but the ultimate design emphasized humanity's drive to rebuild a world torn apart by wars, rebuilding itself exclusive of nature. The forces of nature were again exploited to justify economic growth and production. Nature's resources were inadvertently exploited in order to generate a new vision even more ra-

tional and orderly than the one which preceded it. Purist design encouraged a further separation of humanity from nature because it seemed to make sense. Piet Mondrian, a principle advocate of the de Stijl movement in Holland, created geometrically constructed paintings with flawless linear designs which he considered to be the future of artistic expression. He failed to anticipate the spiritual and moral void this synthetic form of art would lead to. Piet Mondrian comments:

> It would be illogical to suppose that non-figurative art will remain stationary, for this art contains a culture of the use of new plastic means and their determinate relations ... This consequence brings us, in a future perhaps remote, towards the end of art as a thing separated from our surrounding environment, which is the actual plastic reality.[8]

While Mondrian accepted the environment's importance to a living art form, the future environment in which this art would actually exist was conceived as one constructed and dominated by people. Nature, the original, was to be overcome and replaced with a synthetic copy. Likewise, Wassily Kandinsky in his writings titled *Concerning the Spiritual in Art* (1910), while seeking to bring artistic expression closer to human spiritual concerns, chose a codified "system" of design language to do so. The principles of his "language" reversed the intuitive order of expression by placing humanity's reasoned productions at a higher level than nature's own endlessly procreative biosystem.

The stultifying implications of the Bauhaus vision are seen all over the world in office towers like the World Trade Centre, industrial and apartment complexes, and city planning projects. While they might look convincing on blueprint paper, experience has taught us that these imposed geometries are stress-creating environments, lacking in the diversity and natural variation that might bring about relief for their inhabitants. They go against our more curious instinct that seeks the variability that millennia of evolution have adapted us to. René Dubos states:

> The most frightening aspect of human life is that man can adapt to almost anything, even to conditions that will inevitably destroy the very values that have given mankind its uniqueness.[9]

At the age of twenty-three, on the occasion of his first one-man show at the Art Club of Vienna in 1952, the Austrian artist Hundertwasser, who now lives in New Zealand, delivered a lecture, "My aspiration: To free myself from the universal bluff of our civilization." The main artistic influences on Hundertwasser's work come from sources before the rational age: medieval painters, Giotto and Ucello, Indian, East Asian, Maori, African and Amerindian prehistoric cave painting. Hundertwasser pioneered civic planning, architectural and environmental issues from a creative point of view as early as the 1950s, long before there was any broader environmental conscience in the West. Aside from his print and minor works, Hundertwasser has created less than 1,000 paintings during his career. Most of his energy now goes into architectural and urban design projects that are essentially an attempt to break down the rigid linearity of modernity and the idealized fiction of the straight line — something he thinks makes people sick since it does not occur in nature — in an effort to rehumanize our built environment and bring it into closer contact with the rhythms and energy of nature. Hundertwasser believes:

> We are made up of cells, organically built up into humans ... So when these seeing cells perceive something that is alien to them, alien to organic forms, they transmit an alarm signal to the brain. If a lion is stalking you, or a shark is out to kill you, you are of course in mortal danger. We have lived with these dangers for millions of years. The straight line is a man-made danger. There are so many lines, millions of lines, but only one of them is deadly and that is the straight line drawn with a ruler. The danger of the straight line cannot be compared with the danger of organic lines described by snakes, for instance. The straight line is completely alien to mankind, to life, to all creation.[10]

Hundertwasser's organic architecture projects have included an A.G.I.P. gas station in Vienna painted in bright yellow, pink and blue colours under whose roofs of grass and trees, cars can drive in to fill up; the fairy tale-like children's day care centre built by Alfred Schmid in Frankfurt-Hedderheim, an incinerator at Spittelau and the Hundertwasser Kunsthaus in Vienna. Long before the ecological movement had come into being, Hundertwasser pioneered ecological issues from a creative standpoint combining spiral motifs, organic city-like grids reminiscent of Paul Klee and multiple perspectives in

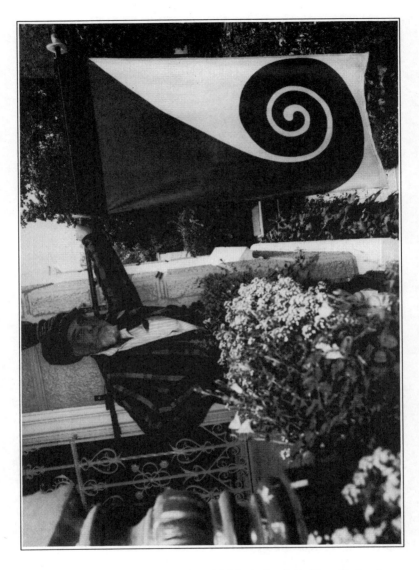

Hundertwasser: Photo of the artist with his design for a New Zealand flag. Photo courtesy of Laudau·Fine Art: Montréal and the Hundertwasser Archives, Vienna.

his paintings. On themes of ecology in his work, Hundertwasser states:

> Humans wanted to kill, not only our brothers but everything that grows organically. This is possible for a while as long as there are resources left, but then you have to put things back, and now we are in this position. This term ecology was introduced, and the word ecology can be considered a mistake, because ecology means nature and the cycle of nature, but one important factor is left out by the ecologists, and that is the feeling of being creative. Without creation and creativity, nothing works, especially not in ecology. We switch from producing cars to building new generators, bicycles, purification plants, catalytic converters and solar cells. Instead of producing weapons and machine guns, the same factory, the same people, the same mentality, wages, and materials are used to produce solar heaters. We use the same technical know-how. This simply does not work, because if you enter a new age you cannot do it with the old mentality. You must start from scratch; everybody must share the responsibility. It is very hard but it is the only way.[11]

In 1958, to emphasize the importance of recycling and the sacred role of the artist in contemporary Western culture, Hundertwasser painted over a work by Arnulf Rainer, effectively recycling it in a work titled *L'Arnal — Contretemps*. One of his latest works titled *The Fax — 30 Day Fax* (1994), consists of a collage of thirty fax pieces sent by Hundertwasser daily from New Zealand to Vienna from the 2nd to 30th of October 1992. These fragments of cultural expression were moved instantaneously along the electronic superhighway and became interchangeable and neutralized in the process. Technology's relativities weaken the inner core of the artistic impulse, whose inspiration relies on the endemic, specific experience. Art's capacity to move us beyond ourselves is flattened out and standardized by the effects of technology. Its metaphoric or poetic potential is lost. Hundertwasser subsequently photocopied the faxes onto drawing paper with white chalk zinc primer and fixed them onto linen with wallpaper glue, thus bringing them out of the void of the electronic superhighway and back to a human level of creative inspiration. The result was a painting of a part-abstract, part-figurative overview of a

city with people and parks that used a variety of media including watercolour, china ink, lacquer, gold and silver foil.

Technologists, scientists and economists can learn much from the intuitive basis of our creative instincts and identification with nature. Art can help industry to design in a more human way so as to use nature as a model for developing habitats, securing regenerative food supplies, and reintegrating the natural world into the urban centres of the twenty-first century. Nature already has its own voice. If we violate it by extracting its resources, its voice is further diminished and, by implication, so is our own capacity to identify with our immediate surroundings. If we respect the diversity that exists around us in nature, we discover a greater depth of knowledge and experience. This is the key to an art of the future. The materials an artist uses are, for their very scarcity, worthy of respect. By realizing this, we use materials more ingeniously.

Friedrich Kiesler, a close friend of Theo van Doesburg, founder of the de Stijl movement, was an exception to the rule in early twentieth-century forays into artistic expression. An architect and artist himself, Kiesler was one of the first to explore the role of future expression in a way that integrated notions of ecology into the economy of creation. His theories of "correalism," expressed in 1939, identified that any design which has lasting usefulness also has a direct relation to the energy in organic and inorganic materials; that the interactive character of real creative communication is a process tied to the mutable principles of energy in the world. In an article titled "On Correalism and Bio-Technique: Definition and Test of a New Approach to Building Design," published in *Architectural Record* in 1937, Kiesler wrote:

> The mutual interdependence of organisms is, in the final analysis, the result of the primary demands of all creatures: proper food, habitat, reproduction, defense against inimical forces. Life is an expression of the co-operation, jostling and strife of individual, and of species with species, for these primary needs ... This exchange of interacting forces I call co-reality and the science of the laws of interrelationships correalism. The term correalism expresses the dynamics of continual interactions between man and his natural and technological environments.[12]

Kiesler went on to analyze the evolution of technological products, differentiating between "standard," "variation" (of stand-

ard) and "simulated." Creative thought, in that it identifies with our interrelation to and with nature, was seen as the basis for new inventive product forms. From these new standard types, their variations and their simulated forms (essentially product forms that are serial reproductions without any original source of procreative experience in connectedness to nature), all productive creations could be seen to derive. The danger Kiesler saw arriving in the later stages of production was that fewer original, truly creative inventions could arise as ideas became increasingly hybridized without any basis in nature (i.e. they would become simulated product forms). This is precisely where our technological evolution has led us today.

Reproduction of material product forms promote a vision of progress that fails to give us a sense of connectedness to the original creative impulse. In post-production societies, Aristotle's comment that "art imitates nature" is now misunderstood to mean that serialism — a parallel to creative innovation that does not generate new ideas or aesthetic prototypes but reproduces ideas in art as mere material — is a representation of life itself. Aristotle's statement was a paraphrase for our inner world, the creative spirit, not what has been produced as material evidence of this. Jane Harrison, in her book *Ancient Art and Ritual*, writes:

> By nature, Aristotle never means the outside world of created things, he means rather creative force, what produces, not what has been produced. We might almost translate the Greek phrase, "Art, like nature, creates things."[13]

We usually ignore the origins of human creativity in nature. While technology offers us certain improvements that can be an asset — the automobile and computer for example — these products are often introduced on an *ad hoc* basis without any critical input or advance social planning. The social and environmental cost *after the fact* is seldom thought of. The same is true for the art in our museums which introduces art to the public through advance programming schedules decided by an exclusive coterie of arts aficionados.

The most experimental and innovative breakthroughs in art and technology are usually inventive and visionary. They involve individual effort, natural observation, common sense and a participatory voice in the production-design process. Our vision of technological progress, like that of art history, is a structurally-based one. Artistic innovations are based upon and adapted from previous

ones and have an expansionist, production-oriented bias. Co-realist designers were expected to consider every object in the universe in relation to its environment."Biotechnics" was Friedrich Kiesler's term for a manner of design responsive to humanity's habits. Kiesler evolved biotechnics as a response to society's "incapacity ... to provide and sustain a healthy and a healthful shelter for each of its members and to deal adequately with these demands for all income levels ... Functional design develops an object. Biotechnical design develops the human being."[14]

As Friedrich Kiesler once commented on hanging the paintings unframed for Peggy Guggenheim's *Art of this Century* show in 1942:

> Today the framed painting on the wall has become a decorative cipher without life and meaning, or else, to the more susceptible observer, an object of interest existing in a world distinct from his. Its frame is at once symbol and agent of an artificial duality of "vision" and "reality," or "image" and "environment," a plastic barrier across which man looks from the world he inhabits to the alien world in which the work of art has its being.[15]

Kiesler also designed the environment for Peggy Guggenheim's *Art of this Century* show complete with curved walls and hanging structures for paintings that were mobile and demountable. Eccentric lighting and sound effects were also part of the project, a creative challenge that defied the dead lighting systems and rectangular architectures of the modern museum. While many museums have installed natural and directional lighting systems, the white cube still dominates the typical postmodern museum space. The landscape that surrounds many of our museums is as monotonous as most suburban grass lawnscapes. Why do we not favour a gentle naturalism of design instead of the environmentally anaesthetized experience for purposes of display in and around our present-day museums? Our public art museums do not generally provide an integrated environmental vision of art, but instead a selective, segregated and ultimately cynical "functional attitude" to culture. Lighting systems have already been developed that project natural light along tubes from outside into buildings, yet most museums still favour the traditional spotlight or overhead lighting system. Spotlighting may highlight works of art, but does it really allow a contiguous perspective with which to ap-

preciate the exhibited artworks' colour, texture and spatial dimensions for what they are?

The spaces within which we work, shop and live use fluorescent lighting that destroys any context based on natural unidirectional lighting similar to that in nature, and our perception of the surrounding space and psychological sense of well-being suffers as a result. In *Lighting and Its Design*, a work published in the 1960s, Leslie Larson explains:

> Apart from colour, which is certainly one characteristic of "quality of light" as experience, there is also the matter of directional and non-directional (or diffuse) light. In this respect, also, incandescent (which follows sunlight) and fluorescent lights diverge. This is also a result of the way in which the light comes into being. The incandescent filament, like the sun, represents a point from which rays of light are directed. This casts shadows and gives clarity and sharpness to the visible world. The phosphor particles in the fluorescent tube, on the other hand, affect the character of the light form projected by the tube. It is basically without shape or direction, aimless, as it were. It is a plane. Since the light originates from an infinite number of points, all over the surface and the rays crisscross one another, the final effect is diffuse and entirely non-directional. The light produced causes fewer, less distinctive shadows and gives a flatter, less highlighted quality to the visible world.[16]

Kiesler's last experiment in designing gallery space involved *The World House* in the Carlyle Hotel in New York, which opened in 1957. In collaboration with the architect Armand Bartos, Kiesler installed a pool of water inside the gallery with a David Smith sculpture standing in it for the opening in order to better afford chances of correlation in the gallery environment. The two-floor gallery well included a glass enclosed staircase and a curved ceiling. The whole interior was conceived as a single elliptical enclosure with detached curved wall spaces for exhibition of works, a cantilevered bench that curved into the walls. The general flow of space from one room to another was contiguous and worked. In the words of Leonard Pitkowsky, "the great lengths Kiesler went to in order to make separate environments for each piece" were an attempt to reduce the conventional museum

or gallery experience Kiesler believed denigrated art by segregating and enclosing it in successive cubes of white space and isolated walls, encouraging a neurotic sense of emptiness and cultural dislocation.[17]

Seemingly incapable of adapting its vision towards an ecological integration, the postmodern museum like its modernist precursor generally conceives of art as something to be put into a hieratic and rationalized architectural context. The postmodern work of art likewise reifies the sterility of the museum context through its ideational bias and the subject-based idioms it represents. The significance of a work of art is measured by the individual artist's place within the pantheon of formalist history by which it is measured, judged and accorded its weight in splendid isolation from the living context of culture. The actual built structures within which it is exhibited also reaffirm the experiential mono-reality of this bias in art.

Seen in this context, where the potential effects of painting, sculpture and installation pieces are effectively neutralized through architectural and environmental isolation, how different is a postmodern work of art from a Turner landscape? For the context within which a work of art exists should truly be considered something as important as the work of art. The more *engagé* in an environmental sense, the less flattering the museum's white cube of exhibition space seems. It might suit the 1960s minimalists Carl André, or Dan Flavin fine, but the effect of more procreative or personalized artistic expressions withers in these circumstances. Goya painted some of his works using candles on a hat he wore at night. His sense of light and colour are partially missed in the modern museum environment; this is precisely because the surrounding space, light, colour, texture and even the air in these environments are as important in the way they affect our response to the work of art as the art itself.

To break the mould of modern society's pragmatic tragedy, production design needs to be brought back to its roots — rediscovering a respect for the transmutable energies in all living and non-living materials — to realize their limited availability and importance to us. Kiesler described the artist's role in bringing about a reawakening of our need to be alive when he stated:

> Creativity seems to mean: an instinctive search for truth; a blind spontaneity when acting; a relentless probing into the world beyond; inhaling the unknown and forming it concretely; a pursuit of purpose to the bitter end until the standard status is changed; fearless-

ness without goal; search for peace through danger;
and most important — disobedience to conformity, and
blind obedience to love.[18]

One of Kiesler's most inventive projects, *The Endless House*, was
never realized in its entirety, but a model of the piece was included in
Arthur Drexler's *Two Houses: New Ways to Build* exhibition at the
Museum of Modern Art in 1952. The Endless House privileged "non-
Euclidean concepts of curved space over the rationalized angularity
of Euclidean constructs, and nature, now, over the machine, and put
into practice the principle of continuous tension, which is nature's
own engineering scheme for the eggshell."[19]
The floors, walls and ceilings of this structure formed a continuous
curve modelled upon the egg shape, a form that defies the sharp-
angled, classical post and lintel male orientation common to most
"domestic" architecture. The windows were to be irregularly shaped
and partially covered with part-opaque, part-transparent plastic. The
interior of this living space was to have frescoes and sculptures and
the floors many textures including grass, heated terracotta tiles,
rivulets of water, sand and pebbles. The building was cave-like,
poetic, textural and cathartic in its conception, embodying Kiesler's
belief in a comforting, spatially relaxing and womb-like feminine ar-
chitecture. This work presaged Kiesler's *The Shrine of the Book* (com-
pleted in 1965), a building whose breast-shaped, curvilinear
double-parabolic domed roof was originally intended to have a foun-
tain of water continuously pouring out of its apex (an idea derived
from the Old Testament myths of the flood), and which now houses
the Dead Sea Scrolls in Palestine, discovered in 1960.

Kiesler's architecture displayed a healthy yearning for spiritual
wholeness and environmental intuition that was in keeping with Carl
Jung's investigation of our unconscious links to nature. For Carl Jung,
creativity as expressed through humanity's myths and metaphors
derived from our primordial past as living biological beings within a
natural ecology. Jung claimed our inner identities, their origins
within our subconscious, are essentially physical and creative and
play a more dominant role in our lives than our rational mind. In put-
ting forward the notion of synchronicity — a meaningful coincidence
of outer and inner events not themselves causally connected (which
realize a symbolically expressed message, the mysterious relationship
between psyche and matter) — Jung's notion of human archetypes

realized the place of the human intuitive unconscious to our sense of inner well-being. As C. Kerényi, an associate of Jung's writes:

> Artists, even a whole nation of artists, city builders and world builders, are true creators, founders, and "fundamentalists" only to the extent that they draw their strength from and build on that source whence the mythologies have their ultimate ground and origin, namely, what was anterior to but revealed in the monadic (a soul, a God, an atom, a person — any ultimate unit of being). The "universally human" would be a fit term for the "pre-monadic" were it not too little and too feeble; for the important thing is not to become "universally human" but to encounter the divine in absolute immediacy ... Every people displays its form most purely when it stands face to face with the Absolute.[20]

The current trend to develop ideas out of seemingly unrelated events is not based in our survival instinct or relation to the Absolute that Jung recognized, but the relation to the self in a world of mass-produced media imagery that becomes tentative and threatens the fabric of our instinctive make-up. As we recognize the images forced upon us daily, we suppress our genuine unconscious reactions. Our relation to place, time and experience is consciously negated. The effects of neurotic dissociation and manifest psychological illness are all part of a culture of over-production. Fear of the self encourages further consumption, leaving us largely unarmed and distrustful of our own instincts. Conceptual, image-based art reinforces this process by offering us an art that relies on mechanical production and reproduction processes. The one-way metaphor replaces the integral experience and we are seemingly bereft of any response. By denying any true connection to the physical world, conceptual art restricts our vision to the non-physical world of ideas. Exclusively idea-based, this art suggests that our artistic vision be restricted to rational paradigms or anti-paradigms. Inadvertently based on "realistic" models, it denies the fact that human beings are dependent on nature for food, shelter and air, and that, as biological beings we are limited by the same constraints as any other living species. In this sense, conceptual art and its close cousin, postmodernism, extract ideas from nature without giving anything back.

Essentially an art of escapism, postmodernism denies any true in-, novation and eulogizes the use of new technologies, hiding behind them. A kind of designer ideology, postmodernism reinforces the growing gap between the original creative impulse and the consumer lifestyle. The language of collective repression has invaded the art world and we now read expression through the screen of media technology as if there were nothing else. We edit our reading of the world around us to suit the language of technology. The nuances of life are missed, and a feeling of numbness, of not actually being there prevails. The "I-ness" of conceptual expression relies on our identifying with constructed environments; image reproduction and linear expression as if, through the act of representing or reproducing an experience of reality, art could somehow dictate what reality could be, that in fact experience is a credo, not a state of being.

Postmodernism is a fallacy of expression that has little to do with generic creativity. Its nostalgic belief that concepts are attached to material things is as retrograde as the suggestion that a television personality or an automobile are intimate friends we can rely on. It is a mirage. As Ontario-based composer, writer and media theorist Murray Schafer expresed:

> To be an *engagé* artist used to mean to be concerned with the restoration of certain social imbalances. Today we could use the word with regard to the restoration of certain ecological imbalances ... For the development of a holistic philosophy we can scarcely turn towards humanistic art works for support and insight. As beautiful as they may be, they are no longer appropriate. It is in different sources, more ancient and strange, that we will find this ability ... to go with nature rather than against her.[21]

We no longer believe our system is developing meaningful, lasting values. Television denies us our thoughts and reduces our sense of choice. Our modern-day vision is a "techtopic" one. We codify and process our responses to images, then we throw them away in preparation for the next. As a result, when we look at a painting, sculpture, an installation or a video, our patience is minimal. We have become consumers of art, no longer appreciators. Likewise, when looking at a natural forest or landscape, we will generalize its elements visually, seldom noticing the diversity of camouflaged, co-dependent elements that exist within their specific microcosm that

mirror the planet's maximally-scaled ecosystem. Referring to the history of modern architecture and city planning in *The Limits of the City*, Murray Bookchin writes:

> With the development of capitalist industry, particularly in the present century, efficiency, reduced costs, and stark functional utility in the interests of the marketplace become the all-important criteria for gauging the success of any enterprise, whether economic or aesthetic. Modern architecture and city planning translate these instrumentalist criteria into canons of beauty and civic integrity.[22]

Le Corbusier's description of the city as a "tool" and Frank Lloyd Wright's view of it as "the only possible ideal machine" are a perfect match, despite the expressed opposition of Wright to Le Corbusier's work. Whether conscious or not, design is hypostatized all the more as a means of neglecting the social relations that vitiate its most rational goals — this by programming the irrationality of the society into the design product.

The uncomfortable Utopias in which we expend most of our daily efforts seem to have been designed by people with an intense disaffection for nature. Our history and art have become frozen by quantification, the material layerings of determinism which, like a pile of rubble, threaten to bury us and our civilization completely. Marshall McLuhan's "typographical man," whose life is merely a representation of built images and concepts that live more inside one's thoughts than in a reality acted on by nature, is now a present-day truth, an actual reality. The model of our expression is one designed by history — a predictable lineage that stultifies any real change. Unlike past appropriative models based on an economic definition for society in a largely patriarchal world, a procreative model for society, closer to the female experience, could engender more positive models for change. Relying on direct intuitive experience without the structure of models on which to base its expression, this approach envisions a future where we can see ourselves as a part of, not apart from, nature.

Notes

1. Johann Wolfgang von Goethe, *Goethe's Worldview, Presented in His Reflections and Maxims.* Ed., Frederick Unger, (New York: Unger, 1963), p. 103.
2. José A. Argüelles, *The Transformative Vision: Reflections on the Nature and History of Expression* , (Boulder: Shambhala, 1975), p. 149.
3. Jules Laforgue, "Impressionism," in *Impressionism and Post-Impressionism, 1874-1904*, ed., Linda Nochlin, (New Jersey: Prentice-Hall, 1966), p. 18.
4. T.S. Eliot, "The Wasteland," *Selected Poems*, (London: Harcourt, Brace, Jovanovich, 1988), p. 62.
5. G. Charbonnier, ed., *Conversations with Claude Lévi-Strauss*, (London: Jonathan Cape, 1969), p. 99.
6. Pierre Cabanne, *Dialogues with Marcel Duchamp*, (New York: Da Capo Press, 1987), p. 100.
7. J. Baird Caldecott, "In Defense of the Land Ethic," *Cultural Studies*, Vol. 2, No. 3, (October 1988).
8. Piet Mondrian cited in Harold Osborne, *Abstraction and Artifice in 20th-Century Art*, (Oxford: Clarendon Press, 1979), p. 142.
9. Anthony Bailey, "René Dubos," *Horizon*, Summer 1970, p. 57.
10. Harry Rand, *Hundertwasser*, (Cologne: Benedikt-Taschen, 1991), p. 45.
11. Piet Mondrian cited in Harold Osborne, *Abstraction and Artifice in 20th Century Art*, (Oxford: Clarendon Press, 1979), p. 74.
12. Friedrich Kiesler, "On Correalism and Bio-Technique: Definition and Test of a New Approach to Building Design," *Architectural Record*, #81, Sept. 1937, pp. 60-61.
13. Jane Harrison, *Ancient Art & Ritual*, (Bradford-on-Avon: Moonraker Press, 1978), p. 10.
14. Friedrich Kiesler cited in *Friedrich Kiesler; Visionary Architecture, Drawing & Models — Galaxies and Paintings, Sculpture*, (New York: André Emmerich, 1979), p. 8.
15. *Friedrich Kiesler: Architekt, Maler, Bildhauer, 1890-1965*, exhibition catalogue, (Vienna: Museum Moderner Kunst, 1988), English translation, p. 13.
16. Leslie Larson, *Lighting and Its Design*, (New York: Whitney Library of Design, 1964), p. 30.
17. Lisa Phillips, *Frederick Kiesler*, (New York: Whitney Museum/Norton, 1989), p. 82.
18. Cited in letter from Lillian Kiesler to John Grande, 1989.
19. Amy Winter, *Friedrich Kiesler's Principle of Endlessness in Perspective*, essay written while at the Whitney Museum, April 14th, 1989, p. 9.
20. Carl Jung and C. Kerényi, Essays on a Science of Mythology, (New York: Pantheon Books, 1949), p. 30.
21. J. Murray Shafer, *The Tuning of the World: The Soundscape*, (New York, 1977) np.
22. Murray Bookchin, *The Limits of the City*, (Montréal: Black Rose Books, 1986), p. 133.

7

Maleness and Femaleness in Art

Attitudes toward "maleness" and "femaleness" in the arts, as in any human endeavour, have evolved as a result of our culture and its ties to a traditionally male-dominated economic system. Cennino d'-Andrea Cennini gives us some idea of the ingrained male bias in Western art when he wrote in "Il Libro dell'Arte," a practical guidebook for artists in fifteenth-century Florence: "Take note that, before going any further, I will give you the exact proportions of a man. Those of a woman I will disregard, for she does not have any set proportion."[1]

The West's sexual identity, Michel Foucault noted, has been exclusively geared to a form of power/knowledge that has its roots in the rites of religious confession. Today the male-female sexual persona of both our tradition and the *ars erotica* of the Orient, which sees pleasure as an end in itself without any structural denial, face the overwhelming obstacle of rapid technological and economic change. Every aspect of how the two sexes relate to each other is affected, including art.

Male art has traditionally favoured an overview, a Utopic mapping of expression. This overview is either consciously initiated or intuitively understood as being important to the process. Historically, art forms have followed the utilitarian model. These tendencies changed from epoch to epoch, movement to movement, but art's external purpose or function was defined by an aesthetics that maintained a superior, unstated relation to economic production models. This male notion of subjugating creativity to an external, albeit aesthetic purpose, has always had historical prototypes on which to build and was considered more important than the ongoing process of life. The superior art was seen as an object of appreciation or a representation of idealized beauty, something whose purpose was perceived as fulfilling a function. These structures are part of the economic *hortus conclusus*, the enclosed plastic garden of creativity whose function males inadvertently followed in fulfilling their dominant role over women and nature.

Societies were built over nature and not through it. Marilyn French writes of this in *Beyond Power*:

For them (men), significance is located only in that
which transcends the natural context and offers some-
thing more enduring than life. Deluded by the notion
that power offers what endures, they ignore the fact
that nothing endures, not even art, except culture itself
— the children we make, and the world each generation
in turn makes. Searching for meaning in what is super-
human, men have ignored their humanity, the only pos-
sible ground for human meaning.[2]

The structure of history promotes and preserves this proto-male
vision because it is tied to economy. Creativity without a formal pur-
pose was, and may still be considered a *non sequitur* in a patriarchal
system. Once segregated from its generic place in the natural order of
things, art becomes a practice that, as Cézanne once stated, parallels
nature rather than being a part of it. Expression was, and is, attached
to the material product and appropriated in a diverse number of
ways. While many visions of beauty are object-oriented, the patriar-
chal one dictates not only ownership of the object, but ownership of
art's subject as a concept as well. The mind, not emotion has tradition-
ally called the shots in art's progression towards economic confor-
mism. Art could not express the spiritual metabolism of the individual
— our link to universal unknowns so eloquently expressed by Emily
Dickinson:

There is no Silence in the Earth — so silent
As that endured
Which uttered, would discourage Nature
And haunt the world.[3]

Appropriation of nature is, by definition a male attitude in any
endeavour because it implies ownership of that which it incorporates
into its sphere. It is also a utilitarian attitude to experience. It relies on
what has existed prior to it to ensure its own ephemeral validity —
either ideas or actual material — and acquires the past history —
remembered use of that which it appropriates. Attached to the
material product, artistic expression is perceived as having a historic
purpose, one endlessly reused and reformulated to become an axis for
new expressions. Appropriation and ownership naturally follow
from this. Money talks and objectifies art. The mind, not emotion,
governs art's progress-oriented and conformist tautology of history.
Previous forms are merely altered or collaged together and personal

idiosyncratic elements are added. No attempt is made to render forms out of primary material without reference to something other than the "beingness" of the creator and the material undergoing transformation. No effort is made to procreate art, to use a biological "feminine" term.

Marilyn French and other feminist historians have made it clear that identifying women exclusively with nature and men with culture is a tactic that inadvertently justifies the patriarchal character of both technology and territorialism. Pastoral societies that implicitly accepted the unity of male and female principles were easier to exploit than accept. Images of the Romantic, pastoral landscape are now incorporated by the machinery of publicity and advertising, from billboards to microscreen receivers on the electronic highway, in the form of close-up or cropped images, de-naturalized visual images that are every bit as pristine as a Turner or Constable landscape once was. Romantic landscape painting incorporated both human and non-human worlds as a subject, but not as a reality shared by nature and humanity. As in advertising, nature was presented in a passive sense to encourage two ideas: that of escape and exploitation. Today the "maleness" of appropriation and an emergent "feminine" procreative model for art which accept that which is unproven, searching, mysterious, and involves a process of self-discovery, of re-establishing our primary links to nature, are merging.

The identification of a woman's body with the earth need no longer be seen as only an inferior or submissive reflection of patriarchal oppression but instead as an abiding source of the integral strength of femininity. Indeed, we are beginning to realize that human (or male) domination of the earth will no longer work. We must rediscover nature's place in human culture at large if the world is to survive and prosper. A shift in creative values is taking place. In the past, female artists seldom had anything but their private visions to work with. Often this involved a marginal view of what it was to be an artist — even in relation to their partners, as was the case for Frida Kahlo (Diego Rivera's wife) and Ana Mendieta (Carl André's wife).

Ana Mendieta's work derived from a direct encounter with the earth, a source both of privation and nourishment. Prior to her untimely death in 1985, Mendieta, a Cuban-American exile, would use her own body to create images in the landscape that identified with nature as procreative force. In part an offering, in part a vehicle of transformation, Mendieta's silhouettes of her own five-foot body gave form to her vision of an intense union with nature. Her earth goddesses, images of violence and procreation are, like Andy

Ana Mendieta. *Silueta Series in Mexico*, 1973-77.Photo courtesy of Galerie Lelong, New York.

Goldsworthy's, ephemeral works, made with leaves, sticks, seed pods, flowers or simply mud and water. Notable for their temporal character, these works are part of a search for a point of belonging, an identification with something greater yet environmentally specific. In 1981, on a return visit to Cuba, Mendieta carved "siluetas," ferocious fecund symbols of fertility goddesses, deep in the soft limestone caves of Jaruco, a mountainous region of Cuba that has traditionally been a shelter for Cuban rebels. Among Mendieta's untitled works is a beautifully lyrical fertility goddess, all the more sacred for the fact that it is painted on a leaf. Another piece, a large vertical slab of wood carved with undulating rhythmic patterns, contrasts the delicacy of the former piece. For its explicit, macho use of gunpowder as a medium to burn the wood, it is a gifted, urgent allegory that underlines humanity's need to shift its priorities, to respect the procreative capacity, and to merge with, rather than destroy, nature as a life-giving source.

Jocelyne Philibert's *Vaste Vestiges* are city-scapes, slices of industrial and architectural life. These microcosmic plans built from recuperated fragments of demolished buildings, sit on small plateaus supported by wooden stalactites that extend like decaying roots to the gallery floor. Appropriating his material from the polemic core of past urban structures, the demolished architecture of our cities, Philibert's modern-day necropolis suggests that a procreative art could be a more positive influence on our city planners and architects than the structurally based, functional approach we now employ in designing cities. It would encourage us to consider values of cultural permanence and continuity. Like the homeless who are displaced by the monopoly games of urban developers (who rely on a conceptual male "overview" or mapping of urban space), the self is dismantled like a building and displaced of its freedom by what is essentially a territorial "male" necessity.

André Fournelle's *Navigating the Cliffs* (1990) exhibited at the Centre d'exposition art céramique contemporain (C.I.R.C.A.) was a narrative, autobiographical work that dealt with questions raised about his own early childhood in England before being adopted. The piece consisted of a series of plates of steel that recreated the archetypal male overview onto which metal fence-like structures, bent as if by a physical force, were placed. The viewer was invited to walk onto the installation, jumping from each steel plate to the next. The plates collectively formed a map of England onto which the words "Resecare," "Navigate," "Cliffs," and "Risk" were cut out of the form. Suspended from a structure of steel bars, these fragments of maps

swung to and fro. The muse-like shadows of the cut out words on the floor suggested the architectural structure of the piece and it's interior, poetic elements were locked in a tensile battle. Other works had morphological fragments, smoothly modelled eyes and ears interspersed into a seascape of wavelike forms through which two lines of flames burned in the shape of a cross. The structural (male) frameworks and poetic (female) elements documented the soul's perilous journey through the uncomfortable "techtopia" of today's urban landscape.

Female artists have always had to search for a language without the maps of their own historical definition. Their vision works in reverse, from the inside out, and gradually expands to include the outer world, the male world of exteriors. The contrast between Françoise Sullivan's paintings and David Moore's sculptures at C.I.R.C.A. and the Dominion Gallery present an interesting juxtaposition of the works of one male and one female artist today. Moore's extemporal material bite, his tribal brut, is more a voice than an ear. In *Viande*, a male torso in rough carved wood stands from the waist up, his arms outstretched and supporting a colossal male head. A neon sign in front of the piece read "Viande." Sullivan's evanescent circular collages of painted fragments stitched together, by contrast, make absolutely no reference to male prototypes in art as they would have had to even twenty-five years ago.

While Betty Goodwin's *Swimmers* (1982-1985) and *Carbon Series* (1986) with their free-floating, visually truncated figures had a tragic note of finality to them, her most recent *Nerve Series* (1993) are no longer her usual allegories of the human figure. Instead, they are tempered by the use of real life photos of exposed root systems transferred onto Mylar and then reworked. The imagery is more potent and mysterious precisely because it is more explicit. The patternings of the root systems that we see in these mixed media pieces allow us to explore our own unconscious associations with the process of birth, life, death and decay in an open-ended way. It is as if Goodwin's metaphorical guardian angels and defensive allegorical structures have fallen away to reveal a more simple truth: our symbiotic relationship to the earth. Goodwin builds upon what is there through trial and error, as the roots themselves do in darkness beneath the earth. *Untitled (Nerves) No. 10* works over these photo blow-ups of root systems in a two-part collage in which the lines have been exposed to become bone-white strands. They move down the canvas-like snakes that have shed their skin, vulnerable and exposed. The single patch of red that bleeds into the composition like a haemor-

rhage from the dark background behind is an exegesis of pain that we accept more readily because the context here is nature. Goodwin's *Nerve Series* bring to mind any number of social issues: the difficulty of communication, death, decay and aging, but its cathartic effect has a lot to do with how she uses her materials to address the inherent vitality, enduring strength and beauty of these themes.

In the past, it was rare for a woman to make it as an artist. If she did, it was for personal, not economic reasons. British Columbia's Emily Carr expressed something of this searching openness when she wrote:

> What do these forests make you feel? Their weight and density, their crowded order ... there is scarcely room for another tree and yet there is space around each. They are profoundly solemn yet upliftingly joyous ... the juice and essence of life are in them and they teem with life, growth and expansion, they are a haven for myriads of living things.[4]

Like so many female artists from earlier generations, Emily Carr evolved largely in isolation on the Canadian west coast in a world dominated by male prototypes. But her inspiration had more to do with where she worked than the art market. There was little place for a woman artist in the pantheon of male stars that then comprised the history of art. Virginia Woolf eloquently describes the woman's place in society at the time in *A Room of One's Own*:

> But for women, I thought, looking at the empty shelves, these difficulties were infinitely more formidable. In the first place, to have a room of her own, let alone a quiet room, or a sound-proof room, was out of the question, unless her parents were exceptionally rich or very noble.[5]

These two distinctively different artistic visions, one an appropriative, male attitude towards expression and the other a visceral, procreative one, are now coalescing. As female artists begin to work in new ways, without reference to an essentially male history of art or past prototypes, their expression becomes relevant to emergent ecological concerns now facing us. The emergence of an ecological conscience with more feminine, procreative models of continuity and the infinite spiral of life are coming into being. Our understanding of

nature's continuity, coupled with a healthy handling of the technology, now allows some female artists the chance to explore a future vision unencumbered by traditional feminist structural discourse. Laurie Walker's installations address these issues of change. Filled with so many sensory, symbolic, structural and natural ambiguities, her work suggests the sensory discontinuities we see in the world around us are largely unresolved, as much guided and defined by our unconscious reactions to technological innovations as our mythologies are shaped by popular culture.

In an early work, *Producing Monsters* (1986), Walker brought together current discourse about art's unstable relation to science with riotous alacrity and an absurd sense of humour. Consisting of a giant *papier maché* moon skewered like a spit on a barbecue, the work looked like a set from a Fellini film. By grabbing a primitive looking oversized handle, one could spin the moon and watch it revolve with awkward irregularity from a small telescope placed near its surface. High up on a wall, a photo of superimposed images of the moon and the mask of a man's face brought to mind the age of pre-Cartesian astronomy and the witch craze of the seventeenth century.

A recent Walker piece titled *Carpet* (1992) consists of a rectangular patch of cast peat moss from which fringe-like strands of illuminated optical fibre projected at both ends. Hovering just above the floor like a magic carpet about to take off, *Carpet* suggested a new set of mythological or fictional cosmologies. The question Walker's work left unanswered was whether these new metaphors for communication — the relationship between technology and nature — have as much to do with origins as with evolution; whether new meanings are endlessly reinterpreted in novel ways as technology evolves, or whether what emerges is a hybrid of these meanings. Upon climbing up one of the four ladders welded to Laurie Walker's post-minimalist tower of steel titled *Altus* (1992) in virtual darkness, one found oneself peering down at a vat of bio-luminescent bacteria. The immediate sensation was of looking up instead of down, of intractable distance. The contrast between the patterns of living light and the austere, structural shell of the piece reaffirmed Thomas Carlyle's notion that unconsciousness is the sign of creation; consciousness being, at best, that of manufacture. Not simply a feminist assault on minimalism, *Altus* foregrounded the space between touch and less tangible forms of sensory experience. Laurie Walker's work drifts between subjects of alchemy, science and pure reason in a way women artists of earlier generations could not have done.

Kim Adams deals with the structural ambiguities of ecological issues and life in a patriarchal paradigm that is changing in a lighthearted way. *Dodes 'Ka-den* (1993), the centrepiece of a recent showing of Kim Adams' work, examines a consumer culture in which utilitarian values have gone into hyperdrive. Loosely titled after Akira Kurosawa's 1970 film about an adolescent who drives an imaginary trolley through a combined garbage dump and shantytown, this post-consumer wagon train Adams has created is put together with the practical know-how and childlike ingenuity of Utopian engineering. A full-scale, non-functioning model of a truck cab — complete with pink windshield wipers and a turquoise body — pulls a septic tank and water tank on wheels, as if ready to roll in a nomadic trance from suburbia to the promised land. The only thing that seems to stop it is a series of vertical metal supports held in place by hockey pucks. Adams riddled the bodies of these plastic containers with multi-coloured plastic funnels, viewer observation posts that provide us with private views of a carnivalesque world. Filled with scenes of holiday-goers and parked Winnebagos, a marching band and a fully operational circus, a Kentucky Fried Chicken outlet with parasols, streetlights, dinosaurs, and a giant, green toxic mutant monster, *Dodes 'Ka-den* figures a post-developer's Eden. Jammed amongst these scenarios, industrial mine sites, trailers carrying trucks, smokestacks, and images of general despoilment vie for our attention. Appearing and disappearing at regular intervals, a model railway train chugs its way around, tooting occasionally, only to arrive at the same place again and again.

Putting a backspin on Bosch and replacing the superstitious fables of the human condition with a fanatically detailed, yet strangely comfortable cataclysm, is not all that Adams does. Adams also includes a tiny, perfect maquette of one of his earlier sculpture installations, as if to parody his own place as an artist in this mélange of cultural critique and fabulism. As creatively hamstrung as they are technologically correct, the minuscule personages who play out their escapist dreams inside Adams' object-containers are as decontextualized as the environmental disruption that surrounds them. Similarly, the partial glimpses we have of the interiors make us aware of the discontinuity of our own passive perceptions. Off to the side, we see three identical sets of brightly painted kids' bikes each with two sets of handle bars and pedals pointing in opposite directions. An allusion to the *pro forma* discourse on sexual identity? While the colours of the bikes vary, the most noticeable difference between them is the colour of their tires. *He, He* (1993) has two black

Laurie Walker. *Producing Monsters,* 1986. Steel, waxed paper, wood, fibreglass, telescope, security mirror, photograph. Photo by Robert Bean. Photo courtesy of the artist.

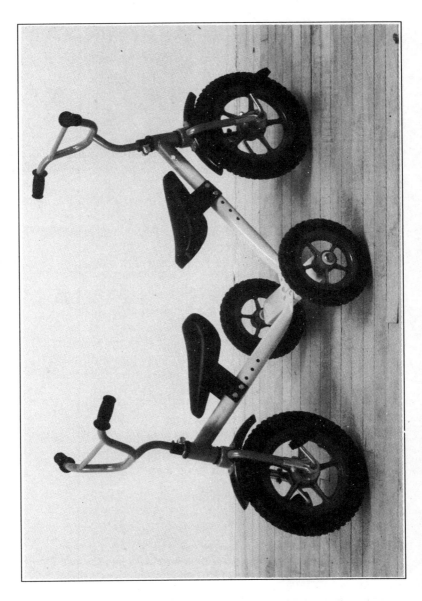

Kim Adams: *He, She,* 1993. Photo by Guy l'Heureux. Photo courtesy of Galerie Christiane Chassay, Montréal.

tires. *She, She* (1993) has two white tires. *He, She* (1993) has one white and one black tire.

If, in a sense, Adams puts all his eggs in one basket by focusing exclusively on the commodification of life in a technological age, *Dodes 'Ka-den* is more than simply another apocalyptic vision. The vehicle itself and its compartmental exteriors — the septic tank and the water tank — suggest a renewed sense of the value of self-sufficiency. The whole issue seems to revolve around the question of how we perceive our own purpose in relation to reality (read: nature). Adams realizes the artist's potential to transform apparent chaos into creative catharsis.

There is wisdom in the new currents in the arts today. It is a place that philosophers have not yet got to and poets may have always known to exist — for they themselves were largely marginalized from the mainstream as their product was largely of little economic value, unmarketable. Rainer Maria Rilke foresaw all of this when he wrote:

> The girl and the woman, in their new individual unfolding, will only in passing be imitators of male behaviour and misbehaviour and repeaters of male professions. After the uncertainty of such transitions it will become obvious that women were going through the abundance and variation of those (often ridiculous) disguises just so that they could purify their own essential nature and wash out the deforming influences of the other sex. Women, in whom life lingers and dwells more immediately, more fruitfully, and more confidently, must surely have become riper and more human in their depths than light, easygoing man.[6]

Notes

1. Cennini d'Andrea Cennini, *Il Libro dell'Arte,* (New York: Dover, 1954), p. 48.
2. Marilyn French, *Beyond Power,* (New York: Summit Books, 1985), p. 535.
3. Emily Dickinson, *Bolts of Memory: New Poems of Emily Dickinson,* (New York: Harper & Row, 1945), p. 250.
4. Doris Shadbolt, *Emily Carr,* (Vancouver: Douglas & McIntyre, 1990), p. 161.
5. Virginia Woolf, *A Room of One's Own,* (Harmondsworth: Penguin, 1970), pp. 53-54.
6. Rainier Maria Rilke, *Letters to a Young Poet,* (New York: Vintage, 1987), p. 76.

8

Andy Goldsworthy: Ephemeral Integration

Andy Goldsworthy is one of the latest innovators whose ephemeral brand of art seeks to integrate nature *as* culture into an environmental expression. His works, which use materials derived from nature *in situ*, are truly part of a new "ecological" school of art. They are a fresh and novel approach to an art based in the land, out of doors. Goldsworthy's art markedly contrasts the original maximal-scaled land art impositions from the sixties. The original intention of the sixties earthworks such as Robert Smithson's *Spiral Jetty* in Utah's Great Salt Lake, Walter de Maria's 390-foot air shaft burrowed through the centre of a mountain near Munich on the site of the 1972 Olympic Games, and Michael Heizer's *Dragged Mass* which involved hauling a thirty-ton granite block one hundred feet across the lawn in front of the Detroit Institute of Arts, was to completely remove the commodity status of a work of art. But, if as Walter de Maria believed, "art galleries are as outmoded as night clubs,"[1] Michael Heizer's statement, "I don't care about landscape. I'm a sculptor. Real estate is dirt, and dirt is material,"[2] affirms the code of the original land art aesthetic which was not to integrate nature and art, but to impose an idea of art in the forum of the exterior landscape. The site-specific landscape was bulldozed, dynamited, moved and displaced. The artist's intention continued to involve the imposition of an idea of art onto nature by the artist.

Of this generation, Christo's most recent projects included the simultaneous unveiling of 31,000 umbrellas along the Tejon Pass in California and across the Ibaraki prefecture, seventy miles north of Tokyo. Financed through bank loans and sales of Christo's drawings and prints, the project cost U.S.$26 million The magnitude of cost and concepts minimize the artist's role in production, making it all seem a question of financing. This past February, the German parliament voted to allow Christo to wrap Berlin's Reichstag in silver fabric, something Christo had been trying to do for twenty-two years. More than 200 climbers will use forty kilometres of rope to secure Christo's wrapping, but Germany's environmentalists succeeded in obtaining a guarantee from Christo that all materials he uses will be recyclable. Andy Goldsworthy, on the other hand, tried to minimize his interventions. His work is usually more modest, almost microcosmic in scale.

Robert Smithson. *Spiral Jetty,* 1970. Great Salt Lake, Utah.

Andy Goldsworthy. Derwent Water, Cumbria, February 20th and March 8th-9th, 1988. Photo courtesy of the artist.

Time is taken to assess the site, materials, climate, life forms, vegetation and location before work is begun on a piece. Goldsworthy seeks to "uninvent" art by removing any metaphoric, subjective or idiomatic associations we might have when considering art. A direct response to local, specific ecologies, his work combines various organic and inorganic elements, and readily available generic details such as snow, ice, berries, grass stalks, thorns, boulders, earth, leaves and wood.

Goldsworthy's notebook comments on the day-to-day experiences of putting together these works. In *Andy Goldsworthy: A Collaboration with Nature*, he tells of animals running over or jumping into works, thus suspending further activity; or, as in the case of some fish and ducks who live in a pond in the Yorkshire Sculpture Park in West Bretton, England, actually nibbling and attacking some rowan berries that formed part of a floating work. Usually temporary, these constructions emphasize an ephemeral aesthetic of near invisibility. As site-specific works, they allow the materials of a local ecology to speak for themselves and can change instantly, or over time according to the action of weather and composite materials. By simply reassembling them into colourful and coherent natural design patterns, Goldsworthy succeeds in broadening our awareness of the range of materials an artist can use to create significant works, bringing art back out of the mainstream of prefabricated, manufactured products. The intention of Goldsworthy's brand of environmental art is to emphasize the volatile, ephemeral side of life and reduce the sense that art must exclusively be presented or prepared with the museum or gallery context in mind. Somehow the immortal, homocentric Utopias to which generations of artists have consecrated their work no longer seem to jibe. In Goldsworthy's own words:

> Looking, touching, material, place, making, the form
> and resulting works are integral; difficult to say where
> one stops and another begins. Place is found by walk-
> ing, direction determined by weather and season. I am
> a hunter, I take the opportunities each day offers; if it is
> snowing, I work with snow, at leaf-fall it will be with
> leaves, a blown-over tree becomes a source of twigs and
> branches. I stop at a place or pick up a material by feel-
> ing that there is something to be discovered. Here is
> where I can learn. I might have walked past or worked
> there many previous times. There are places I return to
> over and over again, going deeper. A relationship with

a place is made in layers over a long time. staying in one place makes me more aware of change.

You wouldn't believe the effect of picking up a maple leaf that looks a little dull and then dropping it in the water where the colour becomes so intense. I began to understand the maple leaf through water, but that's only one way in, all materials have a way in to discovering their nature.

Movement, change, light, growth and decay are the life-blood of nature, the energies that I try to tap through my work. When I work with a leaf, rock, stick, it is not just material in itself, it is an opening into the processes of life within and around it. When I leave it, these processes continue.[3]

Over sixteen years ago, Goldsworthy made a line of stones in Morcambe Bay. He states, "It is still there, buried under the sand, unseen. All my work still exists, in some form."[4] Since then he has worked in an astonishing variety of climates, geographies and remote places. In 1989 he went to the Northwest Territories and with the Inuit, he created a series of vertical, open circles out of blocks of ice. Cut into carefully measured angles that fit together to form the whole piece, they were then documented with a simple 35 mm. camera. The results were exhibited at the L.A. Louver Gallery in Venice, California later that year. In his native Britain he exhibited works not in an art gallery, but in the Natural History Museum in London. In another show in New York, he brought boulders into a gallery. They were sold at the same price no matter what size and shape they were. When Lord Dalkeith, heir to the Duke of Buccleuch took a liking to Andy Goldsworthy's art, he gave him a thirty-five year lease on a two-acre section of grazing land that he owns at Stonewood, Dumfriesshire in Scotland. The only stipulation was that a wall be built between his land and that of a tenant farmer's land immediately adjacent. Goldsworthy's answer to the project was the quintessential embodiment of mutualism, with an element of practicality. He constructed a dry stone wall whose central section formed an open figure eight. The shape of this curvilinear form resulted in two enclosures, both of which extended into the other neighbour's property but such that each had the same amount of land as before.

In another series of works exhibited at the Fruitmarket Gallery in Edinburgh in 1992, Andy Goldsworthy simply presented drawings on paper that were essentially created by the actions of nature. After

placing earth onto the contours of a snowball or icicle, the action of melting ice and snow create the final patterning and design on these large-scale paper works.

By combining inorganic with organic matter in a series of designed symmetries and assemblages, Goldsworthy layers his art into the sites he works on. Tree branches are stacked, arranged like pillars in Cumbria. Rhythmic swirling sand dunes and craters are ploughed into a series of patterns in the Arizona desert. Bamboo ends are pushed into bitten holes along the Japanese coastline to become "nature assemblages." By simply setting one rock to project further out of a mountain side than the natural course of the slope, he causes us to reassess the entire mountainside, to consider it as more than a mere subject: nature. Goldsworthy's art is a silent, sensitized integration into a given environment. His approach to, and use of materials exists outside any formal economy of art. Goldsworthy's greatest contribution to the future of art is this sensitive, ephemeral touch which involves a basic respect and insight into the elements that surround us in the world. We are made to consider "nature" in a less cursive, haphazard way, and realize the diversity that is there before our eyes yet we seldom notice. The variety of ways Andy Goldsworthy has dealt with such simple, yet infinite elements in the world around us shows him to be much more than a mere artist: he is a creative resource whose vision is not fixed on immortality, but instead looks outward for its joyful, extemporal inspiration.

Notes

1. Harold Rosenberg, "Onward and Upward with the Arts," *The New Yorker*, Feb. 12th 1972, p. 42.
2. Michael Heizer cited in Suzi Gablik, The Reenchantment of Art, (London: Thames & Hudson, 1991), p. 140.
3. John Fowles and Andy Goldsworthy, *Hand to Earth: Andy Goldsworthy Sculpture 1976-1990*, (Leeds: W.S. Maney & Son, 1990), p. 160, 162.
4. Ibid., p. 160.

9

Outside, History, Inside, Nature

As we approach the end of the second millennium, it is more evident than ever that our traditional Western approach to art must come to an end. Our extensive dependence on the syntax of our art, its structural basis, is indeed a weakness and not, finally, a strength. It is possible that we can replace it with a more subtle but longer lasting vision of art whose main premise is its silent integration into a built or natural environment. This approach would, out of necessity, require a greater exploration of the driving forces behind our unconscious; of our biological origins and our endemic relation to nature. An art of the future may also represent a modest integration of Eastern and Western values of what art is or could be. Our art and architecture could be revivified if we realize the volatile, endlessly changing characteristics of all materials in nature, both organic and inorganic. All act according to natural laws and should be as important to the artist as to the pure scientist. Art can play a leading role in guiding our society towards a regenerative, intuitive vision of the life process. Our connectedness to nature is part of a holistic energy of life, which is both ethereal and physical. If our artists can understand this process more fully in a sensitized way, then we can cast aside the appropriative models and structural layerings of today's art.

Instead of clever idioms based on a benign fatalism which merely reflect professional narcissism, an art of the future could envision nature in a new way, as a modest reintegration of humanity's spirit back into nature. Nature must remain the model on which the forms for the future are built. The materials an artist uses, their inherent characteristics, their origins, and their functions must be understood fully for the artist to find a truly meaningful voice. If we can only begin to see material as volatile, something which is endlessly changing and which acts according to natural laws instead of as a potential or actual product, then we have a chance. Expression can be brought out of the hermetic force field of purely ideational design. Artists have a choice as to how they express their life experience. Their art could be individualistic in a new way. They could see materials less as objects centred around themselves, more as elements, like themselves, in unity with life. In this way, a respect for the environment which we share with other living species could be part of, not excluded or ex-

clusive to, expression. Expression will no longer mean the shallow commercial bravado that it did in the hey day of Pop art, or the empty ideations of conceptualism with their pathetic nostalgia for materialism. Andy Warhol's famous comment "I want to be a machine" and Roy Lichtenstein's tastefully correct comic book images — like Warhol's — are an art that hides its terror of human communication behind commercial illustration, an art *après la machine*, seemingly afraid of revealing any human side. As the critic Harold Rosenberg commented at the time:

> Apart from the difference in size, what is the real difference between a comic strip Mickey Mouse and a Mickey Mouse painted by Lichtenstein? The answer is art history ... The sum of it is that Lichtenstein had his eye on the museum, while the original worked outside of art history. Art manufactured for the museum enters not into eternity, but into the market.[1]

This kind of art has now found its apotheosis in a former warehouse for steel and concrete in Philadelphia, the only museum dedicated exclusively to the work of a single American artist. Refurbished, redesigned and financed by the Carnegie Foundation, as well as the Dia and Andy Warhol Foundations in New York, the Andy Warhol museum now houses Warhol's images of Elvis, Prince, his mother and Marilyn Monroe, in the city where he was born.

Art could also have a much more pervasive, subtle role. Is it possible that significant art of the future will present an entirely new basis for aesthetic judgement where near invisibility is considered "high art"? This kind of aesthetic neutrality would be judged not by how it stands apart from, but by how it silently integrates into, a given environment. By not being the central feature of a given environment, it would represent an unexpected discovery. It could express a return to the soul and assume a mythic role for art, inspiring us to see our place in nature in new and interesting ways. Art, like nature, could be allowed to exist in its own right, without the codification, labelling and textual translations that render it all so similar, distancing us from natural experience. It could be immediately understood as experience and not through ideational translation. An art of the future could present us with a holistic way of envisioning culture; of embodying a mutualist, co-dependent respect for our ecosystem. Any variety of materials could play an active, equal part in the creative process to that of the artist. This would allow art to renew its

place alongside science in developing a future vision. Materialist values and historic notions of progress would have no place within this proto-causal state. Nature is an open and versatile system. The instinctive life forces that truly propel us and the physical energies that are a part of our universal experience are the art of which we are a part. We can and must move beyond the rigid, production-oriented and mediatic forms that now threaten the extinction of art and learn to communicate with and through life's transformative energies.

It is the reintegration of economy into ecology that will prove the major direction of society in the twenty-first century. The malaise of enforced production-consumption patterns with which we now live must be understood for what they are: an abject form of distraction designed to subject the human spirit to the same sort of exploitation suffered by other life forms and all nature on earth. Today's economists could do well to understand this as they subject human beings and our ecosystem to relentless onslaughts of profiteering. None of us will survive this kind of enslavement unless we develop a new sense of responsibility for the immediate world we live in. We can no longer solely express humanity's joys and despairs independent of, and without considering nature.

As our society does move towards a softer, holistic approach to real human needs and abandons a value system based in pure profit and the excess extraction of natural resources, the artist will be able to change his or her expression to one based on self-reliance and a new appreciation of life on earth. No longer an offshoot of an economic reward system, art can be a celebration of nature. The artist can put something back into nature by direct action. The landscape architect can work with sculptors, as the architect can work with artists to create more organically variable living conditions. Sustainable environments in our cities will relieve the stresses of urban living, encouraging us to improve our everyday environments instead of escaping from them. The future of art will manifest a strengthening of our relationship with nature. We can rediscover a basic curiosity as to who we are, why we are alive, and where we stand in relation to the universe. Perhaps, with the aid of art, we will begin to realize that though other forms of life on this planet respect our place, we have often denied them theirs.

A new emphasis on the immediate environment and culture — decentralized and focused on the specific needs of each bioregion — that realizes the limits to resources on the basis of scale, not sensibility, could be exactly what many regions of the world need in order to regenerate. It would encourage a greater resourcefulness, a

sense of cultural permanence in us all. In the words of an old Lakota song: "Take courage, the earth is all that lasts."[2]

The endless movement of materials and goods so costly in terms of resources, like the endless movement of art to international venues, is a transitional phenomenon, an ephemeral response to unreal demands and expectations. This will no longer be the function of culture in the future. More likely, artists and citizens of the world will seek to be responsible for where they live and they will express these concerns in intuitive ways. It will depend on each individual's commitment to identify less with external, material results — the product — and more with integral, lasting values. A re-souling of art and society based in real communication — the process — is taking place.

Values that call for a reintegration of economy into ecology will be marketable in the future. The "big sell" commoditization of all facets of our lives, art included, is based in the objectification of nature. It empties us of any real emotions and it makes us feel worthless. It also causes moral crises that are simply not necessary. Materialist values can no longer be supported by a responsible, survival-based economy. Nature, on the other hand, is an open and versatile system.

In the future, artists may have to leave their works unsigned so that we can appreciate them for their own merits and envision their integral place within a specific environment. Embodying a principle of near-invisibility, art could acquire new meanings. This process would demystify the material meaning of art which, in this century, has threatened the integral process of creativity and retarded the natural process of exploration and discovery integral to the creative process. This challenge will require as much strength and resistance on the part of the artist as has ever been known in the world's recorded history. An active acceptance of an equal, not superior, relation, to other species and elements in our ecosystem is essential, as is a much needed poetic sensibility in the arts. As Rilke wrote in his ninth Elegy:

> Earth, is this not what you want, an
> invisible re-arising in us? Is it not your dream
> to be one day invisible? Earth! Invisible!
> What is your urgent command, if not
> transformation?[3]

The resultant art forms would represent a sincere blending of culture and nature, a fusion of economy and ecology. The impact of this shift in perspective, from the "I" to the eye would be dramatic. It

would resemble much of what has not been recorded as art in our history, where works of art were unnamed and created for holistic reasons. The priorities of industrial civilization negated much of the best art from so-called marginal or primitive cultures, as well as art by women and children, whose works represented a more sincere blending of culture and ecology. The formal history of the West is just one version of the story. Any art which unknowingly presents an alternative world-view to that of economic expansion is left unrecorded, largely ignored.

Art could become living experience. This is what it was when the Lascaux Caves and Native Pictographs were created, at a time when art and life were virtually inseparable. The problem of theft and damage to petroglyphs and pictographs around the world was recently addressed during the twenty-first International Rock Art Congress in Flagstaff, Arizona. Spray paint, magic marker, nail polish and soot from the candles and campfires have rendered some of these ancient images undatable. Likewise, the theft of primitive art, such as the attempt to saw out the Red Cloud painting from the Gottschall site near Highland in southwestern Wisconsin, irremediably damage rock art. At Lascaux, a copy of the original cave is now the only site visitors are permitted to visit, as the original cave paintings were altered by the oil deposits from tourists' hands endlessly touching them out of curiosity.

The process of un-naming works of art could liberate art from the fetters of economic justification. If we are to overcome established, stultifying value-systems, we should seek new values that bring us closer to finding a new place in the culture of nature, so that instead of looking nostalgically backwards for spiritual solace we can look forward to a new era in civilization. The culture of nature is defined by limits, just as our economies will have to redefine their purpose in similar ways. So too, a new aesthetic can evolve that perceives the limits inherent in working with and through precious and sacred materials. The physical and spiritual could become fused in a way that perceives creation as a procreative process based in regeneration as much as recreation.

Nature needn't be extracted, neatly assembled and contained to make an ecological statement. This kind of approach resembles the Italian Renaissance and Japanese Garden traditions, where nature was manipulated, structured, organized and underlined. Nor should nature be culled simply to justify a particular culture's homocentric worldview. It's been a long time since we let nature simply exist in its own unnamed context without labelling it, or applying our ingenuity

to explain it in rational or scientific terms. For the past 200 years we have adopted the same attitudes towards art as Charles Darwin had towards living bioculture. When Darwin wrote in *The Origin of Species* he noted that:

> Natural selection will modify the structure of the young in relation to the parent, and of the parent in relation to the young. In social animals it will adapt the structure of each individual for the benefit of the community, if each in consequence profits by the selected change.[4]

He provided a rationale for what is truly immeasurable. Darwin's theory of evolution itself was an objective stratagem that quantified, labelled and identified species. It was a reflection of the state in which the industrial age he lived in had reached. In justifying laws of competition between species, Darwin negated the mutualist processes of communication and transformation of energy which occur between species and within our bioculture as a whole.

During his time, the environment was being transformed as factory smokestacks appeared and the effects of industrialization grew at an unprecedented rate. All this to justify an unnatural manipulation of a natural process! We have done the same with art as Darwin once did with nature — quantifying, labelling, ordering by chronology, medium, name — simply to prove that we are alive!

Real art doesn't need an audience — it has its own integral identity and that's why it is there. Simultaneously occupying real space and being a creation of its own life-force, it can, like nature, integrate silently into a given environment. Its camouflage character is an anathema to our current obsessive approach to artistic production. At any moment in time there are thousands of exhibitions taking place in the world. How can an artist construct a meaningful identity if art continues to be seen in these individualistic terms? Even such supposed watershed events as the Kassel Documenta and the Venice Biennale have been rendered largely irrelevant, so numerous have venues for contemporary art become throughout the world. Likewise, our arts institutions have grown to the point that they now demonstrate what Ivan Illich has called "paradoxical counter-productivity."

When museums and art galleries were originally established, their purpose was to recognize the works of what were considered the most outstandingly creative artists of their era. They now seem to foster the most lifeless examples of conformity and cultural subser-

vience while presenting themselves as the vanguard exhibition venues of this civilization's culture. As education systems create conformity, not inquiry, and high-tech medicine generates illness, art institutions standardize, mollify and render banal the sacred role of art. It is now obvious that the resources we consider valueless in nature — seemingly irrelevant species, vast tracts of land deemed uninhabitable — are essential if we are to maintain an ecological balance on our planet. Likewise, what we consider valueless in art — the materials themselves — are the real key to universalizing creative expression in the future, to making art a poignant communication between diverse physical elements.

An artist's main contribution to society is a vision of the culture in which he or she lives. This cannot be measured in economic terms because art can be one of the most labour intensive and personally rewarding activities one could hope to undertake. It outlasts the latest model car and provides the future society with a sense of continuity and identity that is irreplaceable. Adopting a permacultural view based on the continuance of communities could help improve the situation.

If a landscape architect spends twelve weeks on a project instead of six to better his design project and improve his environment, shouldn't these efforts be considered of greater value to the community than that of the standard city contractor whose only sense of value comes from how much he is paid? And if that project has a net effect of reducing stress, encouraging relaxation and a greater health among all the citizens, is that not a better contribution to the community in the long run? Architects and artists are no different. The more self-sustaining and permanent a community is, the greater stake people will invest in those communities. Artists can improve our communities by creating interior and exterior fresco projects (a form of art that has not been fully exploited in northern climates), murals, gardens and fountains, permanent and temporary sculptures for sites in parks, as well as the preserved wilderness environments we will go to from the satellite cities of the future.

If art has a leading role to play in developing the communities of the future it is because art helps us to define our relation to space and time within a cultural context. Artists can play a seminal role catalyzing and generating new environments, encouraging a new sense of community and the lived in human space because they are free agents, capable of creating innovative alternatives every bit as logical and integrated in their vision as today's architects and city planners. If anyone knows colour, light and the processes involved in the ap-

plication of materials — be they wood, clay, glass, aluminum, stone or earth — it is the artist! Artists should be consulted more often by architects and landscape planners. They have a good sense of how to treat and develop a given space so as to integrate its diverse elements naturally in a planned environment. Isamu Noguchi, Henry Moore, Hundertwasser, Constantin Brancusi, Jean Dubuffet, Alexander Calder, Friedrich Kiesler, Antony Gormley and Armand Vaillancourt are but a few of the better known artists who have created projects that have revitalized the relation between the architecture, city environments and nature in settings such as Jerusalem, San Francisco, Florence, Italy, Vienna, London and New York.

Artists have the right to choose what they consider to be significant creatively. They can be responsive and responsible to their place within nature. It is only by learning a new flexibility and adaptability that art will once again redevelop a living basis for creativity. In art, as in life, the development of our greatest resource — our inner being, body, soul and mind together — will be the key to finding a new, meaningful expression. This development can only be achieved through a reversal of values away from those that emphasize outward accomplishments (the museum-gallery scoreboard of every artist's boring and predictable climb to stardom), and toward those that seek to understand our inner persona, other species and life forms. A renewed respect for the resources which we do have on Earth should be encouraged. In the words of the German playwright Heiner Müller, "In the end all that remains is poetry. Which has the better teeth? Blood or stone?"[5]

Notes

1. Harold Rosenberg cited in José A. Argüelles, *The Transformative Vision*, (Boulder: Shambhala, 1975), p. 275.
2. Alexander Wilson, *The Culture of Nature*, (Toronto: Between the Lines, 1991), p. 11.
3. Ranier Maria Rilke, *The Duino Elegies*, English translation, introduction and commentary by J.B. Leishman & Stephen Spender, (London: Hogarth Press, 1957), p. 87.
4. Charles Darwin,*The Origin of Species*, in *The Darwin Reader*, Mark Ridley, ed., (New York: W.W. Norton, 1987), p. 82.
5. Heiner Müller, *Explosion of a Memory: Writings*, (New York: PAJ, 1989).

Part II

10

Native Art *is* Contemporary Art

For the European artist and his North American counterpart in the mid-nineteenth century, nature was something infinite and mysterious, separate from man. The landscape literally had to fit the palette to be a worthy subject. The landscape, as idealized by the Romantic painters, fulfilled the Judeo-Christian mandate of revealing God's dominion over man and man's over the earth. Their clientele of nobility and nouveau riche industrialists preferred to see nature as a bountiful global estate presided over by man. When Eugène Delacroix painted *The Natchez* for the Paris Salon of 1835, he had never been to North America or seen an "Indian." Delacroix's painting was based on François-Réné de Chateaubriand's romantic novel, *Atala* (1801), about the tragic fate of native peoples which he wrote after a five month visit to America. A passage reads:

> We are all that remain of the Natchez, when our nation had been massacred by the French to avenge their brothers ... Man thou art but a passing thought, a grievous dream; thy life is all misfortune; only the sadness of thy soul and the unending melancholy of thy thought dignify thee.[1]

Delacroix's *The Natchez* portrayed a native mother, father and child with all the humanistic bathos of Rousseau's noble savage, unencumbered by the turmoil of Europe's industrial revolution. The Romantics' appropriation of imagery that depicted the primitive cultures of the world as exotic, somehow more pure than their own, had little to do with genuine respect for those cultures. It was more of a genuflection devoted to reaffirming the colonizers' eurocentric mindset. As the filmmaker Loretta Todd stated in *Notes on Appropriation*:

> The valorization of peripheral cultures is frequently undertaken through acts of cultural appropriation. In an extension of the concept of property and colonial conquest, the artists do not value or respect cultural difference, but instead seek to own difference, and with

this ownership to increase their own worth. They be-
come image barons, story conquistadors, and mer-
chants of the exotic.[2]

The itinerant Canadian painter Paul Kane became famous in
Europe virtually overnight when an illustrated folio-style book of his
travels and experiences among the native peoples, *Wanderings of an
Artist among the Indians of North America*, was published in London in
1859. Kane portrayed natives with the endearing, detached eye of an
anthropologist — hunting buffalo, or in their encampments, portag-
ing a river or in formal portraits — at the same time as they were
being decimated, confined to territories and subjugated to colonial
power. Kane's subjects were *indigènes*, not individuals.

For the native peoples, maligned by five hundred years of con-
tinuous cultural exploitation, their culture and art still have a sacred,
soulful function. Eléonore Sioui Jikonsaseh of the Wendat nation ex-
presses the native vision of the universe in her poem, *The Huron are
Rich* (Oukihouen Wendat):

*In the Amerindian
Are found
The tears, smiles, cries
Of the soul of Mother-Earth
For he was born of her—
Made fruitful by the sun—
Amid a rustling of the Spirit
Encircling his brothers
In his new birth*[3]

Until well into this century, the art of the First Nations of North
America was a celebration of collective tribal culture and had little for-
mal economic value. Native works were ephemeral creations meant to
be used. With the passage of time they would eventually disintegrate
and return to nature, to be recreated by a younger generation of ar-
tisans. Materials were an inviolable part of nature before and after
transformation into art forms. Their limited availability made them all
the more important.

The Tsimshian of the north-west coast used to create pairs of
identical stone masks which fit on top of one another. While the inner
mask had holes for the eyes to see through, the outer had none. It was
as if one of the masks possessed the power of objective vision — of
sight and memory — the other an inner vision — transformational

and imaginative. The two fit together to become a material paraphrase for the power of human consciousness.

An art in apartheid or spiritual renaissance?

The spate of shows devoted to native art during 1992 in Canada have exposed the public to a new generation of native artists. These artists are active at a time when the art world is up in arms over questions about the meaning of art. And yet, as the dust begins to settle on these recent shows — *Indigena* at the Museum of Civilization in Hull, Carl Beam's *The Columbus Boat* at The Power Plant in Toronto, The National Gallery's *Land, Spirit, Power*, and Pierre-Léon Tetreault's *New Territories: 350-500 years after* at Montréal's Maison de la culture — has our understanding of native culture truly changed? New native artists have certainly gone far beyond Mordecai Richler's description of an Innu family in *The Incomparable Atuk*, working furiously, carving out trinkets and trophies in their basement solely to sell to tourists. However, the feeling one has in witnessing the broad variety of installation work, paintings, sculpture, textual and video pieces, and photo-based work by the latest crop of native artists remains a duplicitous one. Canada's younger generation of native artists have gone through art college and university programmes and are well versed in the language of modernism. The cultural gap between our Western formalist traditions and the native tribal heritage has diminished, but at what cost? Many of the West's best artists — Andy Goldsworthy, Hamish Fulton, Ian Hamilton Finlay and David Nash — prefer to produce, document and exhibit their work outside the museum and gallery forum in order to avoid the pitfalls of formalism and to reflect a more open, interactive language for expressing the subject of nature *as* culture. Today's younger generation of native artists are working furiously to swim upstream and get into those same ideologically and historically hamstrung institutions.

Are we truly witnessing a rebirth, or merely a reformation of the meaning of native art and culture? Carl Beam, an Ojibway from Ontario, was the first contemporary native to have his work purchased by the National Gallery of Canada in 1986. His work, *The North American Iceberg*, was a caustic comment on the Art Gallery of Ontario's *The European Iceberg* show which brought the European trans-avant-garde to Canada. Beam states:

> At the time I felt honoured, but I know I was used politically ... Indian art that's made as Indian is racially

motivated, and I just can't do that. My work is not made
for Indian people but for thinking people. In the global
and evolutionary scheme, the difference between
humans is negligible ... After 500 years, Ottawa isn't
supporting native individuals with solo exhibits. The
group show of Native art (*Land, Spirit, Power* at the Na-
tional Gallery of Canada) is like art in apartheid. We're
being kept in an artistic reserve, away from English and
French culture.[4]

Primitive art — a pretext for enhancing modernism?

As the Museum of Modern Art's (M.O.M.A.) *Primitive Art* show,
curated by William Rubin in 1985, and the Centre Pompidou's more
recent *Les magiciens de la terre* (1990) demonstrated, primitive art from
all regions of the world is a precious commodity sought after by
curators and museum directors alike. Primitive art — exhibited in the
world's vanguard venues in blockbuster shows — fulfils a need that
our own art cannot. It broadens the meaning of formalist history
without actually revising or changing it. Primitive art thus becomes
sine qua non - just another decontextualized museological object
designed to demonstrate the power of modernism, not vice versa. In
M.O.M.A.'s *Primitive Art* show, primitive became a pretext for enhanc-
ing modernism at the expense of primitive culture. Western artists
were presented in the guise of seers, adding something extra to the
equation of primitivism. In the massive two-volume catalogue that
accompanied the show, William Rubin juxtaposed Picasso's *Girl Before
a Mirror* (1932) with a west-coast Kwakiutl mask. He inferred that
Picasso's poetic license, his modernist interpretation, was evidence of
a superior "instinctual" capacity to have the same creative insights as
a heretofore unknown native carver in painting a split mask form.
Rubin states: "Picasso could almost certainly never have seen a
'sliced' mask like the one we reproduce, but it nonetheless points up
the affinity of his poetic thoughts to the mythic universals that the
tribal objects illustrate."[5] In *Art & Otherness* Thomas McEvilly sug-
gests otherwise:

But most of the world's mythological iconographies
have the image of the face with light and dark halves.
Picasso has surely encountered this common motif in a
variety of forms — as the alchemical Androgyne, for ex-
ample. There is, in other words, no particular reason to

connect his *Girl Before a Mirror* with Kwakiutl masks, except for the sake of exhibition.[6]

This perspicacious kind of tinkering in art history couches a cultural bias in vague, unproven comparative analyses between works from different times and places, decontextualizing culture. To the advantage of art history and the detriment of anthropology, *Les Magiciens de la Terre*, exhibited at France's flagship museum the Beaubourg in Paris, literally juxtaposed contemporary works from underdeveloped countries alongside the West's postmodern stars, providing a postcolonial perspective on both. While works from marginal cultures were expansive in their thematic and material approach, the Western superstars, including Canada's own Geneviève Cadieux, Barbara Steinman, Jeff Wall and John Massey, with the advantage of their greater global knowledge of art were given top billing. Primitive or tribal ideas could be appropriated by the Western artists because they had greater access to historical and contemporary examples of "primitive" stereotypes. Third-world artists simply created works as a response to their indigenous culture. Our aesthetic traditions are so exhausted by materialism that today's curators must look beyond the West's narrow aesthetic traditions in order to legitimate an absence of spiritual values. North American native art has likewise become a subject for Canada's contemporary curators by default. Because it is not modern in formal art history terms, native art becomes contemporized by comparison with Western modernism.

Art with a small a — Native with a capital N

Canada's own recent shows presented works by natives as art with a small a and native with a capital N. The *Indigena* show at the Canadian Museum of Civilization in Hull was a predictably orchestrated assault on traditional ethnographic attitudes to native art by the Museum's curators. Comprised of works by Lawrence Paul Yuxweluptun, Jane-Ash Poitras, Domingo Cisneros, Lance Bélanger, Eric Robertson, Joane Cardinal-Schubert, Mike MacDonald and Carl Beam, the show presented a kaleidoscope of politically and historically *engagé* works by natives —,genre postmodern. Traditional native art got a short shrift. There were no works by Norval Morriseau, Kenojuak or Bill Reid. Political and cultural truisms of the postmodern variety were given the most attention. Some luminaries of the new conservative curatorial ethic such as Jean Fisher feel free to say that:

It must be admitted from the outset that Native Americans are peoples about whom we can have nothing to say that is not totally fatally contaminated by Eurocentric patterns of thinking. The vast body of "objective" data, scientific or literary, that purports to evidence indigenous Americans almost invariably constitutes a mirrored reflection of our own psychic demons instead. For "knowledge" is a matter of interpretation, which is in turn a property of the subject who assumes it, not of the object itself.[7]

However, they offer few solutions for the native and non-native cultural impasse but politics with a capital P. While natives may occupy curatorial positions at the Museum of Civilization, how many curate at M.O.M.A. or the National Gallery of Canada? Instead of gaining greater insight into the new generation of native artist's links with their predecessors, *Indigena* set them apart from their native cultural context and put into the ahistorical box of modernist aesthetics — the non-native paradigm of formal history that drives our museums. If belief structures must indeed be political, then we must not forget that the basis of Western politics is no longer culture, but our economic structures. As such, the *Indigena* show read like a postmodern parable on post-colonial and post-native America.

In *Indigena*, Lawrence Paul Yuxweluptun's near-surrealist *Red Man Watching White Man trying to Fix Hole in Sky* (1990) combines fluorescent and bright, unnatural colours with Coast Salish design motifs embedded in the mountain background of a three dimensional landscape scene. A skeletal caricature of a native person looks on in an otherwise empty foreground. To the right, two men in white lab coats have emerged from a hole in the earth to stand precariously on a quasi-mechanical contraption. They are trying to replace a hole in the sky with a patch of blue. Like repairmen for God, these ludicrous scientists are a symptom of a rational, technocratic society whose reasoned efforts to solve problems inevitably create a new found set of problems.

Joane Cardinal-Schubert is an Alberta-based artist whose work inadvertently questions our culture's need to appropriate primitive and third world culture into our art, music, theatre and writing. She presented an installation piece for *Indigena* titled *The Earth Belongs to Everyone II* (1992). Expressing her belief that all specific cultures must strive to maintain their own distinct identities independent of economic tautologies, the piece alludes to the nuclear accident at

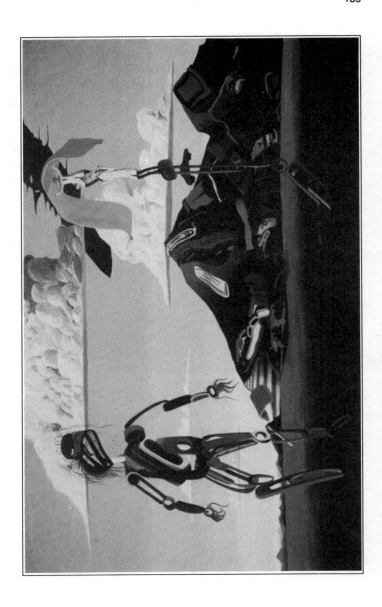

Yuxweluptun. *Red Man Watching White Man Trying to Fix a Big Hole in the Sky*, 1990. 142.24cm x 226.06cm. Acrylic on canvas. Exhibited at *Indigena*, Canadian Museum of Civilization, Hull. Photo courtesy of the artist.

Chernyobyl. Cardinal-Schubert's hybrid narrative on this tragedy is illustrated by a Utopic landscape whose skies are engulfed in flames, encased in an artificial dome of blue sky. The four painted plaster "stones," superstitious talismans or site specific markers that support the main canvas, make this appear an endemic, not a mediatic experience. A second canvas on the floor adjacent to the main wall piece reverses the order of sky and earth present in the main piece.

Eric Robertson's superbly crafted copper ceremonial hats and surveyor's measuring table in the *Indigena* show were an aesthetically readable recipe for our historic malaise of human cultural and resource exploitation. *A force de Terre 1* (1991), Domingo Cisneros' installation was created from the hides and bones of animals he hunts for food near his home in Québec. Hanging from rusting chains and sitting like carcasses on the floor, these remnants project an unsettling energy, a ritualized representation of the endless cycle of life and death. Jane Ash-Poitras, a Cree from Fort Chipewyan in Northern Alberta hurls a postmodern mix of media symbols, painted slogans, pictographic animal representations and abstraction at us in a pot pourri of half-baked styles and incanted political redundancies that are as didactic and copious as they are schooled in the white culture's formalist language of art. Lance Bélanger's *Lithic Spheres* (1991) — an agglomeration of mysterious gold and silver balls placed within a dissembled, gilded picture frame — is a haunting, yet beautifully poignant work. The exhibit recalls the mysterious lithic spheres found in the burial sites of the Taino people from Hispaniola in the Dominican Republic. The Taino were decimated through starvation, genocide and slavery within fifty years of contact with European culture. *Lithic Spheres* becomes a two-fold comment on the European colonizer's so-called Romantic sensibility in art and their utterly duplicitous insensitivity to the culture of the indigenous Taino peoples — one of the best works exhibited at *Indigena*.

Pierre-Léon Tétreault's *New Territoires: 350/500 years after*, exhibited in 1992 at the Strathearn Centre, Loto Québec, and at four of Montréal's city-run *Maisons de la Culture*, was comprised of an eclectic mix of traditional and socially relevant works by forty-three Inuit and native artists from Québec, the United States and Mexico. It was the largest exhibition of contemporary Native Canadian artists ever shown. Born out of the ashes of the Oka crisis in Québec, the event was a serious attempt to reestablish fragile links between native and non-native cultures in Canada. In the midst of the Canadian federal government's constitutional negotiations with native peoples over the right to self-government, the show's timing could not have been

better. Though the quality of the works varied greatly, it provided an opportunity to see the very real discrepancies that exist between postmodern and tribal art together at one and the same place.

Peter Morgan's carvings in *Nordic activities* (1988) shown at the Strathearn Centre for the *New Territories* exhibit, represents the work of an Innu sculptor at one end of the intra-cultural spectrum, whose people have been in continuous contact with white culture for less than fifty years. Following the form of a set of caribou antlers, Morgan carves reliefs of birds, seals and traditional Innu spirits. His piece is an eloquent, passive interpretation of traditional Innu hunting and gathering culture. By way of contrast, the Apache artist Veran Pardeahtan's abstract triptych of triangles of green stitched canvas titled *Self Portrait* (1990) seem quintessentially postmodern. The only clue to this work actually being "native" is a brightly coloured, traditional Apache baby blanket that hangs rolled up and suspended from a cloth loop below. For its formal, triangular composition and simple abstract presentation, Pardeahtan's work recalls the American abstract expressionist Barnett Newman's *Jericho* (1968-69). The relation is so similar that it causes us to reflect on the West's own abstract formalist traditions in art. Upon seeing an abstract work by an Apache — and being aware of Newman's paintings from the fifties and sixties — abstract expressionism seems less a modernist movement that broke from tradition, and more a cult that sought to recapture the sense of wholeness and spiritual unity that we still find in native cultural objects. While the abstract expressionist's ritualized expressions were created for an exclusive élite of museum and business patrons, the traditional role of native art was to fulfil a symbolic function within a collective culture. In present-day terms, do Pardeahtan's works remain native when their purpose and function have changed, mostly intended for gallery and museum exhibition?

Ojibway artist Glenna Matoush's seventeen-foot high totem, *Ain't our mother earth no more* (1992) also exhibited in the *New Territories* show — covered in bright, painted canvas sections from top to bottom — is as physically and environmentally immediate as a Pollock painting. The way she works with materials, texture and colour combines the influence of traditional native crafts sensibility, with a sensitivity to colour, light and movement. Unlike Jackson Pollock's abstracts from the fifties, Matoush's art cannot be categorized as subjective or abstract, "objective" or representational, and embraces an environmental reality. Her work is part of a tradition where working with materials in a creative way is inseparable from lifestyle. The modernist/postmodernist paradigm is averted completely.

Glenna Matoush. Untitled, 1993. Mixed media Photo by Paul Litherland.
Photo courtesy of the artist.

Eric Robertson's *Mo..ment* (1992) presented in a subsequent show at C.I.R.C.A. in Montréal is a purely postmodern parody of the current political and cultural situation in Canada for First Nations peoples. All that remains in Robertson's deconstruction of a historic monument to Paul Chomedy de Maisonneuve — the original founder of the city of Ville-Marie (as Montréal was originally called by the settlers) — is the pedestal and de Maisonneuve's boot. The tiny ship sailing off one of the pedestal's corners alludes to the flat earth theory of Christopher Columbus's era. Surrounding the work are four shoeshine boxes (functional sculpture), and pieces of slate with photo fragments of the original monument — obvious references to ongoing cultural oppression in a postcolonial era.

America loves its Indians!

The most successful of all the native art shows in 1992, the National Gallery of Canada's *Land, Spirit, Power*, presented Native art as it should be presented: the best works by the best artists, yet nevertheless postmodernism reigned supreme. Dempsy Bob, a northern British Columbia native whose painted carvings use traditional native transformation symbols — raven, frog, wolf and man — continues to create works for his native friends, even though most of his pieces go to museums and collectors in the United States, Japan, England, Germany and Canada. His works are a response to the characteristics and feel of the wood he carves with. While Dempsy Bob's works are characterized by traditional motifs, he admits that each work must be original, a new form. The idea of simply recreating traditional motifs and symbols has been supplanted by the notion of originality — a Western conception. For one recent work titled *Raven Panel* (1989) he used a mirror, something a native would not traditionally have used for sculpture, for which he received some objections. His reply was that in the next century it will similarly be considered historic or traditional.

The lines between our own linear, historical archetypes of an art of progress and native people's eternal recreation of heritage are now blurring, and becoming supplanted by an interactive vision. Truman Lowe's *Ottawa* (1992) is as open in its approach as it is surprising for its economy of expression. The flow and flux of elongated bands of wood that move in undulations down a sloped wood construction recall the movement of water in a stream or a river. Beneath these saw cut pieces — and partially concealed beneath the support structure — are eight stripped tree limbs that hang upside down from eyelets.

In Lawrence Paul Yuxweluptun's *Inherent Rights, Vision Rights* (1991-92), a virtual reality installation, the viewer wears an electronic helmet to see visual recreations of a native longhouse and a mask with a tear on a video screen. A control lever allows the viewer to move through the environment. Synthetic environmental sounds accompany the piece. Hachivi Edgar Heap of Birds' *Neuf Painting* (1991) are interconnected areas of pure, bright colour whose jagged edges suggest the movement and the energy of plant and animal life. Contrasting these purely visual expressions of joy are paintings that link together word associations such as: "Laterine Hats," "Your Sport," "Death From the Top," and "Relocate Destroy."

Jimmie Durham's eclectic brand of Cherokee postmodernism was exhibited at the Canadian Museum of Civilization in a show titled *The Bishop's Moose and the Pinkerton Men* (1991). The centrepiece of that show was a moose head Durham recovered from a trash heap near the Cathedral of St. John the Divine in New York — purported to have been previously owned by the Bishop of the Cathedral. This "trophy" had only one antler, the other consisted of plumbing pipes. Presented and poised on a constructed wooden scaffold, the moose alluded to a modernist desire to project a "cultural" vision of nature. This wild animal, killed and then stuffed, exhibited and finally thrown out — this recuperated artifact — reified a colonial attitude to nature.

Never native in the sentimental or nostalgic sense of the word and always contextually current, Jimmie Durham's contribution to *Land, Spirit, Power*, titled *Proceeding* (1992), was made up of a series of loosely assembled plastic water pipes whose ends exposed a Duchampian mixture of incongruous, yet mysterious recuperated objects: a glove, bones, porcupine quills, a shoe, shovel, horn, hair and two plastic vanity mirrors. Durham explains:

> I am a Cherokee artist who strives to make Cherokee art that is considered just as universal and without limits as the art of any white man is considered. The problem lies within this society's myopic vision of itself and what is universal. My Cherokee use of object, form, space and meaning is as deliberate, sophisticated and universal as are anyone's use of the tools. If I am able to see both Cherokee art and all other art as equally universal and valuable, and you are not, then we need to have a serious talk.[8]

For *Mawu-che-hitoowin: A Gathering of People for Any Purpose* (1992), Rebecca Belmore reconstructed the interior of a kitschy kitchen around which a variety of dilapidated chairs were arranged on a blue plywood floor with flower and leaf patterns sprayed onto it. In the earphones that accompany each chair we hear a native woman recounting her views of life in the community. James Luna's *The Sacred Colours are Everywhere* (1992) injected an element of Warholian humour into an otherwise serious show by presenting four sets of non-Native underwear in the traditionally sacred native colours on clotnes hangers. The display had the distinct look of a Benneton advertisement gone awry. Among many other cultural extravaganzas, Luna's *Take Your Picture with an Indian* (1991) at the opening of the newly renovated Whitney Museum in New York, involved his wearing, in turn, street clothes, a breechcloth, and a "war-dance" outfit. Visitors were invited to "take your picture with an Indian" over the public address system. As Luna says, "America loves its Indians" — and they did.

The art of the postmodern era perceives culture as something which can not be measured from within culture. Essentially subjectless and self-transcending, its paradoxical viewpoint mitigates against any belief in original culture and favours cultural relativism. Ron Hamilton, a Nuu-chah-nulth poet and artist clearly expresses the postmodern dilemma in native terms:

> *Lately the rule is, "Don't interpret!"*
> *It's all art now.*
> *But that's an interpretation,*
> *Not ours.*[9]

Postmodernism rejects beliefs in hierarchy, progress and the idea of a centre. As such, it rejects tribalism and cultural distinctions and denounces any real mythology in favour of a saccharine — all too accessible — aesthetic correctness. As Charlotte Townsend-Gault states in *Kinds of Knowing*, her essay on native cultural perspectives that accompanies the National Gallery of Canada's *Land, Spirit, Power* exhibition catalogue:

> In the end, cultural difference is expressed not by attempting to find common ground, common words, common symbols across cultures. It is finally dignified by protecting all sides from zealous over-simplification, by acknowledging a final untranslatability of certain

concepts and subtleties from one culture to another. Despite the immense generosity, the ethical injunction to share, and the holistic, animistic philosophies that are essential to aboriginal societies across North America, self-definitions rooted in cultural distinctiveness must retain their untranslatable difference.[10]

Notes

1. François-Réné de Chateaubriand, *Atala*, trans. by Rayner Heppenstall, (London: Oxford University Press, 1963), pp. 62-5.
2. Loretta Todd, "Notes on Appropriation," *Parallelogramme*, XVI:1 (Summer 1990), p. 30.
3. Eléonore Sioui Jikonsaseh, *Andatha*, (Val d'Or: Editions Hyperborée, 1985), p. 24.
4. Carl Beam cited in conversation with John Grande, September 23rd, 1992.
5. William Rubin, *Primitivism in 20th Century Art: Affinity of the Tribal and the Modern*, (New York: Museum of Modern Art, 1984), pp. 328-30.
6. Thomas McEvilly, *Art & Otherness*, (New York: McPherson & Co., 1992), p. 40.
7. Jean Fisher and Jimmie Durham, "The Ground Has Been Covered," *Artforum*, XXXVI:10 (Summer 1988), p. 101.
8. Jeanette Ingberman et al., *Jimmie Durham: The Bishop's Moose and the Pinkerton Men*, (New York: Exit Art, 1989), np.
9. Ron Hamilton, "Box of Darkness," *B.C. Studies*, op. cit. pp. 62-64.
10. Charlotte Townsend-Gault, "Kinds of Knowing," *Land, Spirit, Power*, (Ottawa: National Gallery of Canada, 1992), pp. 100-101.

11

Prelude or Requiem?

Postmodernism has buried the sacred role of art: its iconic, spiritual significance as beacon of beingness has been hidden beneath a barrage of materialist metaphors, didactic statements, and affirmative narcissisms. The fragmentary idiom of postmodern art parallels the dissembling of personal and social identity in our society. This is a direct result of our identification with consumerism — the materialist values that leave us feeling somewhat empty, looking for something else. As we approach the end of the millennium, we are thinking twice about the role of art in society. Its place has become so intertwined with economics and the market itself, that it is now seen more as a vehicle for storing investment capital. Meanwhile, its intuitive meaning diminishes. For this reason, it was a relief to hear that Claude Gosselin, Director of the Centre internationale d'art contemporain (C.I.A.C.), chose the global issue of art and the environment for the 1990 *Savoir-vivre, savoir-faire, savoir-être* show at La Cité in Montréal. If any cause célèbre could offer both artists, and society as a whole, a way out of our current malaise it is this one — the environment. As Gosselin noted, all twenty-six artists invited to participate in the show understand the notions surrounding ecological values in art and the importance of radically changing our approach to living, and to the material arts.

The ecological banner carries its own truisms and excessively rigid orthodoxies along with its good intention. Though still in a process of formation, these truisms can lead to didactic statements being made in the name of a "good" cause, reinforcing the historic and economic biases already in place. If art is to really help in leading us to restructure our global economic order in an ecologically responsible way, it can only happen if we sacrifice our traditional approach to what artistic expression is, or will be.

Among the superstars included in the show were Joseph Beuys and Buckminster Fuller, both of whom are no longer with us. Fuller's futuristic vision was part of the first wave of ecological activism, combining Utopian ethics with a practicality born of a solid engineering background. Fuller placed great faith in humanity's technological capacity to overcome the obstacles embedded in our habitual ways of designing society. As we look at his structural designs — his famous

geodesic domes at C.I.A.C. — they seem the very embodiment for humanity's capacity to overcome the limitations of using non-renewable resources and redefine our habitable spaces. His work influences us in wondering what force of habit has stopped us, in the face of all the signs, from beginning to take major steps in restructuring our physical and social landscape.

Joseph Beuys was a widely different sort of artist. He was committed to the happening. He used the social event as a way of bringing social and environmental issues to the attention of the public at large. The videos, mementos and photo silkscreens of Beuys at work were a testament to his awe-inspiring faith in "direct democracy," the ability of the individual to take action in his immediate society even if it meant simply planting trees on a hillside. Beuys' vision was one of the last which placed the artist in a God-like realm — as omnipotent and able to compete with science in serving to direct our social vision towards action.

Jimmie Durham, a Cherokee artist who now lives in Guernavaca, Mexico, attracted a lot of attention as the 1990 siege at Oka continued a stone's throw from Montréal during the run of the show. His fetish-like sculptural pieces, dreamy and fantastic, as well as his mixed-media works on paper (one of which realizes a dream in which he foresaw using butterfly wings in an art piece and then did so), go to the heart of the artist's dilemma of walking the tightrope in dealing with the histrionics of avant-gardism in Western art at the same time as questing for completely new approaches to a living ecology of art. The reasons are purely cultural. Durham views material objectively, as a facet of life to be integrated, not appropriated, into the artist's expression.

Contrastingly, Francine Larivée's *L'offrande* (1990) arranged living grasses and mosses atop a series of wall-mounted metal disks and a central podium form. Larivée fashioned her natural living appendages into design-like pieces that look like they are meant for a naturalized living room of the future. Instead of integrating her art into a natural setting, Larivée reversed the order by appropriating nature and integrating it within the framework of traditional architectural design. Her work altered our perception of living elements and made us consider their potential as part of a more holistic living space, instead of neutral elements to be relegated to plant pots and patios in the home or museum space.

Ashley Bickerton's *Biofragment No. 2* directly addressed the dilemma of art's appropriation of nature by making us look in on living coral matter through a kind of incubator. As he said:

Our understanding of the natural order depends on our
interaction (or lack of interaction) with it. Our repre-
sentations of nature have always been tied to the use we
have made of it. Western culture has too often likened
nature to a property or a resource. This attitude now
seems to be changing. This group of works infers that
no glance cast on nature is innocent, disinterested —
whether nature is seen as a product or a museum. In the
United States, the talk is no longer about how nature
treats us, but how we treat it. And what do we still call
nature at this time of genetic transformations, waste
management, desertification and "natural" frozen fruit
drinks?[1]

Dominique Blain's *Untitled* (1990) piece was well versed in the art
of mechanical reproduction. It presented a series of colour
transparencies of people within a smooth architecturally gothic
framework. Its hierarchic arrangement carried faint echoes of a
religious altar or church arrangements. It was pure and unadul-
terated, yet the way she approached her art as process was basically
social, mediatic. Somehow it all looked too clean and self-conscious,
as though reifying the godliness of all artistic endeavour by removing
any human traces or passionate expression from the work.

Robert Filiou's idiographic tautologies comprised a series of
diagrams and linear mechanical drawings whose sole intention
seemed to be (perhaps inauspiciously), to launch an attack on the
very spirit of poetry. He did this without any conscience, failing to
recognize the realities that guide our individual experience. It was
as though all the world was merely a mechanical model driven by a
T-square.

In *Varrioota's Daydreams After His Escape from Aroona Homestead*,
Nikolaus Lang's bleached white pulp pieces, cast directly from a tree
trunk, languished beautifully across the gallery floor. Behind them
was a large-scale print taken from the inked bark of a tree that was
also part of the same art work — inverting the process of printing by
directly reproducing nature in another medium. Traditionally, bark
paintings were made in Tasmania and southeast Australia, but the
best were made in northern Australia in Arnhem Land. Those il-
lustrating everyday events, animals of the hunt and non-sacred
myths were painted on the inside of bark shelters during the wet
season. Others were made to explain ideas to younger members of
the tribe. Still others were incorporated in sacred rituals and

destroyed after the ceremony.[2] Nikolaus Lang's use of tree bark as a medium works in reverse to the Australian aborigines' by neutralizing any iconographic significance and using the skin or vessel of a tree itself as metaphor for the life (and art) process. These pulp prints reveal the engravings of the scars of insect ravages on trees and the tree's own bark patterns: examples of the many aesthetic forms achieved by nature itself. An open and honest work, it suggests that art can play a positive role in reducing our anthropocentric attitudes to nature. Our appreciation of cultural diversity increases the more we recognize our mutual, permacultural sense of place as individuals within the Earth's ecosystem. East coast artist John Greer's *Reconciliation* (1989) was in a similar vein, but was a super-realist reconstruction of a leaf. It was expanded to an oversize scale with surrounding seed pod forms, cast in bronze and supported on a wooden beam. Like Lang's piece, Greer's work is moving in an honest direction, one that relieves the artist of a lot of the unnecessary and overbearing didactic conceptual baggage we see so often in the galleries these days.

Japanese artist Saburo Muraoka's haunting "fly machine" is the most eclectic example of entomology in art I have ever seen. The cold, prison-like metallic cube of Muraoka's contraption became a living space for flies, which he fed for three weeks. At that point they had reproduced to number 385, providing a strong comment on the limitations nature places on the natural reproduction of selective species. The only selection lever in this post-Darwinian production machine is the food supply. After Muraoka halted their source of nourishment, they didn't live very long.

Fastwürms is a Toronto-based, three member collective of artists (Kim Kozzi, Napoléon Brousseau, and Dai Skuse), a society in microcosm best known for their *Birch Hive*, a temporary art exhibit installed beside the CN tower in Toronto in 1989. As Kim Kozzi's affirms: "We have a real responsibility to bring information back, and to reconstruct systems based on what we see out there."[3] Human in scale, the *Birch Hive* reflected a more mutual, equitable approach to human culture's relation with the ecosystem. The structure offset the anonymous oversized scale of the urban core of Toronto's skyscraper architecture surrounding it. From within the hive, Fastwürms projected a low-frequency magnetic field tuned to the natural frequency of the earth — 7.83 cycles per second. Designed to deflect the man-made stress-producing frequencies of radio transmissions, the fifteen foot high hive was built out of birch bark and copper wire. It was spot-lit from within, refracting filaments of light through thin

John Greer. *Reconciliation* (detail), 1989. Wooden post supporting bronze leaf. Photo by Guy l'Heureux. Photo courtesy of the Centre international d'art contemporain, Montréal.

slices of mica, while a coniferous tree crowned the piece. Their idea for *Onze Bezoins*, was conceived while Fastwürms were hiking in the mountains of Japan. At C.I.A.C., the viewer was confronted with a bewildering mixture of realism and high fantasy at the entrance to *Onze Besoins*: a Hydro-Québec logo, cheaply manufactured simulated wood wall panelling with repeated images of a rustic cabin scene, and a pious madonna that hovered in the air surrounded by a series of electric lights. Inside one could see planetary sketches of the Big Dipper constellation's diurnal movements, paintings that collaged different images together along the walls and a large cooking pot. The work stood out garishly in day-glo paint and ultra-violet lighting.

Todd Siler's completely synthetic canvas painted in unreal, highly unnatural colours made completely out of materials used in the nuclear industry. The statement, "Is this creation? Is this expression? It can't get much uglier. Is this artificial or physical?", was painted overtop the canvas, injecting some well-needed humour into the show. Siler's work holds a lot of meaning for this unresolved period in art, one that finds itself caught between the art market and sincere attempts at expressing art's meaning and purpose.

The most important art now being produced has not yet been recognized by the arts establishment. It is no longer addicted to all things ideational: word-text, Duchampian appropriations, eulogies to the manufactured object for and of itself, a rigid fixation on the avant-gardist game, an inbred narcissism born of a self serving art milieu, and an endless need replace one style with another, one artist with another, again and again in order to feed the market's endless thirst for something new.

New art doesn't have to rely on novelty items and gimmicks. Cultural preservation is no longer thought to be a threat to cultural integration. These changes are evident in a growing confidence with the intuitive use of materials, an acceptance of their origins in nature, and a quieter integration of art within a living environment. For this reason, it was fitting that the work seen when entering and leaving *Savoir-Vivre, savoir-faire, savoir-être* was Juan Geuer's *Prelude Qua*. Juan Geuer is an artist whose works de-emphasize the artist's visible role by using natural physics — light, magnetism, and even seismology — to universalize our sense of the lived experience. Geuer used elements that cannot be controlled, bought or appropriated, but merely interacted with; comprising a part of nature which plays the role of collaborator in each piece. Geuer's previous "light trap," are site-specific works that used Lexan, a transparent material curved into the shape of cones and installed out of doors. Sunlight is captured and forms

part of the visual effect in the cones, injecting a poetic element whose evanescent character is the very essence of being. *Prelude Qua* consisted simply of a mirror on a stand that pointed to the glass wall beside it, on which the trapezoid shape of the view it encompasses was marked with tape. As we stood in front of the piece, it was not the architectural skin of the building that we could see, but instead a green leafy tree, the sky, and the immediate environment outside. As Geuer says:

> Rationalizations, however poetic and sophisticated, have a habit of failing us. But no matter how many philosophies we have weathered, one thing appears certain, namely the frustrating awareness that there is an abyss between our consciousness and the world out there. That frustration has grown into a rage now that we are increasingly aware of our total dependence on what we are unable to fathom.[4]

If we chose to move closer to the piece we could even see ourselves.

Notes

1. Ashley Bickerton, cited in, *Savoir-vivre, savoir-faire, savoir-être*, (Montreal: C.I.A.C., 1990), p. 2.
2. Aboriginal Bark Paintings from the Collection of the Art Gallery of New South Wales: North-East Arnhem Land - Maningrida, Milingimbi, Yirrkala, (New South Wales: D. West, Government Printer, 1981), p. 2.
3. Lisa Rochon, "Natural Inclinations," *Canadian Art*, Summer 1990, p. 61.
4. Juan Geuer, cited in, *savoir-vivre, savoir-faire, savoir-être*, (Montréal: C.I.A.C., 1990), p. 3.

12

Solid State Angels:
Contemporary Japanese Sculpture

A Primal Spirit. The title of this exhibition suggests something primeval, like ritualistic fires or Stonehenge's mysterious circle of monoliths; something so at odds with the visually complex, synthetic universe of our built environments and urban meta-technologies that we can't help but be curious as to the content of this show. Organized by the Los Angeles County Museum of Art and the Hara Museum of Contemporary Art in Tokyo, *A Primal Spirit* made its final stop at the National Gallery of Canada during the summer of 1991, giving many Canadians their first real look at Japan's current art scene. These sixteen mega-works by ten of Japan's most accomplished sculptors have nothing to do with the transistorized, hyper-materialist techtopia of Tokyo, with its crowded bullet trains filled with businessmen reading comic books or eating at sushi stands at lunch hour.

Any controversy this show aroused, on the contrary, resulted from the fusion of a vital modernism and ongoing respect for tradition. What stands out above all in these works is the vigilant perfectionism of the artists' craft and their near-censorial adherence to the use of elemental, natural materials: wood, stone, fibres, minerals and metal. Many Western artists, raised on an exuberant diet of consumerism and wilful self-expression, will consider these pristine works as a kind of aesthetic fence-sitting. Apolitical and anti-conceptual, devoid of any social or economic statement, they contain the spirit of their expression in the handling of the materials themselves.

Japan is a notoriously xenophobic island nation where the folk traditions of ikebana, bonsai, basket weaving, textile design and calligraphy are vital, yet outside the everyday world of work. The limitations of geography, resources, and individual space are exacting forces that have made the Japanese superb innovators, wise with natural resources. It was only in 1854, when Commodore Matthew C. Perry and the American fleet of Black Ships forcibly convinced Japan to sign diplomatic agreements that led to the opening of Yokohama. Until then Japan had been in a state of splendid isolation for 250 years, perfecting and refining its cultural traditions. Soon after, *Japonisme* had invaded Europe; *ukiyo-e* (floating world) woodblock prints, textiles, and

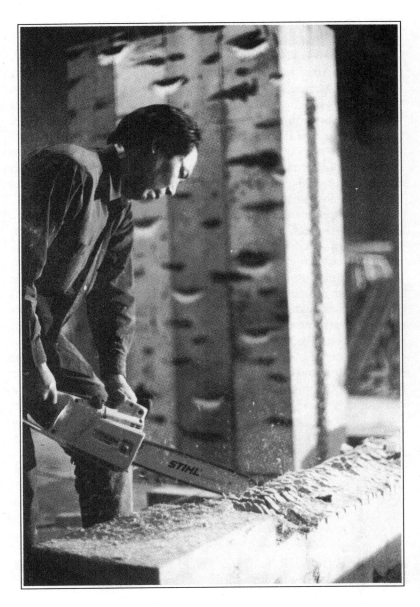

Shigeo Toya. Photo of the artist at work. Photo courtesy of Los Angeles County Museum of Modern Art.

folk art profoundly influenced numerous artists including Manet, Degas, Monet, Toulouse-Lautrec, Gauguin and van Gogh.

Contemporary mainstream Japanese art, operating out of a cultural history that included Buddhist and Shinto religions, is largely apolitical and conceives the universe in different terms from the West. The Japanese language likewise has nuances and meanings that lose some of their meaning in translation. There was no word for nature before the reign of Emperor Meiji, at which point, the distinction between nature and culture was introduced. The world-view of Western culture markedly contrasts Shinto and Buddhist philosophies which are devoted to the guardians of life and custom and see the spiritual universe as a single indivisible manifestation of matter and spirit.

Contemporary art is seldom acknowledged by the broader public in Japan. Artists receive little in the way of public or private support. Japan is renowned for small, private galleries in which there is virtually no market for younger artists' work. They are often expected to pay all exhibition expenses and to arrange events themselves. Museums of contemporary art such as the Hara and Tochigi Prefectural Museum have only recently come into being, modelled on contemporary art museums in the West. The Japanese approach to art markedly contrasts Western art, where individualism is sacrosanct, a vindication of the ego's beingness. The material and philosophical culture of the West demands change and causes us to hunger for novelty. We consume the latest movement and discard the last with a near superstitious alacrity.

The first work one encountered on entering the exhibition by Takamasa Kuniyasu, was permeated with the smell of a forest interior. Like a cross between a woodsy David Mach installation and a Schwitters *merzbau au naturel*, constructed out of thousands of terra-cotta "bricks" and pieces of wood, it literally filled an entire room of the gallery. The way this interior land art work dimensionally carved and scaled the inner volumes of gallery space makes us feel tiny and insignificant.

Toshikatsu Endo's *Lotus* (1989) was less conscientiously barren in its idolatry of natural materials. This redolent circle constructed of massive wood sections, their surfaces blackened by fire, had an inner track of steel filled with water which could be lit to burn oil in a ritual flame. It projected a primeval feeling of ritual. Endo talked of the process involved in making his art:

> I am not sure whether my use of wood has any particular meaning. More important that the actual use of

wood as a material are the methods used to create forms from primordial substances ... I never think about bringing out the life in the wood, rather I use it as a substance to its fullest extent, and in the end I often burn the works to complete them. I think of this final burning as a form of burial, marking the completion of the work.[1]

Chuichi Fujii's massive cedar logs were vigorous, lyrical configurations — forms that seemed to be embracing in a slow dancing movement. Created by a process of cutting slices out of the main trunk and disguising the cuts, these giant trees were direct transplants from a mature forest interior that moved with a mysterious inner presence. As Fujii stated, wood is "no different from humans: it breathes air, it cries. If I am responsive to the wood, then it will also be responsive to me."[2]

Kazuo Kenmochi and Isamu Wakabayashi are two artists whose art seems to have the taste for singular idioms characteristic of today's international art scene. In Kazuo Kenmochi's *Untitled* (1990), photographs of industrial warehouse spaces were painted over with a fiery flair for instant Armageddon reminiscent of the German artist Anslem Kiefer's paintings. A central vertical construction of discarded floor segments pulled the construction together and upwards, heightening its eschatological feeling. Isamu Wakabayashi's installation was a hermetic memory. Two steel boxes in the centre exuded a smell of sulphur while shiny copper wall sections sealed the place in, furthering the Kafkaesque feeling of claustrophobia and containment by time and materials.

Shigeo Toya's *Woods II* (1989-1990), one of the most accomplished works in *A Primal Spirit*, combined the best of Japanese traditions in working with materials, and a natural facility for the international language of sculpture. Shigeo Toya commented that:

> In minimal art there is a clear and definite relationship between form and meaning, but I tend to wander between them. I want my work to be a place of encounter with something that is greater than I am.[3]

Woods II had a series of thirty vertical pillars of wood, roughly three feet apart, arranged in neat, linear configurations through which the spectator could walk. Carved, chiselled and embalmed in ghostly white with rivulets of paint that followed the course of the cuts and

Shigeo Toya. *Woods II*. 1989-90. Wood and acrylic. Thirty pieces each measuring 220cm x 31cm x 31cm. Photo courtesy of the Los Angeles County Museum of Modern Art.

curves (conscious man-made erosion marks), it resembled a silent forest in winter: sensuous, feminine and passive. The work awakened feelings of belonging, mystery and imagination, a natural dimension at once exhilarating and wholly uncommon to postmodern work.

Emiko Tokushige, the only woman represented in the show, created works out of palm thatch: an inherently light material whose physical bulk and texture have a living tension that threatens to jump out of its form. In creating these works she found herself engaged in a physical struggle with the material — pushing, bundling and binding it with rope until the size of the forms reached the limits of her ability to manipulate it. The final forms resembled the carcasses of beasts strewn over the gallery floor, creating a strong visual presence. Other studies in miniature, rope and twine-bound single palm thatch pieces, are more lyrical and playful. By contrast, Koichi Ebizuka's studies, in wood, leaving some sections untouched and others carved, seemed too clean — mere material studies. His larger installation, *Related Effect S-90 LA* (1990), constructed of wood and coal, contained evidence of Ebizuka's architectural training. Neatly arranged, with each element fitting the perspective and placement of the others, it presented a strong example of the classic Japanese mind at work: economizing space, relating elements, organizing and contrasting materials, textures and forms.

Kimio Tsuchiya's *Silence* (1990), assembled out of old "found" driftwood boards and magazines, was a beautifully reflective composite sculpture whose varied textures and colours had a cathartic and ultimately calming effect on the viewer. The natural origins of the wood and its later use were secondary to the idea that wood, as a material, has an inherent energy in the total context of life that could only be called sacred. For Tsuchiya, wood has a perpetual life of its own that relates directly to the human experience. Its life goes on regardless of its supposed transformation from living element to functional material, eventually returning to nature. Tsuchiya feels the value of the life of a tree is no different from that of human life and goes on to say that

> ... the human ego is such that people feel free to cut whatever trees they wish, to destroy trees they have no use for. Seeing this attitude in Japan, and in other parts of the world as well, raises serious questions about human behaviour. In using wood, I am questioning where we come from and where we are going, what it is to live and what it means to die.[4]

It was Tadashi Kawamata, whose site specific work, *Favela*, (1991) aroused the strongest public controversy both locally and nationally. The best known of all Japan's latest generation of artists, Kawamata has more recently worked in Paris connecting several adjacent roof-tops by creating one of his dramatic assemblages of wood. Intended to contrast the strict formalism of Cornelia Oberlander's reconstruction of a Northern Taiga landscape in which it was situated, *Favela* consisted of thirty-five wooden huts made from scrap lumber. Intended as a comment on the poverty-stricken shanty towns that have sprung up in Rio de Janeiro as a result of overpopulation, the Ottawa work seemed more like an exercise in pure political opportunism. Had this piece actually been constructed in Rio, Kawamata's "aesthetic" statement would probably have been ignored and the materials stolen to actually build homes.

Janet Koplos' recent book, *Contemporary Japanese Sculpture*, is the only comprehensive appraisal of current trends in Japanese sculpture to date. It presents numerous examples of alternate kinds of expression to those in *A Primal Spirit*. Urban artists, such as Ushio Shinohara and Ryochi Majima, appropriate materials to create high kitsch symbols of the garish reality of life in the modern-day metropolis, just like their Western counterparts. Koplos points to artists working in a more distinctly formalist vein, akin to Isamu Noguchi. Takeshi Tsuchitani and Kenjiro Okazaki are artists who use a variety of materials to create symbolic archetypes — forms whose aesthetic is less constrained by tradition. The contrast that arises out of this art is entirely different from ours. Koplos comments:

> While reductiveness is common, there is no Donald Judd type minimalism. The works retain individuality and evidence of touch, even in the most minimal forms. One sees almost no political work. Although some sculptors concentrate on social reality, they do not use the world as a source of data, and they do not make polemical statements. There is no Japanese Hans Haacke, no Japanese Adrian Piper.[5]

Japan has had some short-lived, aggressively avant-gardist movements over the years. The *Gutai Bitjutsu Kyokai* (Concrete Art Society) group, active as early as 1954, created kinetic sculpture, environmental work, paintings and performances that predated similar "happenings" in America. In their October 1956 manifesto, Jiro Yoshiwara writes: "To let material live to its utmost is the method to vivify spirit.

To enhance spirit is to guide material in the field of sublime spirit."[6] The *Mono-Ha* ("School of Things") movement (1968-1972) was intellectually led by Korean-born U-Fan-Lee, who stated at the time:

> The highest level of experience is not to create something from nothing, but rather to nudge something which already exists so that the world shows up more vividly. An artist's work is shifting the "as it is" to "As It Is."[7]

One of Mono-Ha's earliest pieces by Nobuo Sekine, titled *Phase-Mother Earth* (1968), resembles Italian Giuseppe Penone's outdoor installations. It consisted of removing a cylinder of earth from the ground and placing it on nearby ground and later returning it to its original condition.

Contemporary Japanese sculpture has progressed rapidly over the past decade. It is now a vital embodiment of the eclectic and multifaceted forces at work in Japanese society. The insular traditions which so recently have opened up to international influence provide their sculptors with an enthusiastic capacity to work with natural materials as well as technology in a way that does not preclude tradition. Instead, it makes us see modernity in an entirely new way, as an extension of cohesive traditions, rather than as something which endlessly replaces itself, destroying its own past. For this reason it seemed entirely fitting that as a follow-up to *A Primal Spirit*, the National Gallery of Canada invited Tatsuo Miyajima, a Japanese artist who uses technology, not nature, to present his latest work titled *Two Thousand Road* (1991) as part of their artist's project series. The work consisted of two eleven-metre long parallel tracks of luminous digital counters arranged along the floor in a darkened room. It projected a series of electro-luminescent, paired numerals in sequence, numbered from one to ninety-nine and then returning to one. The effect of the work was hypnotic. As the rhythms repeated themselves, moving at varying speeds, they projected different conceptions of time — linear, cyclical, and relative.

In the 1994 installation, *Landscape in Silence*, for his *Provenance: A Fragmented Silence* show at La galerie d'art du Collège Edouard Montpetit in Longueuil, Kimio Tsuchiya worked with glass, ashes, roots, a dome-like structure and books. His use of materials was remarkably different from his earlier "found" wood assemblage works such as *Symptom* (1987), an inward spiral of joined tree branches, or *Silence* (1990) presented in *A Primal Spirit*. Tsuchiya once commented: "Even when a tree has been cut, it is still a tree. Even

when it burns to ash, as ash it still has life. It is from this point that I want to consider and create art."[8] What has brought about the shift in Tsuchiya's latest work? It is a question of both context and intent. Kimio Tsuchiya's aesthetic explores a society where materials, spaces and sites in the urban landscape are temporary and constantly changing. His latest pieces involve the ritual of burning the detritus of an architecture of consumption into cinders.

Tsuchiya began transforming recuperated wood from demolished buildings into cinders after seeing a child's dictionary left inside an abandoned building. The immediate sensation he experienced in the skeletal remains of a once lived-in building was like what one feels on the death of a close relative or friend. The lifeless body is there but something is missing. Is it truly possible to know past experiences that are not our own in an absolute sense?

Tsuchiya's work suggests that Japan's foreword-looking economic momentum is the product of social conditioning and market forces. There is virtually no instinctual memory of what he calls "the forgotten cycle of civilization." Collective amnesia is the result. The vast accumulations of records, books, ideas and images that bear witness to the destruction of living cultural knowledge and experience are now objectified like any other consumer product. At the same time as stored information grows exponentially in bits and bytes, the individual is stripped of any creative, ethical or socially responsible role he or she could potentially have. Historical time is flattened out and rendered generic by the digitization of meaning. Our ritual sense of experience, and personal relation to nature, the source of our deepest creative feelings, is lost. Architecture into ashes thus becomes a metaphor for the individual's relation to eternal time, involving Tsuchiya's own quest for self-discovery through the materials he uses.

Landscape in Silence (1994) is a work that is consists of a semi-domed structure of haphazardly welded metal forms, some of whose openings or "windows" are covered over with various types of rippled, frosted, clear or opaque glass surfaces, while others are simply left open. For those who have visited Japan, the effect brings to mind the *shoji*, a screen that separates the balcony of the traditional Japanese home from its interior. When the *shoji* is closed, the balcony is outside the home. When open, it is part of the interior space. The dome, with its reflective glass sections and openings, becomes a living skin that simultaneously presents an interior and exterior view of the ghostly white ashes and tree roots inside the piece. The manner whereby Tsuchiya transforms wood into ashes, incinerating it many

times over until it is a pure white colour, recalls purification ceremonies associated with burial rituals in many societies. While his process could be seen exclusively as a comment on an architecture devoted to planned obsolescence, Tsuchiya's ritual relates as much to an inner, bodily sense of self as it does to the outer, structured world of the modern city. The borders between existence and non-existence become relative. The house is not only a body but also an idea. The cinders Tsuchiya brought with him from Japan have not only been subjected to the ritual of material transformation, but were also ritualistically installed before being superimposed within a structure resembling a hemisphere of the world.

Landscape in Silence is a paraphrase for nature's eternal presence in a world we think of exclusively in relation to human civilization. The windows of *Landscape in Silence* were not standardized, but eclectic and varied like the haphazard growth of the modern-day megalopolis. They were also as rigid and brittle as the windows or screens of technology, reflecting the legacy of humanity's global pursuit of progress. *Provenance: A Fragment of Silence* suggested that it is not just capitalism that has led us to mismanage our global environment, but the way we undervalue and alienate ourselves from nature. As Tsuchiya says, "One talks of people consuming nature, but people are also consumed by technology."[9] The tiny fragile root structures placed inside the piece and covered over with ashes are a burial enacted within a human context. The burial signifies death, transformation of the body, and the soul's return to the highest plane of being within the social hierarchy.

The movement from material existence to non-existence is something we do not often consider in a utilitarian society. As we go about our daily lives, acting and reacting within the modern context, we are distant from our own origins and place in nature. An economics of progress conditions us to objectify the world around us, not seeing it for what it really is. By placing ashes on top of tree roots, Tsuchiya simultaneously alludes to the inviolable laws that govern the cycle of nature and our material origin in nature, both cultural and physical. Each of us eventually returns to the earth and, like Tsuchiya's cinders, will be buried like these ashes inside the house we all inhabit: the planet Earth. Can we truly know ourselves in relation to cyclical time if we deny our essential connectedness to all kinds of matter of which we are also a part? As beings who temporarily inhabit the earth, our understanding of an existence that is not object-based is a perplexing one because it defies the notion of continuous time. This question seems central to Tsuchiya's work.

The shape and form of the second Tsuchiya exhibit in Longueuil, *Proto-landscape* (1994), was circumscribed by a layer of cinders. The work had no exterior structure and represented the shadow of a house that once existed. The dates 1965-92, projected onto the piece from above, bear witness to the brief life span of this once lived-in, now-demolished structure. Tsuchiya considers the shadow of a house and its actual physical structure to be inseparable. Like seeing the shadow of a leaf on another leaf in a forest, this notion involves recognizing each element's relative relation to another in a given environment. One would not exist without the other. Books, sacred texts Tsuchiya gathered from different countries around the world, are randomly strewn and buried among the ashes so that we can only guess at their actual form and content. These books represent both a spiritual link between past and present and our ultimate physical vulnerability in relation to absolute truth. The cinders act as a mask that smothers the material manifestations of our religious and cultural heritage. Tsuchiya's suggestion is that the pragmatics of progress have deadened our sense of ritual, weakening our natural sense of social propriety and creating a moral and ethical void in which our sense of the holistic context of experience suffers.

Kimio Tsuchiya's work suggests that ritual can build a bridge between these two separate sides of our world, between our physical self and metaphysical other. Nature is still there, a constant reminder of the resilience of the spirit in the face of all this. Each of Tsuchiya's twenty-five pen drawings on ordinary correspondence paper in *Drawings for Ashes* can be seen as complete within themselves — particularized, atomized, yet universal or as part of the whole diamond-shaped assemblage. They can be considered in the Greek sense of *agape*, where subject and object are dissolved. As Hilary Thompson states:

> You can cut a square in the universe and you stand on the bottom of that square and you call what's on the other side of the window "nature." But where are you going to cut that square? At the molecular level, and you see the entrancing dance of molecules and flashing electric skins and light that at another level might be pollution. This beautiful vision you are having of the dance of molecules in nature might be a New Jersey toxic dump! But inside it, at the molecular level, it could be wonderfully natural! Or, you could be at the level of a supernova, exploding and creating havoc, and that can be nature too.[10]

It is a notion that nature, perhaps better than humanity, deals with realistically.

In modern society choices are constantly being made for us about the nature, intention, structure and context of our environment. Technology alienates us from our inner selves and conditions us to become passive receivers instead of transmitters of social and cultural experience. Our personal and collective memories are destabilized by this process. The social mirror of our own identity becomes distorted.

Human needs are as primordial, immediate, environmentally sensitized and reactive as ever. The earth is our house. It is as flexible and adaptable as time itself, but fragile as well. The rites and rituals of birth, childhood, initiation, adulthood and old age are disappearing to be replaced by a moral void of consumption and replication — of houses, ideas, meanings and products. There is no sense of time or element of social choice in the way we construct our self-image in society. Tsuchiya comments: "The loss of (physical) sensation is a greater threat to humanity than world disaster."[11]

Provenance: A Fragment of Silence, suggests we can only effectively come to terms with issues of social integration by recognizing the importance of cause and effect in constructing a picture of the world in which we live. This has to do with recognizing our place in the permanent context of nature.

Human will builds meaning out of experience regardless of the state of our social structures. As the third millennium draws near, the Western view that nature and culture are separate is, out of necessity, beginning to vanish. By identifying so strongly with natural materials and using them in an astonishing variety of ways, Japan's artists present us with an entirely different world-view; one that instinctively recognizes that what is cultural is natural.

Notes

1. Howard N. Fox, *A Primal Spirit*, (Los Angeles: L.A. County Museum of Art/New York: Harry N. Abrams, 1991), p. 55.
2. Ibid., p. 29.
3. Ibid., p. 103.
4. Ibid., p. 105.
5. Janet Koplos, *Contemporary Japanese Sculpture*, (New York: Abbeville Press, 1991), p. 16.
6. Jiro Yoshiwara, "Gutai Bijutsu Sengen," *Geijutsu Shincho*, December 1956, p. 12.

7. Koplos, op. cit., p. 42
8. Howard N. Fox, *A Primal Spirit*, (Los Angeles: L.A. County Museum of Art/New York: Harry N. Abrams, 1991), p. 105.
9. Kimio Tsuchiya in conversation with John Grande, June 10th, 1994.
10. Hilary Thompson, "Mind Jazz," in *Wild Culture: Ecology and Imagination*, Whitney Smith and Christopher Lowey, eds., (Toronto: Somerville House, 1992), pp. 179-80.
11. Tsuchiya, op. cit.

13

Anish Kapoor: Presence and Absence

Like the mysterious "butterfly effect" where the movement of a butterfly's wings could unleash a typhoon a thousand miles away, Anish Kapoor's art suggests that the hidden meanings of art are as elusive and mercurial as life itself. The tropes and ideotypes of postmodernism's reflexive search for meaning inadvertently decontextualize our relation to nature in order to eulogize the art object. Kapoor's enigmatic archetypes have less to do with the persona of the production, and more to do with the imagery of the collective unconscious.

Kapoor's art explores an aesthetic that oscillates between the pragmatic stereotypes of Western formalism and the enlightened spiritualism of Hindu mythology. As objects of perception, Kapoor's sculptures are sensual. They symbolize the hidden polarities that exist between our own unconscious inner associations and the sum of their primal energies: exterior form, colour, light and material/mass. Unassuming and open-ended, they mark the cross-over point between inner feeling and outer perception, yet are difficult to describe or define. Kapoor's aesthetic is relativistic and permeable, suggesting archetypal images that are universal — metaphors for the human body and its psychic transmitter, the mind. When cultural overviews are made relative, perpetuity itself becomes a relative value.

Western aesthetics are defined in relation to mass production by relying on notions of exclusivity, a mono-logic of individualism and a hierarchical view of history. Anish Kapoor's art moves in the other direction, toward a process of cultural inclusion where the mutability of materials is a sublime reflection of the endless flux and impermanence of the culture of nature, of which we are a part. Kapoor's naturalism is every bit as classic as the art of ancient Egypt because it reifies our relation to nature. He states: "I take an alchemical view of matter as being in a state of flux, progressing towards the spiritual. As an artist, one is helping it along."[1]

Our current crisis of inspiration is greatly linked to an ephemera-culture that views planned obsolescence and overproduction as the very icon of progress. Kapoor's art suggests that by working through materials *with* nature, artists have a major role to play in achieving spiritual healing, rather than merely exposing the wounds of civiliza-

tion. The original, integral forms we see in his sculptures engender a response that is as much physical as psychic. Like Magdalena Abakanowicz's *Great Ursa* — (1988) the haunting image of a partially sculpted tree taken from Poland's environmentally desiccated forests exhibited in her *War Games* solo show at PS1 in New York in 1993; Wolfgang Laib's pseudo-archaic wooden *Passageway* covered in beeswax seen at Sperone Westwater in New York in 3993; or Antony Gormley's *Field* (1990-93) of 42,000 terracotta figurines installed at the Montréal Museum of Fine Arts in the same year — Anish Kapoor's art is aimed at reinstating the age-old myths by which humanity identified with its place in nature by working directly with materials *as* nature. In this way, the specific origins of their initial context are revealed.

The Healing of St. Thomas (1989) consisted of a bright red, ogival scar of pure pigment cut into the walls overhead the entrance to Kapoor's show at the National Gallery of Canada. This was Kapoor's comment on architecture's inveterate capacity to distort and subsume the artist's original intended message. While the work's shape resembles the detached vagina symbol used to represent Kali, the Hindu goddess of fertility, it also alludes to "Doubting Thomas," the apostle who thrust his hand into Christ's side before accepting the validity of his resurrected appearance. There is no more obvious symbol of the structural paradigm of patriarchal history than architecture itself. Rational and pragmatic, its containment of space is hierarchical, yet Kapoor's architectural intervention is the absolute opposite: matriarchal, searching and wholly intuitive. It denies rational discourse and recalls tantric art, where bodily orifices represent openings to the inner body and mind.

A key element in Kapoor's imagery — the binary oppositions between maleness and femaleness — are also central to Hindu culture, where the feminine deity Shakti is perceived as the energizing female counterpart, or consort of the male god. Hindu theology perceives masculine potential as dormant, even dead, without the energizing force of the feminine.[2]

From a distance, *When I am Pregnant* (1992), appears as a faint shadow, or as slight variations of shaded patterns on a white wall. As we approach the piece they still remain indistinct. It is only when we look from a side view that we recognize that the wall itself has a contour like that of a pregnant woman, and that this voluptuous contour has given the shaded texture to the light surrounding it. When we look at it a second time from in front, we actually can read its form. The optical sensation is illusory, a symbiotic *trompe l'oeil* effect. The double symbolism of *When I am Pregnant* consists of the "male" structure of its

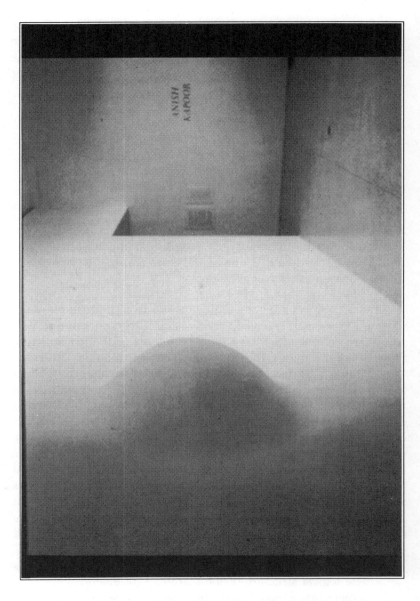

Anish Kapoor. *When I Am Pregnant*, 1992. Mixed Media. Photo courtesy of Lisson Gallery, London.

architectural wall support and the sensual fecundity of the female form affixed to it. Kapoor's associations allude to the "anima," the female side of man's nature that Carl Jung described as part of the universal assimilation of archetypes. In *The Development of Personality,* Jung writes:

> Every man carries within him the eternal image of woman, not the image of this or that particular woman, but a definite feminine image. This image is fundamentally unconscious, an hereditary factor of primordial origin engraved in the living organic system of the man, an "imprint" or "archetype" of all the ancestral experiences of the female, a deposit, as it were, of all the impressions ever made by woman ... Since this image is unconscious, it is always projected upon the person of the beloved, and is one of the chief reasons for passionate attraction or aversion.[3]

In one of Anish Kapoor's untitled works from 1991 we see a slab of rough hewn marble scaled to body height. The scales of Kapoor's works are conceived and executed *as they are*, without maquettes, blow ups, or the reverse: the scaled down neo-geo module. The iridescent, flat frontal surface that surrounds the slab's oval opening looks as thin as an eggshell. Our perception of the "inside" and "outside" of the sculpture is ambiguous. It works on two levels, what we can and cannot see. When we look within, we experience its womb-like quietude as an inner sensation. The calm calms us. At the same time we consciously formalize and identify with the contrasts between the finished and unfinished elements of its exterior shape. The shift from conscious to unconscious sensation, from presence to absence, is as much a physical, bodily sensation as it is ethereal. The hidden dualities of our own perception are relativized, yet never entirely reconciled. They favour a relativistic, rather than structural, view of emergence. Michael Polanyi writes in *The Tacit Dimension*:

> The logical structure of the hierarchy (of emergence) implies that a higher level can come into existence only through a process not manifest in the lower level, a process which thus qualifies as an emergence.[4]

This scientific point of view bases its analysis on the empiricism of individuation. Kapoor presents culture as an indivisible web of trans-

formative energies. Anything can be beautiful and timeless if the process is based on inclusion. As Kapoor states: "I don't want my work to be something or some time ... but all time."[5]

The term interactive is generally used to refer to works of art that use machines to initiate a process through sound, light, movement, or manually operated machine controls. These activations involve a one-way process, the withholding and controlling of "spontaneous" human action by machines. The artificial lighting used by most museums and galleries is seldom considered part of the artwork, yet it is an environmentally interactive element like any other. Artificial light affects the way we code our experience of an artwork. Kapoor comments on the function of light in his work:

> I do not believe I have anything to say: I don't think of the artist as an expresser or teller of tales ... but as a receiver and transmitter of collective information. Most artworks are auto-referential. But switch off the lights and mine don't exist any more. I am anti-hero.[6]

The interactions we experience in Anish Kapoor's works are entirely natural. They involve feelings, intuitions and sensation of natural energy — a kind of communication that invokes the dualities of real environmental experience. The fundamental polarities of perceived and actual reality they reflect are virtuous not virtual. Nowhere is this more clear than in an 1990 untitled piece (on loan from the Lisson Gallery in London, England for the National Gallery of Canada show) consisting of a triptych of fibreglass hemispheres literally appended to the walls of the gallery. Its conception recalls *At the Hub of Things* (seen at the Musée d'art contemporain's *British Now* show in 1988-89), in that it defines interior and exterior space in architectural terms, but in this case, at a monumental scale, with each part measuring almost three metres in diameter. The surfaces of the hemispheres are covered with dark prussian blue powdered pigment, a device that has become a trademark of Anish Kapoor's sculptural work, intended to conceal the hand of the sculptor and isolate the sculpture-object from the act of creation. It projects a profound feeling of peace and womb-like security. Kapoor describes his method:

> There is a fine line between polishing and removing the marks of manufacture ... The void is not silent. I've always thought of it as a potential space. I'm coming to think of it more and more as a transitional space, an in-

between space. It's very much to do with time. I've al-
ways been interested in the idea that as an artist one can
somehow look again for that very first moment of
creativity, when everything is possible and nothing has
actually happened. It's a space of becoming.[7]

The movement from scale and volume to the illusory density of dark-
ness within these forms requires a shift from reflection to perception.
Our perception of surface textures disappears in the central voids ex-
perienced within the three spheres. There is no way to judge the rela-
tive scale within.

Kapoor's art marks a subtle shift in the West toward an aesthetics
of inclusion, where assimilation and identity can reflect intercultural
similarities instead of differences. It perceives links between certain
dualities that define Kapoor's art: infinity and finitude, completion
and incompletion, presence and absence. The open-ended am-
bivalence of his art is autobiographical and conciliatory: the product
of transhistoric integrations. Like the ambivalent Leopold Bloom in
James Joyce's *Finnegan's Wake*, whose character is never made clear —
Is he Jewish or English? — Kapoor's experience is culturally
heterogeneous. Born in Bombay, India in 1954 to a Hindu father and a
Iraqi-Jewish mother, Kapoor trained in engineering and worked on a
kibbutz in Israel before studying at Hornsey and then Chelsea College
of Art in London, England. He returned to India in 1979 and began to
see his own cultural background with fresh eyes. The open-ended na-
ture of his transnational and trans-theological life experience con-
tributed to his perception of aesthetics in terms of cultural relativism. It
helped him to develop a language of expression that did not need cues
or hidden metaphors. His language was integral — the human body
became a paraphrase for universal concerns.

Despite the fact that he holds an Indian passport, Kapoor has
represented Britain twice at the Venice Biennale. Once with the
"New Generation" British sculptors Richard Deacon and Tony Cragg
at the Aperto in 1982, and again in 1990 when he was awarded the
Premio Duemilo 2000 Prize for most promising young artist under thir-
ty-five. The winner of the Tate Gallery's prestigious Turner Prize in
1991, he also represented Britain at the last Documenta where his ex-
hibit, *Descent into Limbo* (1992), received critical acclaim. At the 1992
Seville Expo, Kapoor designed *Building for a Void*, a cylindrical con-
crete and stucco structure with spiralling exterior ramp that symboli-
cally rivalled Sir Anthony Caro's *Tower of Discovery* for its conception
and execution.

Angel (1990), was a series of eight ubiquitous slabs of slate covered in prussian blue pigment and strewn around the N.G.C.'s floor like many pieces of felt. While many artists in the West begin with a truth to eventually arrive at a falsehood, in *Angel*, Kapoor starts with an illusion of reality to arrive at a truth about the appearance of reality. The layering of synthetic cobalt-based pigment onto the exterior of these pieces produced the feeling of weightlessness — of floating islands of feelings. While we usually read the mass of an object subliminally with our minds before we read its external appearance, *Angel*'s mass and weight is so disguised, we read it as equal to appearance. As Kapoor says, "I am sure if I were to insist that these forms were quarried blocks of Prussian blue, you'd believe me."[8] One could just as readily believe they were hollowed out rocks. The actual truth is the contrary: the entire Kapoor show, as presented at the National Gallery of Canada, weighed 49,654 lbs. and required the floors of their exhibition halls to be reinforced with a series of eight-by-eight foot steel plates.

We often consider Asian culture to be more sincere in its relations to nature and perceive Western culture as excluding nature. The theatrical aspect of *vrai-faux* that underscores Kapoor's *Angel* suggests that Asian culture's vision of nature involves aspects of illusion that are little different from our own, but have evolved their own theological and culture-specific meaning over millennia. Kapoor describes his approach to presentation:

> My trick, the staging, is situated beyond the threshold that you have prepared and that you will know how to recognize, and that which you will find beyond the threshold is there for you and you alone.[9]

The questions of perception *Angel* raises are those prescribed by the empirical laws of science:

> ... an infinite intellect, which is nothing but pure thought, and a thought in which are involved the ultimate principles and essences of things, is no longer Self-consciousness, like man's individual perception and sentiment, but it is, in this sense, Unconsciousness.[10]

Perception involves a hierarchy of preexisting knowledge, preconceives the meaning of appearance. For Kapoor, reality itself may be wholly unconscious — something we can never entirely comprehend.

In the Presence of Form (1991) resembled an archaic *menhir* of sandstone into which an entrance had been cut. Not entirely visible, the emerging form within was the very embodiment of birth, growth, life and transformation. Dramatic in its incompleteness, its rounded, unfinished form cannot be realized without the natural material context of its rough-cut exterior. The metaphor becomes the subject of the material. As a sublime idea it verges on metaphysics, suggesting that scientism and the imperatives of technological advancement, for all their innovation and serialized discoveries, are still as dependent on the collective unconscious of humanity's potential imagination as ever. Anish Kapoor believes that "there are truly sublime moments — flashes of genius — when we are engaged in something beyond death, but I don't look for or declare a condition beyond death."[11]

Like ice in midsummer's heat, the endless transformations we see in nature are an inspiration to the soul, melting to flow like water over the structures and strictures of dogma. The answers to humanity's problems, Kapoor reveals, depend on our identifying with the perpetual change and volatility of life itself. Anish Kapoor's sculptures bring with them a state of transcendence whose effect is achieved without the self-conscious expectation one associates with sublimity, but instead through material "real-ization".

In collaboration with the experimental dancer and choreographer Laurie Booth, Kapoor made a series of five *Bright Mountain* sculptures for *River Run,* performed in the Queen Elizabeth Hall in London on March 27th and 28th, 1993. Envisioned by Booth to be a kind of imaginary journey and accompanied by Hans Peter Kühn's musical collage, the production was named after the opening of James Joyce's *Finnegan's Wake.* During the performance, Kapoor's pure white, translucent mountains were moved around the stage, enhancing the sense of spatial other-worldliness in which the dancers moved. The piece was originally conceived for the theatre, where reality is suspended and the here and now is constantly relativized by what has just passed and what is about to pass. When exhibited in the inner sanctum of the Barbara Gladstone Gallery in New York in early 1994, one of Kapoor's translucent *Bright Mountain* pieces projected an aura of miniaturized monumentality, intense calm, purity of light and timelessness. Kapoor's enigmatic *Bright Mountain* actualized the viewer's powers of imagination by simply hiding the personal traces of authorship and letting the interplay between light, space and the materials themselves create a quiet sensation of transcendence — of a presence and absence in many presents.

Notes

1. Sarah Kent, "Mind over Matter," *20:20*, May 1990, p. 40.
2. Jeremy Lewison, "A Place out of Time," *Anish Kapoor Drawings*, (London: Tate Gallery 1990), p. 11.
3. C.G. Jung, "*The Development of Personality*," in *C.G. Jung: Word and Image*, Aniela Jaffe, ed., (Princeton: Princeton/Bollingen, 1983), p. 226.
4. Michael Polanyi, *The Tacit Dimension*, (Gloucester: Peter Smith, 1983), pp. 44-5.
5. Anish Kapoor in conversation with John Grande, June 17th, 1993.
6. Sarah Kent, "Mind over Matter," *20:20*, May 1990, p. 40.
7. Anish Kapoor,cited in, "Anish Kapoor: Theatre of Lightness, Space and Intimacy," *Parallel Structures: Art, Dance, Music, Art and Design Profile no. 33*, p. 58.
8. Lydia Forsha, interview with Anish Kapoor, Museum of Contemporary Art, San Diego, February 2nd, 1992 quoted in her catalogue essay for Anish Kapoor, San Diego Museum of Contemporary Art, 1992, p. 12.
9. Anish Kapoor, cited in Pier Luigi Tazzi, "Breath of Air, Breath of Stone," *Anish Kapoor*, (San Diego: San Diego Museum of Contemporary Art, 1992), p. 19.
10. A. Vera, *An Inquiry into Speculative Philosophy*, (London: Longman, Brown, Green & Longmans, 1856), p. 21.
11. Anish Kapoor in conversation with John Grande, June 17th, 1993.

14

Armand Vaillancourt:
The Eye and the Storm

I first met Armand Vaillancourt while visiting Québec City during the summer of 1987. He was working on Drapeau Blanc, a monumental sculpture composed of over ninety-two tons of calcite brought in from the Saguenay Lac-St. Jean region to Laval University in Ste. Foy. There Vaillancourt stood — the embodiment of every Canadian postgraduate art historian's search for a *living* Canadian mythology of art. His long white hair and beard blowing in the wind, Vaillancourt was, and still is for me, an artist to reckon with.

History has not treated Vaillancourt the person particularly well. His *bois brulé* and abstract metal sculptures from the fifties and sixties are in most of Canada's major museum collections because they are unquestionably some of the most spontaneous and original sculptures made in Canada at the time. But if you ask a curator in either Québec or Canada about Vaillancourt's work, they usually avoid the question, shrug or laugh, as if it's too painful to talk about. He has never been given a solo show by a major museum nor has he represented Canada at major international events such as the Venice Biennale or Documenta. His persona is at odds with the spin-dried tastes of today's curators who prefer the universe to be neatly placed in a box or squeezed into a tight little metaphoric ball for exhibition purposes.

Drapeau Blanc, that incongruous collection of brilliant white boulders imported from Québec's sacred *indépendentiste* heartland, embodies Vaillancourt's primal vision that art can be a force for transforming society. An emblem of Québec's culture of resistance in the face of an all-pervasive and vacuous North American consumer culture, *Drapeau Blanc* had quotes sandblasted and carved in relief. Sources ranged from renowned Quebecers such as Felix Leclerc, Gaston Miron and Gilles Vigneault, to others including an anonymous Hindu poet and Martin Luther King, whose quote read "We have to learn to live together like brothers, otherwise we'll die together like idiots." Another quote from Simonne Monet-Chartrand on one of the boulders read, "I do not want the snow, the years and the cold to freeze my memory."

The media, on the other hand, has treated Vaillancourt remarkably well. No Canadian artist has ever had so much ink spilled on his work. Literally thousands of articles have been published on Vaillancourt in major and minor newspapers and magazines internationally and at home. When Vaillancourt was invited to the International Sculpture Symposium in Toronto's High Park in 1967, he proposed a monumental sculpture for the site. After three months, the 340 tonne piece was finally completed in cast iron whereupon Vaillancourt titled it *Je me Souviens* and the project was aborted. Over four hundred articles appeared in print as a result, not to mention the television interviews. When Toronto's Mayor Crombie gave Vaillancourt the option of taking the piece back to Québec twelve years later, so long as it was insured and removed in its entirety, Vaillancourt hired a convoy of eight tractor trailers to bring it back to Québec at a cost of $12,000. It now sits in pieces in a field near Côteau-du-Lac awaiting a final installation site close to his former atelier (which he claims the Québec Government stole from him, destroying all his equipment in the process). The same year that Vaillancourt created the piece (1963) he was awarded the prestigious Confederation Medal, which he kept, while refusing to accept the honour.

Vaillancourt also won the international competition in 1967 for a monumental sculpture fountain to be located in Embarcadero Plaza, San Francisco, located adjacent to an expressway overpass. Titled *Québec Libre*, this work is better known in the United States than at home. A massive construction of rectangular concrete forms that rise dramatically out of the water, it was once described by Canadian art historian David Burnett in *Contemporary Canadian Art* as a work that "looks like a result of some massive disaster or a warning of physical and cultural upheaval."[1] The night before its inauguration in 1971, Vaillancourt stencilled the words *Québec Libre!* in red acrylic paint onto the sculpture. The words had already been whited out by civic employees when the dedication ceremony commenced the next day. Thomas Hoving, then director of the Metropolitan Museum of Art in New York, along with a slew of civic dignitaries drawled out their specious platitudes and the poet Lawrence Ferlinghetti read some of his poems while Vaillancourt, held back by two police lieutenants, jumped into the water of the fountain and painted *Québec Libre!*, yet again, all over his creation. The San Francisco Redevelopment Agency's Executive Director Justin Herman, unaware of exactly what was going on, then asked from the podium, "If our artist is in the audience will he please raise his hand so that we may applaud him?"[2] Instead of replying, Vaillancourt, with his feet dangling in the water

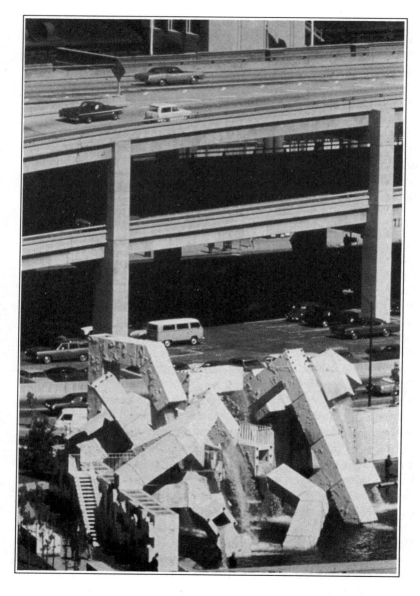

Armand Vaillancourt. *Québec Libre!*, 1971. Embarcadero Plaza, San Francisco. Photo by Peter Stackpole. Photo courtesy of the artist.

of the fountain, let out a loud war whoop for freedom and was immediately surrounded by a bevy of cameramen and journalists. Later on that day, the rock group Jefferson Airplane played for the Embarcadero Plaza inauguration bash that followed.

Controversy, controversy. Seven years ago, Bono, from the rock group U2, painted the words "Stop the traffic. Rock and Roll" on the sculpture. More ink and celluloid spilled and spent all over the United States. When Bono contacted Vaillancourt to support his action, Vaillancourt backed him up. He was in San Francisco the next day painting "Stop the Madness" on stage at the Oakland Colosseum before a crowd of 70,000 spectators while U2 played their *Joshua Tree* show.

During the recent San Francisco earthquake, the Embarcadero expressway collapsed and has since been torn down. The plaza was also damaged and the whole area is now undergoing extensive reconstruction. San Francisco's chief urban design consultant has recommended that Vaillancourt's sculpture (which was not damaged) either be demolished or moved in order to make way for "a better people gathering place."[3] The dilemma over artists' rights surrounding *Québec Libre*'s aesthetic, historic and civic importance as a landmark remain unresolved. A committee has been organized to defend Vaillancourt's sculpture and the legal ramifications promise to be as fascinating as the controversy that surrounded the dismantling of Richard Serra's *Tilted Arc* sculpture installed in 1981 in Federal Plaza in downtown Manhattan.

Most Quebecers still remember the fiasco during the seventies surrounding Vaillancourt's appearance on Lise Payette's television programme *Apellez-moi Lise*. To protest what he saw as the manipulation of the masses by the programme, Vaillancourt stripped naked before the cameras. The programme was never aired. Québec's most prestigious arts award, the Prix Paul-Emile Borduas, was awarded to him in 1993 and his criticism of the state of Québec culture was broadcast live on Radio Québec. Here is part of the speech:

> So, I want to share this honour with all the dispossessed of the earth, in shouting my helplessness in the face of the rapes, the social inequalities, the abused children, the tortured, the genocides, the market and trade of organs. How can one remain indifferent to the atrocities of the Gulf War, to those of Bosnia, Haiti, Angola, where 2,000 people die each day, to the invasion of Panama, and finally to the countless injustices done to the developing countries? How can we remain indifferent,

in the warmth of our homes, seated comfortably in front of the television, looking at the horrors happening around the world pass in front of our eyes? How can one advocate an art for art's sake, without being concerned about the well being of some which brings about the unhappiness of others?[4]

During the summer of 1994, Vaillancourt was yet again refused a grant by Québec's Ministère de la Culture. He talks of mortgage payments and hydro bills at the same time as he shows slides of recent computer animated designs for a 110 metre tower of steel dedicated to planetary consciousness proposed for the banks of the Eastman River near James Bay — now dried up due to the Hydro Québec hydroelectric project. An ascending spiral ladder with lights, hundreds of suspended bells and an observatory with satellite communication equipment on top, Vaillancourt's *Tour Écologique* — like *El Clamor* (1985-87), his nearly-completed wall of stone with sculpted hands in Santo Domingo — seeks further funding.

Born in Black Lake in the Eastern Townships on September 3rd 1929, the 16th of 17 children, Vaillancourt grew up on a three-hundred acre farm with no electricity or indoor toilet. Some of his earliest memories involve freezing in the bitter cold sitting on the logs his father cut with a whipsaw. He took a course in classical studies at Ottawa University in 1949-50 before coming to Montréal in 1951 where he studied at the Ecole des Beaux-arts until 1954. It was during this time that Vaillancourt created *The Tree of Durocher Street* (1957), his first major public work (now at the Musée du Québec in Quebec City), outdoors before crowds of bystanders who watched him carving, cutting and shaping the tree with hand tools and an axe over a period of two years. After the work was completed in 1957, Ossip Zadkine, the famous Russian sculptor associated with the early days of Cubism in Paris, then visiting Canada for a touring exhibition of his work, knelt before Vaillancourt's sculpture exclaiming that it was the work of a master. Zadkine invited Vaillancourt to come to Paris and work in France, but Vaillancourt was already committed to working in Québec.

In 1961, for the International Festival of Contemporary Music in Montréal, Vaillancourt created a musical environment for a twenty minute concert of live music comprised of twenty-two tonnes of self-created musical instruments and a motorcycle: a work he still refers to as the most daring show of his life, "an orgy with matter." Yoko Ono later used it for a recital of her poems and John Cage, who also per-

formed at the festival, referred to it as the work of a genius. Word of Vaillancourt's musical event spread. Edgar Varese invited him to come to Greenwich Village to meet Picasso and the other great artists of the era, and Merce Cunningham asked him to create the decor and the music for his experimental theatre in New York, but Vaillancourt was too busy at home to go.

The second time I met Vaillancourt was in Montréal in 1989. Before entering into his studio on Esplanade Street in Montréal, with its view of the Mount Royal, I could see a large, as yet uncarved, imported African tree trunk in his yard. Not far away beside some old oil barrels, three metal pieces with the words "JUSTICE !" carved into them sat in restive solitude, like the sculptor's talismans guarding his studio. The actual building has a theatrical and slightly comical roof, like a grenadier's hat with a pointed spire on top. Entering into Vaillancourt's home, the first objects I noticed were his sculpting tools that he had just taken out of his station wagon: the large mallet covered in duct tape, an axe, adzes and chisels in a large bucket. There were a vast array of materials — styrofoam package forms, blocks of wood, I-beams and strips of metal, and street signs. Looking around, I could see some fascinating hints of his past production of over 3,000 sculptures and 2,000 paintings. They included several exquisite small bronzes cast in the lost wax technique, collages, acrylic and water-colour paintings, paper prints from his *Manhole Series* cast from actual Montréal sewer ducts, and a maquette of *Je me souviens*.

In one corner, I noticed a minute set of the complete works of Shakespeare sitting on a shelf. In an adjacent room, not far from an old piano, amid all the disarray of Vaillancourt's irrepressible creative spirit, was one of his famous large-scale *bois brûlé* sculptures dating from 1953-65. Enormous and ominously primeval, these works made from tree trunks seem to be an invitation to some earthly paradise, not that of Gauguin, but a northern one, a world not yet created, but somehow anticipated in Vaillancourt's life struggle as an artist. The *bois brûlés* are some of the strongest ever to be made in wood by a Canadian sculptor, extending Borduas' *automatiste* painterly style further into a much more difficult medium — sculpture. Technically, they were an innovation. Using a one and a quarter horsepower motor and drill to carve up to two hundred holes — each three to four inches in diameter and up to eight feet in length — into a single tree trunk, Vaillancourt would pour oil onto select areas and let the fire burn into the piece, after which it was doused with water. It was an innovation that allowed for more deeply controlled modelling. The fire acted differently according to the varied densities of the wood.

Today, the *bois brulés* have become rare collector's items and can be seen in many of Canada's major museums, though they are less well known to the public in general.

Styrofoam casting was yet another technical innovation Vaillancourt pioneered in the fifties. Using a flame, he could create a moulded sculptural shape in seconds out of styrofoam. The model could then be set in a sand mould and cast in iron. It allowed Vaillancourt to work with monumental sculpture in a way never before attempted anywhere in the world. The action of the flame on styrofoam was instant and the resultant forms were purely spontaneous but highly controlled abstractions. *La Force* (1964), located on Mount Royal near Beaver Lake, used 74,000 lbs. of cast iron which took three days to cool down. There is a rare balance between artistic intention and the characteristics of materials in Vaillancourt's *bois brûlé* and styrofoam cast metal pieces.

Throughout the years, Vaillancourt has always worked for the betterment of society. As he says, "Art has an essential role to play in the collectivity, the society, and the artist conscious of this role must fulfil it with joy, whatever happens in his own personal life or his work."[5] Vaillancourt's commitment to social change resurfaces continually in performances, sporadic sculpture and painting events he participates in or puts on at popular Montréal venues in St. Henri, the Inspecteur Epingle, Café Campus, and the Foufounes Electriques — an underground rock bar on Ste. Catherine Street now threatened by police closure. One of his first public performances was in the fifties when he paraded in the Montréal business district wearing a sandwich board style clock with the words "Don't Lose your Time" painted on it. But Vaillancourt has also built practical, no-nonsense engineering pieces, including a five hundred foot breakwater in San Francisco and a two hundred foot, 80,000 lb., modernist steel bridge for the citizens of Plessisville in Québec.

In a controversial work titled *Paix, Justice et Liberté* created in June 1989, he inscribed the names of thirty-two of Québec's leading corporations involved in the arms-trade and their annual profit figures, onto an enormous discarded cistern placed in the downtown shopping area of Crescent Street in Montréal. Inscribed onto the work were the words: "Two days of military expenditures worldwide, around five billion dollars, would allow the United Nations to stop the desertification of the world within twenty years." Including pylons, a chair with virginal white wings and a series of metal disks over which those who drove by actually made contact with the piece,

Vaillancourt's interventionist sculpture dealt with issues of social justice, militarism and ecology from an non-official point of view.

This past year, yet another controversy has developed over Vaillancourt's *Hommage aux Amerindiens* (1991-92) a work consisting of an eclectic assemblage of thirteen tepee-like sculptures made out of recycled wood painted in bright colours with traditional native symbols on them, bolted together and dedicated to the Amerindian and Innu tribes. Originally exhibited in front of the Standard Life Building on Sherbrooke Street in 1991 and then at numerous other sites in Québec, it was chopped to pieces by the avant-gardist theatre group *Carbon 14* not long after they bought the building it was stored in, despite the fact they had earlier given their permission for the works to be stored there. Vaillancourt was never notified of their intention.

Vaillancourt's art is something an English-Canadian can appreciate for its theatrical flair for life if one ignores the political jargon on both sides — particularly when contrasted with the straight puritanism of Toronto's *quasi-engagé* "official" arts scene. His previous separatist aspirations remain pure and distant from Parizeau's small c conservatism and he still admonishes Réné Lévesque for giving up in for what he called the "beau risque" in 1984. His views are clear — less malicious and obfuscated than the political soup most Quebecers and Canadians are trying to fathom in these uncertain times. During the recent Québec provincial election, Vaillancourt ran for the New Democratic Part (NDP) in the Westmount-St. Louis riding. The only artist to run for a seat in the entire province, he was attracted to the NDP's political programme commitment that the State should serve artists.

The paradoxes present in Vaillancourt's life and art stem from his insistent curiosity and spontaneity and his consistent belief that art has an important role to play in building a future vision for society. There is a contradiction between the media-wise, aging Don Quixote of Québec's art scene and the quiet, poet's soul, the muse that stands behind much of his art. The secret behind Vaillancourt's art ultimately comes from his love of life and the people he has known over the years, yet nature remains a primary source of inspiration. During the fifties he spent nine months in monastic solitude in the country to reflect on his own private questions about life's purpose. Vallaincourt comments, "the city makes us blind and makes us forget the meaning of life. I discovered in solitude that silence is the best of friends."[6]

Now over sixty-five years old, he has been working in Québec's schools with children and young adults from the ages of six to eighteen to encourage and develop another generation's interest in

creative expression, so tenacious is his belief in the importance of a strong and vital social culture to the future of society. In Vaillancourt's own words: "I do not want to be a spectator in a world that is building itself. My mission is to maintain the spirit of humanity and make it grow. I must conquer matter to give it back its freedom in other forms."[7]

Notes

1. David Burnett and Marilyn Schiff, *Contemporary Canadian Art*, (Edmonton: Hurtig, 1983), p. 233.
2. Robert Hughes, "War Whoop for Freedom," *Time Magazine*, May 3, 1971, p. 64.
3. Gerald D. Adams, "Vaillancourt Fountain's fate hangs on waterfront plan," *San Francisco Examiner*, Oct. 18, 1992, p. B1.
4. Armand Vaillancourt, *On ne peut pas éteindre les volcans!*, Prix Paul-Emile Borduas presentation address, Montréal, November 1993.
5. John Grande in conversation with Armand Vaillancourt, June 1990.
6. Armand Vaillancourt, Artist's statement (unpublished), May 1992.
7. John Grande in conversation with Armand Vaillancourt, June 1990.

15

James Carl's Euphemistic Reality

An artwork is not just a signpost to be grafted onto the walls of some museum's warehouse of tautologies sometime in the future. Nor is it just something to fill a servile place in a public space allotted by city planners and architects to assuage nagging doubts about the wholesale disruption and dislocation of the city as a community. It is a reflection of a far less grand and self-assured search for meaning. The controversy surrounding the removal of Richard Serra's monumental *Tilted Arc* sculpture from Federal Plaza in downtown Manhattan illustrates the contentious debate surrounding public art. Installed in 1981, it had been commissioned by the General Services Administration in 1979. This 120-foot-long, twelve-foot-high, seventy-three tonne leaning curve of welded steel was the epitome of modernism. Inflexible and unyielding, it dominated the public space like a heroic and confrontational spectre — the very model of social independence, the ego's eye — modernity personified. For the local office workers it was, in Suzi Gablik's words, "another version of the Berlin Wall."[1] As one employee of the Federal Department of Education stated:

> It has dampened our spirits every day. It has turned into a hulk of rusty steel and clearly, at least to us, it doesn't have any appeal. It might have artistic value but just not here … and for those of us at the Plaza I would like to say, please do us a favour and take it away.[2]

The debate and subsequent trial became confused. Issues of caring and responsiveness were thrown out of the window as different interest groups clamoured to protect or dismantle the piece. In the end Serra lost. In a caustic comment on one of Serra's prop pieces — which as well as looking dangerous, actually killed one workman and injured others — Montréal-based artist James Carl created a work titled *Que Serra* (1990). He simply propped a cardboard box on top of a cardboard cylinder in the corner of his studio. The same minimalist notions and architectural relations were established in microcosm, yet were rendered harmless. As such, *Que Serra* became a humorous parody of the extra-human expectations and desires of the artist who

seeks to fulfil the obligations of the West's formalist tradition — its self-evident materialist ethos. The piece raised questions about artistic freedom in the modernist sense, where the artist dominates by opposing domination, confronts in reaction to confrontation, and reduces empathy to a whimper. In the process, the artist excludes the public at large, who are as remote from public art as they are from the politicians who sponsor these projects. The codes and signifiers of our postmodern paradigm are so pervasive that they create a web where the real and the artificial meaning of art and life become intertwined and confused, just as they have become in all areas of life.

In the solo show, *Border Patterns* (1990), held at the Central Academy of Fine Art in Beijing, China, James Carl assembled a group of works that expressed a different state of confusion — an intercultural one, far from the Western hue and cry over formalism. With the ghosts of the Tiananmen Square massacre still lingering, Carl presented a foreigner's view of the cultural situation in Beijing, confronting, among other topics, the emergence of a consumer ethic. Demands for products and services were becoming part of the new spirit of communist China. Objects found by Carl in Beijing markets were assembled within architectural and artifact constructions made of chopsticks whose configurations echoed local architectural traditions. Despite the adverse conditions and political chill in the air, his show was well received, probably because he approached his subject with a sense of humour and some understanding of Chinese attitudes about art. Carl relates the experience of being a foreigner in this way:

> While living abroad, one's aesthetic faculties are naturally exercised in confrontation with new art forms and architectures; yet these same faculties are also instrumental in such simple decisions as the purchase of such common items as toothpaste or batteries.[3]

In *Rearguard*, a ping-pong paddle resting neatly on top of a world globe in miniature became a loosely orchestrated comment on the two-sided face of "Ping-Pong" diplomacy. In the period after the Tiananmen Square uprising overseas, business with China from abroad was halted for a short while to then quickly resume as usual. Within China, the intelligentsia, university scholars, poets and artists were being silenced and imprisoned. Surrounding this innocent contruction was a form made up of a continuous series of black and red chopsticks, assembled in the shape of a tri-pedal Shang dynasty (1766-1028 B.C.) ritual vessel. Intended to highlight the mysteries of the an-

cient Chinese art of bronze cast vessels, whose deep relief and casting techniques excel anything created in the history of Western sculpture, the piece had the benign charm of a *Time* Magazine cover illustration. But Carl's parody of the international media-generated image of China versus the internal realities of life in China could not be missed. Exploring a similar notion, *Encore* (1989-90), a sound-activated installation piece where the latest in Chinese toy technology — a replica of a giant panda — sat ignominiously on a red platform surrounded by a construction comprising 2,000 disposable chopsticks, presented an architecture of self-defense, welded together with a glue gun. With a clap of the viewer's hands, the battery-operated panda clapped *its* hands, made a squeaking sound, its eyes lit up and it moved in a disturbing robotic fashion like the toys in a Duracell battery commercial.

Soon after returning to Montréal in 1990, James Carl presented an ongoing exhibition at his studio on St. Laurent Boulevard that embodied the influences of his stay in China. *The 5 Elements* (1990-91) was a transitional work that interpreted the five elements theory of ancient Chinese cosmology: earth, fire, air, water and wood. Presented on altar-like pedestals, these assemblage constructions, made from a vast range of consumer and found materials, had their constituent elements moved around each day to suggest the sense of constant change and ritualistic immolation that the Chinese vision prescribes as part of the mutual dependencies which exist between all elements — an interconnected continuity and atomized web of nature's particularized elements. Air was represented by an aerosol can and coffee filter; Fire, by an *Oxford English Dictionary*; Water by a freezer pack, and so on.

For the Strathearn Centre's interactive group show dedicated to nature in the city, *Les Jardins Imprévus*, in the summer of 1991, James Carl made a site-specific installation at the spaghetti-like traffic intersection of Pine and Park Avenues. His work was comprised of a set of headphones installed in a metal box which visitors were invited to wear to block out the background noise of traffic. The title of Carl's piece, *Les Paumes de Terre*, commented on the curves and shapes of the roadway patterns, resembling the lines a fortune teller might read in one's hand. The elements of chance and luck can be understood as an eastern parable on Western determinist notions of progress and opportunity. Carl's work also suggested that the role of the artist is to intervene and go between the standard thinking of a culture — its *modus vivendi* and *raison d'être* — and to suggest alternative ways of seeing. In this work, our standard spatial and temporal reading of the

environmental surroundings is slowed down, producing a "moment of realization." Each evening the box was locked and each morning the box was opened by Carl, in a parody of the work-a-day world. The hustle and bustle of traffic apparently going somewhere, but from this vantage point seeming to go nowhere, was mirrored by the purposeless method of Carl's routine of opening and closing of the installation like a jailor. James Carl's piece demonstrated what the performance artist Alan Kaprow, in an essay titled *The Real Experiment*, has called "lifelike" art, that which remains connected to everything else, as opposed to "artlike" art, which remains separate from life and everything else.[4] The latter performs a function in relation to mainstream Western historical traditions because art galleries, journals, museums and professionals need artists whose art is "artlike." "Lifelike"" art remains outside these traditions and performs a more generic social and ethnological function.

In the same year, at another location in Montréal (*Parc Portugais*), Carl presented *Spring Collection*, a five-by-eleven-foot igloo assembled out of discarded plastic containers. The supreme irony of this symbol of a northern shelter against the cold was that its component parts were discarded anti-freeze containers left lying around on the streets after winter. As an inducement for the public to interact with the artist, Carl set up a table and served drinking water tinted with an attractive bright blue colouring that looked more like Prestone windshield wiper fluid than Perrier or Labrador "naturally pure" drinking water.

For a solo show at Galerie Clark in 1992, Carl presented a myriad of consumer appliances "disposable art" that called into question art's position in the production-consumption chain. Meticulously pieced together out of cardboard in a one-to-one scale, these constructions were indeed "lifelike" reproductions of functional consumer objects. Fridges, stoves, radios, record players, toasters, a television, washer and dryer littered the gallery space. The process they engendered, the craft of construction and contemplation they entailed, presented a mask of consumerism — the "artlike" design of the production assembly line. The care and time taken to make these pieces — usually constructed from the discarded containers of exactly the products they represented — in fact, became a kind of creative employment — albeit without consumer value. In this sense, the work was also a comment on the value placed on dehumanized work in an age of mass production. Carl's attitudes to the role of the artist in the creative process recalled Walter de Maria's *Meaningless Work* manifesto from 1960 which stated: "Meaningless work is potentially the most ... important art-action experience one can undertake today."[5]

As such, Carl's installation show became a place where East met West. Henry Ford meets Gautama Buddha somewhere between the product assembly line and the recycling depot. The work became a deep felt comment on the meaning of culture seen from two philosophical points of view: that of the third-world vision, religiously astute in a state of being consumed, and that of the West, overloaded with the products of an ephemera-culture of materialism and spiritual vacuousness. In *Small is Beautiful*, E.F. Schumacher comments on the Asian Buddhist view of work, one that is presently being challenged throughout Asia by an emergent consumerism:

> The Buddhist point of view takes the function of work to be at least threefold: to give a man a chance to utilise and develop his faculties; to enable him to overcome his ego-centredness by joining with other people in a common task; and to bring forth the goods and services needed for becoming existence ... the consequences that flow from this view are endless. To organize work in such a manner that it becomes meaningless, boring, stultifying, or nerve-wracking for the worker would be nothing short of criminal; it would indicate a greater concern with goods than with people ... Equally, to strive for leisure as an alternative to work would be considered a complete misunderstanding of one of the truths of human existence, namely that work and leisure are complementary parts of the same living process and cannot be separated without destroying the joy of work and the bliss of leisure.[6]

Seen within the context of the creation of art, the same notions apply, yet Carl has taken this one step further. Each week during the installation, he placed several of these "appliances" out in the street as garbage. Often, they would "disappear," having been picked up by passers-by. Carl recorded these actions using a spy camera from a window located above. Alternatively, the discards were taken to a garbage dump, another kind of "site" — thus bringing the process of production full circle.

By not actually using real appliances and incorporating the element of work into the equation, Carl broaches questions of meaning that are no longer standard to current artistic practice. It becomes a third world comment on contemporary fashions in Western art, accomplished by using the language of Western materialism itself. Ob-

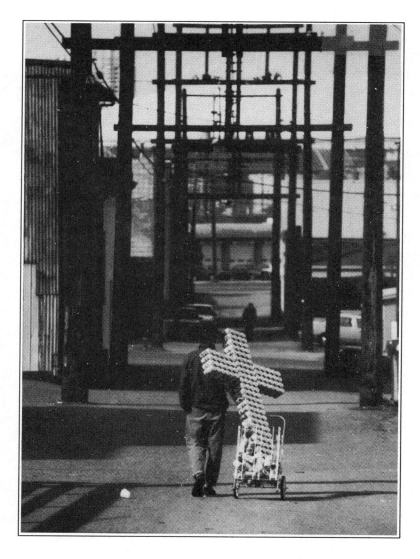

James Carl. *Redemption,* 1993. Grunt Gallery, Vancouver. Beer cans, trolley and artist. Photo courtesy of the artist.

jects are made to appear like consumer items, but are every bit as ephemeral, changing and short-lived as elements in nature. While their appearance and design is made to seem structural, it is a facade, a mask. The whole question of appearance and beauty in art becomes a side issue. James Carl mimics the production process to suggest a different sense of self and community, one that is at once timely and coherent, but ultimately humorous and poetic.

Carl took irony a step further with his *Public Works* (1993) show held at the Grunt Gallery in Vancouver. In his realization of the artist's intimidation, based on the "disintegrated sense of community that characterizes our urban environment, and the alienated sense of art and the artist within that non-community," Carl attempted to "focus on issues and materials that form a sort of common currency within these fractured, polycentric social environments. Searching for the wider disunity that we have come to accept as (post) modern Canadian life."[7]

In a piece titled *Public Works* he reconstructed to full-scale, the dumpster that stood in the alleyway outside the gallery out of corrugated cardboard. The work was exquisitely scaled and detailed down to the nuts and bolts. At the end of the show, the work was placed in the alleyway beside the "real" dumpster. Carl's "maquette" of the real thing challenged the waste disposal function of the original container by building the same purpose into material that itself was judged as mere waste.

Redemption (1993), the other work in the Vancouver show, consisted of a crucifix made out of returnable beer cans that Carl towed around Vancouver. Carl commented: "If there is no salvation in emptying the bottle, at least there's redemption for the empty bottle."[8] Part of an effort to re-establish a meaningful dialogue between the artist and public outside the usual context where art takes place, Carl's *Redemption* was a "performance" piece that, like the replicated dumpster, became a tongue-in-cheek caricature of the sacred or mystico-religious side of the ecological movement.

Notes

1. Suzi Gablik, *The Reenchantment of Art*, (London: Thames & Hudson, 1991), p. 63.
2. Ibid., p. 64.
3. James Carl, cited in Ming Pao Yue Kan, *Meditations at the Foot of the Great Wall*, Hong Kong, May, 1991.
4. Suzi Gablik, *The Re-enchantment of Art*, (London: Thames and Hudson, 1991), pp. 137-38.

5. Walter de Maria cited in *The Reenchantment of Art*, pp. 135-6.
6. E.F. Schumacher, *Small is Beautiful: A Study of Economics as if People Mattered*, (London: Abacus, 1977), p.45.
7. James Carl, cited in Liane Davidson, *Public Works*, (Vancouver: Grunt Gallery, 1993), np.
8. Ibid.

16

Bill Reid and the Spirit of the Haida Gawaii

Looking like the last survivors from a great natural disaster or a motley crew of mythical expatriates embarked on a journey to who knows where, the profusion of half-human, half-animal characters that populate Bill Reid's *The Black Canoe (1991)* aren't the typical ones one would expect to meet up with in Washington D.C. Culled from the ancient Haida culture, this mysterious cast of redolent beings have all the intricacy of a jewellery box design scaled to one hundred times their usual size and woven in bronze. Part of the cosmology of Haida beliefs and customs, the heraldic and traditional motifs that adorn this canoe are outward expressions of a seafaring culture that thrived along the coastal bays and inlets of the Queen Charlotte Islands in northern British Columbia for some 8,000 years before they began their collision course with European economic expansionism.

It is typical of Bill Reid's resilient character that he did not see the placing of this massive bronze tribute to cultural self-sufficiency in the wasteland of America's bureaucratic and commercial empire as an act of cultural subjugation. In Reid's own words:

> In considering the art for the building, it occurred to me that this was an appropriate opportunity to represent the kernel of the founding nations, which are really not acknowledged in any other way in Washington, except in museums.[1]

Born of a Haida mother from Skidegate, B.C. and a Scottish-American father, Bill Reid is a native craftsman and a sculptor par excellence. He is as readily at home with European, as with native traditions in art. Often credited with singlehandedly resurrecting the Haida language of formline painted relief carving and three dimensional carving, Reid revived a sophisticated cultural legacy that lay dormant for decades, in danger of extinction. He brought the formal traditions of Haida art back to life, transforming them into a truly contemporary art form. In part, it was because he had the liberty of knowing that no one was looking over his shoulder to tell him how to do it.

As a youth, Bill Reid was relatively unaware of his native roots. His original interest was in American and British literature. He went up north in the forties to visit the Haida Gawaii and met his grandfather, Charles Gladstone, an argillite carver. That was when his curiosity about Haida customs, mythology, and carving traditions was aroused, but he remained an outsider looking in. While working as a C.B.C. broadcaster in Toronto, he studied jewellery and engraving at Ryerson. By the fifties he was carving in both European and Haida styles back in Vancouver. While attending his grandfather's funeral in 1954, he discovered the sculpture of Charles Edenshaw. Edenshaw was one of the last great Haida carvers with direct links to the original craft traditions, still working at a time when the Haida culture proper had collapsed.

In 1957 Reid gained direct experience working with one of the last old time Haida carvers, Mungo Martin, recreating a Haida totem that had disintegrated at the Friendship Peace Park on the Canada-U.S. border in Blaine, Washington. Martin sang to the wood as he worked, as if evoking the ancestral spirits of long ago from the wood itself. He didn't speak much, simply pointing to a small human figure and signalling Reid to begin carving. A little later Reid asked, "Mungo, where are the Band-Aids?" and was told, "We don't use 'em," the implication being that a native carver never cut himself.[2] Reid went on to study goldsmithing at the Central School of Art and Design in London, England in 1968, furthering his already significant technical expertise. The numerous small scale carvings he has made over the years — boxes, jewellery and carved relief work in gold, silver and cedar — are now in many private and museum collections worldwide. He is one of few natives who have combined a sophisticated knowledge of traditional native imagery with advanced technical expertise based on years of formal training.

The Haida were a brash, sometimes violent seafaring culture, but in tune with the ecology of nature. The potlatch ceremonies that took place between opposing families of the Eagle and Raven lineages were an effective form of social, familial and economic exchange in a region with burgeoning natural resources. Any number of items: cedar boxes, masks, jewellery, utilitarian and decorative objects were given away in these feasts of reciprocal gift-giving. The notion of capital accumulation beyond basic necessity was simply not high on a Haida's list of priorities. In 1895, a colonial commenting on the potlatch activities of the Kwakiutl, the Haida's neighbours to the south, wrote that he was, "told by the older men that they might as well die as give up the custom."[3] Douglas Cole, a cultural historian at Simon

Fraser University states that, "Instead of adopting the social values of their European employers and customers, they used their earnings to reinforce the most significant aspects of their social systems."[4]

Contact with white colonial culture catastrophically reduced the Haida population from 8,000 to a mere 600 people due to smallpox epidemics. Villages were abandoned and the remaining Haida regrouped to live in Skidegate and Masset. The carving and painting of war canoes, body painting, oral literary and dance traditions effectively died out, though artifacts were still made for collectors and visiting tourists.

The collections of Haida cultural heritage we see in many world class museums is relatively recent — less than 200 years old. The Haida did not believe in preservation of artifacts, but instead recreated them perpetually. They lived in a world of wood and water and did not go through the stone, bronze, and iron ages progression like the Europeans. As a result, we have little evidence of the golden age of their past, one that is every bit as complex as our own for its indigenous evolution and local variation. In *the Black Canoe: Bill Reid and the Spirit of the Haida Gawaii*, a book co-authored with Vancouver-based photographer Ulli Steltzer that documentes the five years that went into the making of *The Black Canoe*, Vancouver poet and writer Robert Bringhurst compares Reid's cultural heritage and craft with the traditions of Europe:

> I think of another boat as well, that sits in a public space in front of another embassy in another major capital, yet seems to differ from this canoe in every way. It is Pietro Bernini's little vessel in Piazza di Spagna in Rome. The animal images it contains — the family's bees — are heraldry alone, with hardly a shred of mythology left, Bernini's boat is white instead of black, and full of ruminative sighs instead of embryonic speeches. And though the tourists crowd upon it by the thousands, it is resolutely empty: an abandoned ship, simultaneously melting and sinking into its pool.[5]

In 1985, when he was asked by Arthur Erickson to create two welcome figures for the Chancery — the entrance court to the new Canadian Embassy in Washington D.C. — it was already apparent that Bill Reid's plans for the project were decidedly more ambitious than that. He wanted to create more than a mere adjunct to Erickson's building, a sculptural calling card that would be humbled by the ar-

chitecture. Reid decided that he would prefer to create a monumental
sculpture that would recall the black argillite canoe carvings of the
nineteenth century, replete with figures from Haida legends — a
form he always appreciated intensely. The result was *The Black Canoe*,
one of the most ambitious native sculptures to have been created in
this century. George Rammell, his project manager, suggested that in-
stead of black granite, cast bronze patinated black would better suit
the vicissitudes of long term outdoor exposure at the future site. Reid,
who suffers from Parkinson's disease and required the help of assis-
tants throughout, began work on the clay maquette in 1986. When
funding for the project could not be found, Ray Johnson, the Win-
nipeg-born president of Nabisco foods, committed his company to
supporting the project in its entirety.

In late 1986, after a bronze cast had already been made from the
clay sketch, Reid halted work on the project, steadfastly refusing to
work on anything destined for a federal government building. The
reason was the long-standing Haida land claim, imminently
threatened by commercial logging firms' plans to clear-cut sections of
Lyell Island. When a deal was finally struck between the federal,
provincial, and Haida governments, the blockades came down, and
Gawaii Haanas (literally "the Islands of Awe" in the Haida language)
became the South Moresby National Park Reserve. Work on the con-
struction of a full size clay prototype built over a complex web of
welded steel and wire mesh armature resumed in 1988. Over one
hundred interlocking positive sections were formed and cut from a
plaster mould.

Continually critical of the work as it progressed "from one end
to the other," Reid had sections taken apart and reassembled
numerous times in order to rework details he was not satisfied with
directly on plaster. Each piece of this three dimensional jigsaw puz-
zle was coated in white shellac to stabilize the plaster during ship-
ment to the Tallix Foundry in Beacon, New York. The casting,
welding, chasing and patinating of the final seventy-nine pieces was
completed by February 1991, whereupon the entire piece was
patinated with commercial black shoe polish to give it a dark, reflec-
tive patina as is done in contemporary Haida argillite carving. The
foundry allowed Reid's celebrated ark to paddle on to its final rest-
ing place in Washington D.C. only after an additional payment of
$250,000 was made (costs for the project, from start to finish, had es-
calated to $1.5 million). Owned by the Canadian Government, the
4,900 kg *Black Canoe* now stands in a pool of moving water at the
entrance of the Canadian Embassy in Washington. A second casting

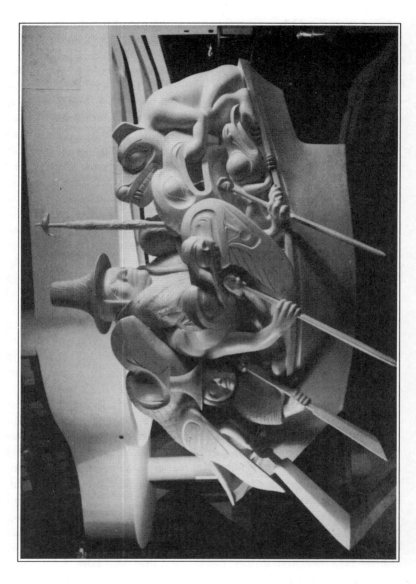

Bill Reid. *The Spirit of the Haida Gawaii*, 1988-89. Original plaster maquette of eighty assembled pieces. Six metres long, 4 metres wide, 3 metres tall. Photo courtesy of The Canadian Museum of Civilization, Hull.

of *The Black Canoe* has since been commissioned for the Vancouver International Airport.

Located in the centre of all the benign symbols and powers that make up *The Black Canoe*'s overall composition, stands the resolute figure of the chieftain who is the undoubted leader of this self-contained voyage into the dark heart of Haida mythology. Each figure seems to exist in relation to all the others by necessity, not choice. We get the feeling that this boat is not truly a seafaring vessel at all, but instead a powerful emblem of cultural survival on the periphery. The whole complex matrix of the piece, its unfamiliar equations, suggest that spiritual wholeness has nothing to do with mankind's conception of itself as the conscious centre of the universe, but with how we realize our connectedness to all other forms of life. After all, it is the ubiquitous Raven, not the tribal chieftain who is actually steering the canoe with his wings and tail, determining the direction of this voyage. He is the trickster of Haida mythology, an omnipresent character, greedy, curious and timeless as the universe. Nestled under one of his wings we see the tiny figure of the bewhiskered Mouse Woman, the meekest and wisest of all the characters in Haida legend.

The staff held in the hand of the chief is an actual reconstruction of a staff purported to have belonged to chief Xana from Masset, in storage at the Smithsonian Museum for over one hundred years. Reid commissioned Don Yeomans, a young native sculptor, to recreate its original figures of a Raven with human hands and the Snag (a power who lives at the bottom of the sea) in the form of a grizzly bear with finned arms and a killer whale's tail. By reclaiming the symbolic imagery on the original staff Reid has, in a sense, liberated it from its permanent museological imprisonment. As we look at the rich visual and cultural symbols that the staff represents, it becomes a sculpture within a sculpture, a key to the past whose ancient motifs are intact, encoded in its sculptural form.

At the opposite end of the canoe sit a group of figures consisting of Bear, Bear-Woman and her two cubs. Haida legend tells us that Bear-Woman once made a wicked comment about the bears which annoyed them. A man guided her beyond the mountains to a village inhabited entirely by bears, who when they went indoors, took off their skins and became people. Bear-Woman won the bears' confidence by leaving pieces of her copper jewellery around. She married the village chief's son, raising two bear cubs for children — transformers who had the power to adjust the balance of the world. This internal grouping of four figures (Reid named the two bears Good Bear and Bad Bear after A.A. Milne's *Winnie the Pooh*) communicates a

message of overall harmony through their succinct sculptural inter-
relation. The Dogfish Woman with her beak-like nose is a more
austere, unsettling figure. She is lost somewhere between the human
and other-than-human undersea world. The Frog (land crab in
Haida) is a *female* transformation figure, a child of the Raven's wife
who symbolizes wealth and migrates between the two distinct realms
of the sea and the land. This segment bears resemblance to *Phyllidula,
the Shape of Frogs to Come*, a yellow cedar carving made by Reid in
1984. Other figures on the canoe include Beaver, Wolf, Eagle and The
Ancient Reluctant Conscript. Named after a poem by Carl Sandburg,
the latter alludes to Reid the creator of the work, a rare occurrence in
Haida art of any kind. He is paddling and wears a cedar bark cape
and plain woven spruce root hat, traditionally crafted by Haida
women.

These composite figures are not a modern-day theatre of the ab-
surd, but a concrete representation of the multiplicity of forms the
human spirit can take in Haida culture. The worldliness of Haida
wisdom lies in its implicit realization that any physical relation to
the beyond relies on our recognizing *that* which is within every-
thing. More than mere symbols — what philosophers would now
call an ecology of the mind — the balancing and interchangeability
of human and animal imagery in these complex, near abstract
figures is part of the entropic cosmology of the universe. Their func-
tion parallels symbolic animal representations in all distinct cultural
traditions. As Aniela Jaffé commented in her essay, "Symbolism in
the Visual Arts,"

> [They] show how vital it is for men to integrate into
> their lives the symbol's psychic content — instinct. In it-
> self, an animal is neither good nor evil; it is a piece of na-
> ture. To put this another way, it obeys its instincts. These
> instincts often seem mysterious to us, but they have a
> parallel in human life: The foundation of human nature
> is instinct.[6]

The creatures that inhabit Bill Reid's *The Black Canoe* are not in a
race with time, but are a composite expression of the fact that when
mystery is attributed to apparently ordinary things, they give whole-
ness and form to everything we experience.

Notes

1. Chris Dafoe, "An Odyssey of Mythic Proportions: Bill Reid's 'The Spirit of the Haida Gawaii'," *The Globe and Mail*, November 16, 1991, p. C5.

2. Hillary Stewart, *Totem Poles*, (Vancouver: Douglas & McIntyre, 1990), p. 53.

3. Douglas Cole, "The History of the Kwakiuth Potlatch" in *Chiefly Feasts*, Aldona Jonaitis, ed., (New York: American Museum of Natural History, 1991), p. 137.

4. Ibid.

5. Robert Bringhurst & Ulli Steltzer, *The Black Canoe: Bill Reid and the Spirit of the Haida Gawaii*, (Vancouver: Douglas & McIntyre, 1991), p. 76.

6. Aniela Jaffé, "Sumbolism in the Visual Arts," in *Man and His Symbols*, Carl Jung, ed., (New York: Dell Publishing, 1964), p. 265.

17

Americanacirema
The Other Side of the American Dream:
Duane Hanson

The fibreglass security guard who is staring at you looks virtually identical to the real one who stands across the exhibition room. They're both part of the same scenario and its all about art, reality and the modern-day museum. Clothed in the generic uniforms of their blue collar lifestyles, Duane Hanson's life-size people sculptures on exhibit at the Montréal Museum of Fine Art (M.M.F.A.) in 1994, are as homogenized as milk in a carton. Unlike the wax models from Madame Tussaud's, Hanson's humans are modelled to look as real as you and me. Their bloated bodies, flaccid composures and blank stares are the natural extension of nineteenth-century philosopher Jeremy Bentham's utilitarian principle in which he states: "It is the greatest happiness of the greatest number that is the measure of right and wrong."[1] Unlike Bentham's actual corpse which still sits, fully clothed, on exhibition at University College in London, Hanson's sculptures are the real thing — the cannon fodder of a culture built on pragmatism, now force fed on image culture and mediocre lifestyles — the other side of the American dream. In Hanson's own words:

> My images don't go near what you see in real life. The world is so remarkable and astonishing and surprising, that you don't need to exaggerate. What exists out there is mind boggling. I don't know what it is. They don't take care of themselves.[2]

Duane Hanson emerged as an artist during the heyday of the late sixties Pop art movement. His mentors included George Segal, whose typical proto-installation pieces had ghost-like plaster people, gas pumps, coke bottle stands and assorted objects appropriated from reality; and Edward Kienholz, the master of the nightmare, whose works confronted faceless institutionalization and expressed the neglect of America's marginal citizens. While Duchamp's *objets trouvés* sought to prove the museum was not capable of ingesting *everything* as art within its walls, his appropriated objects paved the way and softened the walls of the museum and gallery institution so

that virtually anything could be collected and exhibited. Idolizing the consumer logos, products and signs of sixties image culture, Pop art perpetuated Duchamp's legacy of the appropriated, ready-made object but gave it an overtly commercial twist. Duchamp's L.H.O.O.Q (1919) — Mona Lisa with a moustache — became Andy Warhol's *Marilyn* (1962). Once irreverent, now decadent, subversive art became as American as apple pie. The museums and galleries sought it like bees do a flower.

Marco Livingstone's catalogue essay for Hanson's M.M.F.A. show resurrects Michael Fried's infamous 1967 attack on minimalist (or literalist) art titled "Art and Objecthood." At the time, Fried stated that "the experience of literalist art is of an object *in a situation* — one that, virtually by definition, *includes the beholder*."[3] Livingstone refers to Fried's commentary on the views of minimalist sculptors, Donald Judd and Robert Morris, on actual space, the spectator's body and the sculpture-object. He notes that these views could as readily describe Duane Hanson's sculptures.[4] As object representations that also play on our perception of reality and actual space, Hanson's people sculptures both subvert and cleverly disguise Duchamp's legacy in the guise of "found humans." The illusion is all the more remarkable because of the complexity of Hanson's sectional casting, assemblage and cosmetic painting techniques. The gap between art and life becomes virtually indistinguishable, yet the concerns are quintessentially human.

The Sidney Janis Gallery's breakthrough show, *Sharp-Focus Realism* (1972), included the painters Malcolm Morley, Philip Pearlstein, Tom Blackwell and Richard Estes, in addition to David Hanson. As American critic Harold Rosenberg noted, *Sharp-Focus Realism* ushered in a new era in art history but, "it was (history) being made rather listlessly."[5] While gallery owner Sidney Janis flitted to and fro serving clients during the *vernissage*, Hanson's plastic sculptural replicas stood there like eternally patient, if somewhat sardonic, alter-egos of those visiting the show. For Duane Hanson, realist sculpture avoided the pitfalls of formalist sculpture's structural concern with space and architecture altogether. The result of his work was a three dimensional realism that took the illusion of representation one step further by adding layers of detail in a process similar to painting. The show was a triumph for all that *trompe l'oeil* stood for. For an instant, the spectators own perceptions were called into question because Hanson's sculptures looked so real yet were just plain sculptures. Harold Rosenberg comments:

The spectator's uncertainty is eliminated by his recognition that the counterfeit is counterfeit. Once the illusion is dissolved, what is left is an object that is interesting not as a work of art but as a successful simulation of something that is not art.[6]

War (1967), an assemblage of monochrome mud-coloured and bloodied soldiers slain in a rectangular field; and *Policeman and Rioter* (1967), an image of a black man being bludgeoned to death, were both in the M.M.F.A.'s 1994 show. They addressed sixties themes of social unrest, the Vietnam War and racial tensions in the United States. Hanson's more recent sculptures are of everyday people. A photographer in a polyester shirt and Keds kneels beside his camera bag. Three construction workers take a break surrounded by scaffolding, drills, cables, tools and lunch boxes. The cleaning lady from every office tower from Montréal to Fort Worth stands behind her Rubbermaid waste container with her feather duster in hand like a drill sergeant. These figures have a muted apathy to them that is no less political because it suggests the flip-side of violence where the victim, like the protagonist, cannot escape the confines of conformity and social norms. In real life they would be boring, but as subjects on display in a museum venue they evidence the contemporary art museum's gradual transition from high art legacy to the popcorn ethic of *realistic* cultural agendas. Citing the example of Caravaggio's "humane realism" in *The Invisible Dragon*, Dave Hickey writes:

> We must ask ourselves if Caravaggio's "realism" would have been so trenchant or his formal accomplishment so delicately spectacular, had his contemporary political agenda, under the critical pressure of a rival Church, not seemed so urgent? And we must ask ourselves further if the painting [*The Madonna of the Rosary*, 1606] would have even survived until Rubens bought it, had it not somehow expedited that agenda? I doubt it. We are a litigious civilization and we do not like losers.[7]

Whether it's the cheerleader, the football player, the unemployed worker who sits on a box holding a "Will Work For Food" sign, or someone collapsed in his armchair with a can of beer, Hanson's reluctant tenants of the American dream chart out their progress within the narrow confines of mass media culture in a fine art venue. One thinks of Gustave Courbet, a realist from another time who, despite

his fear of seeing his works debased by art market commodification, was frustrated when he found his *Après-Dîner* was denied a place beside the old masters in the Louvre. Surrounded by the objects associated with their lifestyles, like mannequins from a Walmart store, Hansonian people explain a social condition in its own terms. As banal enigmas of contemporary American life they look like exhibits from a late twentieth-century culture display in a twenty-first century Museum of Civilization and recall University of Michigan anthropologist Horace Miner's famous tongue-in-cheek essay *Body Language among the Nacirema*:

> the Nacirema ... are a North American group living in the territory between the Canadian Cree, the Yaqui and Tarahumare of Mexico, and the Carib and the Arawak of the Antilles. While much of the people's time is spent in economic pursuits, a large part of the fruits of these labours and a considerable portion of the day are spent in ritual activity ... The fundamental belief underlying the whole system appears to be that the human body is ugly and that its natural tendency is to debility and disease ... certain practices which have their base in native esthetics depend upon the pervasive aversion to the natural body and its functions. There are ritual fasts to make fat people thin and ceremonial feasts to make thin people fat ... The Nacirema (are) a magic ridden people. It is hard to understand how they have managed to exist so long under the burdens they have imposed upon themselves.[8]

Art's symbolic or political role in contemporary Western culture has waned in recent years because the public distrusts pretense, no matter what shape it takes, yet popular mass culture is no less manipulative than the high art of the past and a great deal more pervasive. The sunbathing woman wearing a flowered bathing cap and polka dot bikini, with her bag of Fritos, scooter pie and a can of Diet Coke, has her necessary dose of supermarket tabloids near at hand whose headlines read: "What Thief Butler Saw ! Burt and Loni's Explosive Marriage. What a drag. Burt Dolls up in Loni's Wig." They represent America in microcosm, as distant from the White House and depoliticized as Disneyland. What is even more disturbing is the way these sculptures explain emptiness. It's like an echo without a reply, as seamless and devoid of human sentiment as crinoline in a

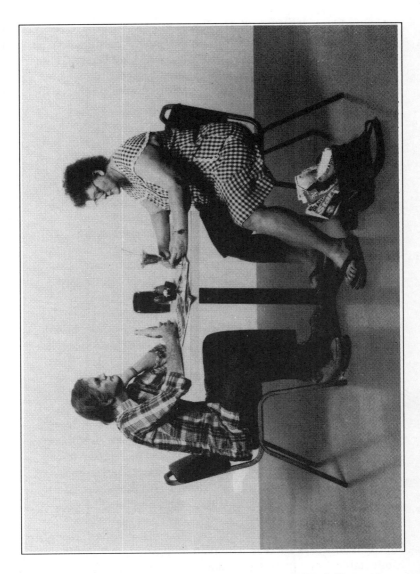

Duane Hanson. *The Other Side of the American Dream*, 1979. Self portrait with Model. Polyvinyl acetate and mixed media polychromed in oil with accessories. Life size. Collection of the artist. Exhibited at the Montréal Museum of Fine Arts in 1994. Photo courtesy of the artist.

white cube, as if all the dignity and willpower of these people has been drained by the effects of mass media culture. In the film *Manufacturing Consent* by Montréal-based filmmakers Peter Wintonick and Mark Achbar, the world-renowned linguist and social theorist Noam Chomsky speaks of this diversionary effect which the mass media has on the American population:

> There's the real mass media — the kinds that are aimed at, you know, Joe Six Pack. The purpose of those media is just to dull people's brains ... for the 80 percent or whatever they are, the main thing is to divert them. To get them to watch National Football League. And to worry about "Mother with Child with Six Heads" or whatever you pick up on the supermarket stands and so on. Or look at astrology. Or get involved in fundamentalist stuff. Just get them away. Get them away from things that matter. And for that it's important to reduce their capacity to think.[9]

Making the real look real is an extraordinary thing to do because it causes us to question what ordinary is. Duane Hanson states:

> These sculptures are a panorama of American society. I'm a sculptor. I use hair and objects. I've never seen abstract as better than realism. This is the result — take it or leave it. The human condition revealed. I have great sympathy for the cleaning lady, for instance. We're all in the same boat. The face is like a road-map. You study the face and you can see that it's not so enjoyable. There's been ups and downs and that's related to the body and the whole thing comes together.[10]

Revealing the human cost of progress involves recognizing failure as much as success. The pain is never stated and it's a fairly comfortable tragedy, but you can feel it anyway. These sculptures are the forgotten people who live in the shadow of the Hollywood minute — the other side of the American Dream played out for all to see.

Notes

1. Jeremy Bentham cited in *The Oxford Companion to English Literature*, Margaret Drabble, ed., (New York: Oxford University Press, 1985), pp. 88-9.
2. Duane Hanson cited in Marco Livingstone, *Duane Hanson*, (Montréal; M.M.F.A., 1994), p. 48.
3. Michael Fried cited in Marco Livingstone, *Duane Hanson*, (Montréal: M.M.F.A., 1994) p. 57.
4. Marco Livingstone, *Duane Hanson*, (Montréal: M.M.F.A., 1994) p. 57.
5. Harold Rosenberg, "The Art World: Reality Again," *The New Yorker*, Feb. 5th, 1972, p. 88.
6. Ibid.
7. Dave Hickey, *The Invisible Dragon: Four Essays on Beauty*, (Los Angeles: Art Issue Press, 1993), pp. 18-20.
8. Horace Miner, "Body Language Among the Nacirema," *American Anthropologist*, Vol. 58, 1956, pp. 506-07.
9. cited in, *Manufacturing Consent; Noam Chomsky and the Media*, Mark Achbar and Peter Wintonick, eds., (Montréal: Black Rose Books, 1994), p. 90.
10. Duane Hanson in conversation with John Grande, February 1st, 1994.

18

Carl Beam: Dissolving Time

"Perhaps if they'd stolen your land, your culture and your spirit, you'd paint a different picture of history too," announced the Canadian Museum of Civilization's brazen advertisement for *Indigena*, one of a spate of shows featuring contemporary Canadian native art held in 1992 including the National Gallery's *Land, Spirit, Power*, Pierre-Léon Tétreault's *New Territories: 350-500 Years After* in Montréal, and Carl Beam's *The Columbus Boat* at The Power Plant in Toronto. If redressing five hundred years of cultural oppression and colonial exploitation has always been something of a delicate matter for ethnographers, it was an about-face for the Canadian art establishment.

As recently as 1986, when the National Gallery of Canada decided to purchase Carl Beam's *North American Iceberg*, (1985) it was the only native work of art (aside from a small group of Inuit prints and sculptures assembled in the fifties and sixties), to have been put in the gallery's collection since the acquisition of a northwest coast Argillite pole in 1927.[1] Emily Carr's paintings of disappearing totems and villages had been selected that same year by Eric Brown, director of the National Gallery, for a major exhibition of west coast art. The real stuff, native-produced art, was relegated to curio collectors or destined for storage in the Smithsonian, the Museum of Man, or further afield at the Palais de Trocadero in Paris or the Ethnology Museum in Vienna.

North American Iceberg was Beam's caustic comment on the Art Gallery of Ontario's 1985 blockbuster show, *The European Iceberg*. Theoretical and cultural stereotypes were imported from Europe via renowned German and Italian artists of the trans-avant-garde — artists who could afford to cast aspersions on the museum and gallery institution, considering them ideologically and historically hamstrung. At the same time, Carl Beam, like most of Canada's younger generation of native artists, was still largely unrecognized — relegated to bush-league regional shows. Some years earlier, his graphic works were rejected by the McMichael Collection in Kleinberg (a "family gallery")because one of them contained a rude word. On the National Gallery purchase of his work in 1986, Beam later commented:

I realize that when they bought my work it wasn't from
Carl the artist but from Carl the Indian. At the time, I felt
honoured, but now I know that I was used political-
ly...Indian art that's made as Indian is racially
motivated, and I just can't do that. My work is not made
for Indian people but for thinking people. In the global
and evolutionary scheme, the difference between
humans is negligible.[2]

At the time of its purchase in 1986, Diana Nemiroff, co-curator of the
1992 *Land, Spirit, Power* show, referred to *North American Iceberg* as, "a
reminder of cultural relativity, of the cyclical and inevitable nature of
change, and an affirmation of the visionary power of the artist."[3]

The prices themselves reflect another story. *North American Iceberg*
was bought by the National Gallery of Canada for $14,000, while Bar-
nett Newman's *Voice of Fire* (1967) sold for $1.8 million in 1989. So-called
primitive art effortlessly bridged the gap between abstract principle
and environmental reality, and yet this was where Newman drew a lot
of his inspirational fire. In a catalogue preface to a show of northwest
coast Kwagiulth art at New York's Betty Parsons Gallery in 1946, New-
man called the use of the geometrical shape in Cubist and post-Cubist
painting "a formal abstraction of visual fact." In northwest-coast native
painting the same shape was referred to as a "living thing."[4] While
abstract expressionists were "freeing [themselves] of the impudence of
memory, association, nostalgia, legend, myth, or what have you, that
have been the devices of Western European painting,"[5] they still had
the arrogance of an effete, formalist vision of art on their side. If anyone
had dared to consult natives to ask their thoughts on *Voice of Fire*, they
probably would have called the painting a fetish object, little more,
nothing less. It was what their own ephemeral creations had been for
millennia.

Birth of a modern

Carl Beam was born in West Bay on Manitoulin Island in 1943, to
an Ojibway mother. His father, whom he never met, was of European
descent. At an early age, Carl Beam went to a Catholic boarding
school for native children. He held various labouring jobs: on the
Bloor St. subway tunnels in Toronto, as a millwright's assistant in
Wawa, as a hand in a sawmill, and in logging in British Columbia. His
formal studies began at the Kootenay School of Art in 1971. He later
transferred to the University of Victoria in 1973 to study with Donald

Harvey, Mowry Baden, Roland Brener, Pat Martin Bates and John Dobreiner, finally completing his Bachelor of Fine Arts in 1976. In 1978, after walking out of a University of Alberta MFA program after disagreements over the nature of his thesis on native art, he returned back east with his family.

The Woodland School of native painting, initiated by Norval Morrisseau, a self-taught artist and master of colour and form, was in full bloom at this time. Morriseau's images come to him in what he calls "dream visits from the astral plane." He considers painting to be therapy for both painter and viewer. His importance as the father of contemporary Canadian native art is unquestionable. Like his grandfather before him he considers himself to be a shaman in the Ojibway tradition. For a contemporary Ojibway artist such as Carl Beam, "It's a complicated issue. If we accept the notion of 'market', then I've got nothing to say. But art must be relevant and ongoing and I find that particular school [Woodland] allows very little room for personal creativity."[6] Beam's generation of native artists has run the gauntlet of art school and university training and emerged holistically intact, but well versed in the stone-washed formalities of postmodernism. Carl Beam carries a new set of cultural variables into the foray.

In 1978, while living in Sault Ste. Marie, Beam made contact with other native artists including the Manitoulin Island painters Don Ense and John Laford and produced a wide range of experimental prints, collages, watercolours and constructions. While his works referred to native mythology, they dealt with universal themes in a thoroughly modern way. They were culturally distant from Norval Morrisseau's accepted "Indian formula. Their non-native use of contemporary imagery and notations mystified collectors of native art just as collectors of vanguard modernist art had not yet accepted that native could indeed be contemporary. In *Inter-Stellar Village Communion* (1980), a cosmic map divided into computer-like grids with stencilled letterings read "East Longitude (Degrees) and Latitude (Degrees)" along its borders, while a native's face haunted one of the boxes within. *New Medicine* (1979), with its abstract "quotational" form and its feather imprints below (a representation of the real that looks abstract), is more perplexing because it uses the latest language in modern art to poke fun at the formulaic niceties of Western avant-gardism, like a laconic joke made by an outsider looking in. Other works from this period show a bird in flight, its internal anatomy exposed, skulls and bones of animals integrated into painted constructions, and hand designs recreated to resemble those in cave paintings.

Before moving to Santa Fe, New Mexico in 1980, in part to escape the limitations (some self-imposed) on native artists in Canada, Beam painted a watercolour titled *Self Portrait in My Christian Dior Bathing Suit* (1978-80), a tongue-in-cheek portrayal of the artist as naked savage/noble warrior. As a caricature of the native in warrior stance, vulnerable yet defiant in designer underwear, the work is a sardonic inquisition into the native artist's quandary — caught in the spin-dry cycle of generic consumer culture — as seen from both sides. The shaman is unmasked by fashion, the fashion seeker is unmasked by cultural alienation. Beam has long grappled with questions of identity in an age where the arms race keeps the jobs back home while people are blown to bits in the third world.

> If you have your own face next to a rocket, if you have your own face next to the Sadat assassination, this, to me, implies that one...has to have personal responsibility for world events. You have to respond personally. Everybody eventually has to learn how to respond or to filter what's happening through their own senses.[7]

In *The Malaise of Modernity*, McGill political science professor Charles Taylor states:

> In pre-modern times, people didn't speak of "identity" and "recognition," not because people didn't have (what we call) identities or because they didn't depend on recognition but rather because these were too unproblematic to be thematized as such.[8]

Does a native artist really worry about "identity" and "recognition" after millennia of cultural neglect? It depends on what one's notions of time and the meaning of history are. As Beam stated during a panel discussion in Vancouver in 1989:

> This is totem pole country. For a Native person, if you raised a pole on one of the islands, it's an event itself. It is historical in the sense that it means something to the community. They don't remember it as: This pole was erected in 1979. They have no idea when it was raised. Their relationship to history is totally different...if you just take all the forms in the totem pole — however true and right they may be, anthropologically speaking, the

whole point is that the Native people see it in a different
context — a monument raised in time. It's not about
structure and forms — form and structure are secon-
dary to the definition of a thing being raised in time. If
you don't take that into account, and try to learn from
that kind of information, you can never understand
anything foreign; you are only looking through the
standard eye glasses of European tradition. If you just
introduce the idea of time, real history and what's im-
portant, they might just drop off.[9]

Healing the wounds of the past

Spending time in New Mexico allowed Carl and his wife Ann to
investigate the ancient Anasazi earthenware style and techniques of
the Pueblo Indians. They later utilized these techniques to create pot-
tery with Ojibway motifs and designs using images of animal skulls,
eagles and native peoples, as well as bowls with illustrated portraits
of Anne Frank and the Statue of Liberty. Dr. J.J. Brody, then curator at
the Maxwell Museum in Albuquerque, New Mexico, wrote of Ann
and Carl Beam's first solo show there:

Smaller, more carefully made, more refined and more
highly finished than the Anasazi originals ... in many
respects these pots are more like easel paintings than
crafted objects and for that reason raise questions about
our categories of fine arts, craft arts and ethnic arts.[10]

The interiors of the Beam's unglazed, brownish pottery bowls — fired
with red cedar to give a reddish colour and rough pebblish texture —
are sculptural spaces decorated in relation to their inner dimen-
sionality. In a later show titled *Ascending Culture* (1986), in Hull, Beam
applied his ceramic expertise to a different purpose. A series of flat
square glazed plates, formatted like paintings, transposed photo im-
agery onto clay in order to explore textural and colour contrasts. One
of the plates juxtaposed images of Pope John Paul II, military tanks
and helicopters, the stencilled number 677, a blown-up playing card
of a queen and handwritten autobiographical notations.

The Artist with Some of His Concerns (1983), one of Beam's water-
colours from trying times in the early eighties, deals with a different
kind of cultural vivisection, one that is not an equation at all. The
work was comprised of a self-portrait and two views of an eagle par-

tially obscured by a grid, as well as a painted recreation of Egyptian President Anwar Sadat's assassination taken from stop-action news photos, and studies of a horse's head below. The work declares the act of representation to be an exercise in quantification. A topographic measurement of visual vocabulary is captured in time, fitting into a repertoire of reactive meaning. The truisms of technoculture are as clichéd as they are reprehensible — recreated, transposed and transmitted for posterity, not eternity. Like a wrecker's ball in a hall of mirrors, Beam's curious composite images *look decontextualized*, but suggest another level of cultural permanence — of spiritually flying through time with nature, not against it. You're never sure what's going to happen next.

In the summer of 1992, Beam hung eighteen huge banners titled *Colours of Humanity* from Toronto's Skydome stadium. These words accompanied the piece: "Ojibwe belief holds that four colours (black, red, white and yellow) represent all peoples of the earth. These races exist within a circle forming a powerful spiritual union ... We are all united."[11] At the same time, The Power Plant was presenting part of Beam's *Columbus Project*, a selection of works titled *The Columbus Boat*. This work was part of his ongoing reevaluation of history — both the white man's and the native's, an open search for a less qualified, universal language of self-realization. In phase one of *The Columbus Project* (1989), exhibited at Artspace and the Art Gallery of Peterborough, "The Need to Explain Everything" was painted in large letters on top of a blank canvas. The paintbrush that hung from one corner of the piece referred to the Romantic landscape painter's legacy, the representation of nature as an aesthetic commodity. In Beam's own words:

> I did a painting in school — all it had on it was some loose painting, and a three-foot metal ruler all bent up on it — tied up on top with a little ball of cloth dipped in paint tied onto it, and I swung it back and forth on the painting. It was a little crippled yardstick painting. I just wrote on it: THE NEED TO EXPLAIN, and that was the whole one-liner painting. Somebody looked at it and he was really driven crazy. He said: "What are you trying to do? What you are saying here is that the need to explain is really a redundant aspect of our being here. The way it looks — without saying good or bad — is that you are trying to pre-empt the whole thinking process — explicating and explaining, books and charts and

maps — all that investigative experience — is
preempted in the painting." I said: "That's what you
read into it. See, even now you're explaining. Where
does your need to decipher my painting come from?"
The truth of the painting, although it didn't solve any-
thing, raised the question of how much explaining do
we need, or how much explaining should I do? Or why
am I doing it?[12]

The twisted ruler covered with a ball of cloth suspended in the centre
of *Burying the Ruler* was echoed in a video with the same title also
presented at The Power Plant. The video was a record of Beam's visit
to the Dominican Republic in 1992 to "meet" the original native in-
habitants, the Taino tribe of Hispanola, who became extinct fifty years
after Columbus' visit due to starvation, genocide and slavery. The
Burying the Ruler video and multimedia painting both portray Beam
burying a ruler in the sands of the Dominican Republic near the first
landing site of the first European colonizers. The act of burying the
ruler was purely symbolic, an attempt to underline our culture's need
to reason, measure, and quantify the world around us. By leaving the
shape of the ritual wide open, Beam's intent was to heal the wounds
of the past, emphasize the need to innovate, create new meanings,
and find other ways of interpreting life.

Outside the entrance to The Power Plant's exhibit, Beam's *Altar*
(1992) invited gallery-goers to attach available feathers to a twig with
string and plant them in the sand-filled well, making a wish for the
young people of the world — the future. Inside the Power Plant, a
twenty-foot long replica of the hull and mast of the Santa Maria, built
to one-fifth of scale, stood like an empty shell. Over forty mixed-
media paintings and prints on the gallery walls spewed a profusion of
images reproduced in photo emulsion on canvas — painted or drawn
over, annotated, and condensed like information bits — creating an
ahistorical rhetoric of image production. Escaping like so many live
sardines out of a can, Beam's condensed and intensely personal im-
agery collapses and consumes our stereotypes of history, the legacy of
Cartesian thinking. Superficially, the media images and objects Beam
incorporates in his paintings owe some debt to Robert
Rauschenberg's *flatbed constructions* from the fifties. Beam's hand-
written autobiographical notations, curious numerological and al-
phabetical references recall Cy Twombly's works. Yet these styles are
appropriated by Beam as composite elements we read in a broader
context of cultural relativism and stylistic freedom.

Cyclical Temporal Adjustment (1992), a cropped and expanded portrait of Christopher Columbus (of whom no known likeness actually exists) depicts him, in his typically sympathetic Occidental guise, as European venture capitalist supreme. The picture's title, stencilled in above becomes just another visual design, no different than a native pictograph. A crucifixion scene from a painting by Andrea Mantegna (1431-1506) occupies the lower half of the painting, simultaneously representing the religious and political values Columbus exported with him to North America and the native initiation rite known as the piercing ceremony. Mantegna's painting becomes just another visual image among many and loses its iconographic significance.

Partially covered with drips, swaths and runs of paint, and with hand drawn vertical and horizontal lines, all the images and cultural artifacts Beam uses, both textual and visual, are given equal weight. Taken out of any natural chronological (historic), sequential (linear) or compositional (formalist) context, images of dramatic historical events (Hiroshima, Viet Cong shooting prisoners) co-exist alongside images of famous personages (Albert Einstein, Chief Sitting Bull, Abe Lincoln, Martin Luther King), documents (Eadweard Muybridge's quasi-scientific photo studies of locomotion), reproductions of religious paintings, anomalous family and personal portraits, and other incongruous items such as images of Galapagos turtles, parking meters, bees, stop lights, hydrometers, and confetti-like pieces of a cut-up fifty dollar bill. Carl Beam's images are reproduced in photo-emulsion on canvas to become interchangeable anachronisms — postcolonial composites that particularize the contents of each image. They become information bits of visual imagery whose random selection and juxtaposition mimics the codes and methodologies of representation from which we derive a sense of historical permanence — but their symbolic meaning has been equalized in a way that collapses our conception of time and consumes our own stereotypes of media-related imagery.

Like a latter-day Paracelsus who persists in rendering all manner of imagery equal, Carl Beam seeks to invent a new epistemology that evokes the non-rational, spiritual side of experience. History becomes a synthetic composition — a paradigm of the values our ancestors brought with them to the New World that emphasizes only those established formal histories based on dualistic Cartesian mechanisms that quantify, compartmentalize, endlessly textualize, and document all manner of material. The synchronous visual legends in Beam's mixed-media works at The Power Plant see history from the other

side, as a story like any other story open to a multiplicity of inter-
pretations.

The images of adobe housing seen in Beam's paintings shown
during Phase Two of *The Columbus Project* at Artspace in Peterborough
in 1991 were not just additional data bits or information fragments
from media overload. In early July 1992, Beam presented *Look Ma No
Mortgage!*, Phase One of his *Adobe Project* at the *Arnold Gottlieb Gallery*
in Toronto. Consisting of architectural blueprints and a few hand-
made moulds and adobe bricks set on a table in the gallery, it was
Beam's answer to the recession, an alternative model for a single-
family dwelling built out of adobe using locally available materials:
mud, clay and emulsifier. This kind of housing is now common in the
southwestern United States. Prairie sod huts and a Victorian home
near London, Ontario are examples of the use of adobe in the north
during the latter part of the nineteenth century, however Beam is the
first to revitalize interest in adobe for use in the north in recent times.

Since September 1992, Beam has been back in West Bay,
Manitoulin Island with his family. By December 1993, he had con-
structed and fitted a large-scale custom-built home with multiple
level contours out of five thousand adobe bricks at a total cost of
$50,000. A smaller house could be built on the same principle for
around $20,000. While the high-tech crowd would consider this a
Luddite's dream, for Beam it is a low-tech reality. Not made of con-
crete or standard brick, but using materials from the site itself — a
practical response to the rising cost of housing — adobe cut the stand-
ard cost of construction by fifty percent and uses seventy-five percent
less virgin wood.

The London Regional Art & Historical Museum presented a fur-
ther exhibition of the adobe project in 1993 titled *Living in Mother
Earth*. The work included photo-documentation and plans of the
house on Manitoulin Island, a video of the project in progress, and an
installation of segments of Beam's adobe construction as well as ten
new paintings. The show examined the relationship of housing debt
to poverty by questioning the concept of the modern single-family
dwelling and the purported aspirations it represents for suburban
middle-class life in Western culture. During the autumn of 1994, the
Beams have again been building a guest house on their Manitoulin
property using an even lower-cost rammed earth building technique.

Carl Beam's struggle as a native artist has not just been a search
for cultural recognition. It often has less to do with art and more to do
with presences, real and imagined — the presence of two visions of
the past in the present. The illusion of history that Beam has had to

Carl Beam. *The North American Iceberg*, 1985. Acrylic, photo-serigraph and pencil on plexiglass. 213.6cm x 374.1 cm, assembled. Photo courtesy of The National Gallery of Canada, Ottawa.

deal with is the white man's — as an outsider looking in. The distance between the past and present is less clearly distinguishable for the colonized than for the colonizer. Carl Beam's solution for Canadians seeking to find answers to our perennial questions of identity is a simple one. We must learn to dissolve our past conceptions of (historical) time based in the philosophical and cultural traditions of the "discoverers," which have marred our true sense of geographic and cultural identity and seek to understand that culture is a flexible system of eco-dependent interrelations. These are as vital to the survival of mainstream Canadian culture as they have always been to Canada's first inhabitants.

Notes

1. Diana Nemiroff, *Land, Spirit, Power: First Nations at the National Gallery of Canada*, (Ottawa: National Gallery of Canada, 1992), p. 18.
2. Carl Beam in conversation with John Grande, September 23rd 1992.
3. Diana Nemiroff, "National Gallery Collects Contemporary Works by artists of Native Ancestry," *Native Art Studies Association of Canada Newsletter*, 11:3 (Summer 1987), n.p.
4. Harold Rosenberg, *Barnett Newman*, (New York: Harry N. Abrams, 1978), p. 41.
5. Barnett Newman, cited in *Barnett Newman: Selected Writings & Interviews*, John P. O'Neill, ed., (New York: Alfred A. Knopff, 1990), p. 173.
6. Carl Beam in conversation with John Grande, September 23rd, 1992.
7. Elizabeth McLuhan, *Altered Egos: The Multimedia Work of Carl Beam*, (Thunder Bay: Thunder Bay National Exhibition Centre and Centre for Indian Art, 1984).
8. Charles Taylor, *The Malaise of Modernity*, (Concord: House of Anansi, 1991), p. 48.
9. Carl Beam, Artist's statement in *The Columbus Project Phase 1*, (Peterborough: Artspace and the Art Gallery of Peterborough, 1989), p. 13.
10. Robert Reid, "Ontario: Carl Beam in Brantford," *Artpost*, August/September, 1985, pp. 29-30
11. Carl Beam cited in gallery statement, Arnold Gottlieb Gallery, Toronto, 1992, np.
12. Carl Beam, Artist's statement in *The Columbus Project Phase 1*, (Peterborough: Artspace and the Art Gallery of Peterborough, 1989). pp. 11-12.

19

Dmitri Kaminker's Mythical Menagerie

Despite the fact that they worked in the incubus of a highly demotic aesthetic programme, Russia's artists had a much simpler job of identifying their expression in relation to a collective culture before Glastnost than they do today. Before the collapse of Communist ideology and Gorbachev's initial efforts at democratizing the country, unofficial artists exerted much of their energy working against "official" Soviet art and its repression of free expression. "Official" artists went about their work, largely ignoring the ideology of the State but with the State's approval. Thus, artists on either side of the fence could always define their actions vis-à-vis the ideological imperative, as either part of the "official" cultural programme or alternatively, as unofficial artists, marginalized by a moribund political system.

Throughout the world today, we are witnessing an unprecedented collapse of ideologies. The new basis for creative expression stands firmly outside any traditional ideological ethos. In the West, the very basis of avant-gardism is now being brought into question: its ongoing imperative being so closely associated with the art market and an economic model for historical progress. Similarly, as more humanistic concern begin to surface, Russia's artists are questioning the same limits to ideology from the other side of the coin.

For Dmitri Kaminker, whose large-scale installation *Firebird: Beyond the Fence* was held at the Toronto Sculpture Garden in the Spring of 1990, life as an artist in Russia was never that simple. After graduating from the Leningrad Decorative and Applied Art College, he spent eleven years in an inexpensive basement studio and states modestly, "It was a hard life." Kaminker was an "official" artist, "because if you're not an official artist you can't rent a studio."[1]

A 1989 show of Leningrad artists presented at the Harbour Exhibition Complex in Leningrad 1989 was the first merging of modernist works from all camps. Here, both official and unofficial artists sought to leave behind the narrow structures of political definition and exhibit together. It was here that Rina Greer, director of the Toronto Sculpture Garden first saw Kaminker's work and invited him to complete a project for Toronto. He arrived in the summer of 1990 to work

at York University's sculpture studio in North York, his suitcase loaded with various assemblage items he and his two children gleaned from his apartment to be included in the piece — bits of wallpaper, nails, door handles, anything that was moveable. While in Toronto, Kaminker spent two months, up to sixteen hours a day preparing the various individual works for installation. The sculptures he created are rough-cut wood assemblage pieces that have a folksy, larger-than-life flair. They represent a selection of everyday characters drawn from a typical suburb of Leningrad, a microcosm of life that resembles the place where Kaminker now lives. "The suburbs in Russia are very poor and sometimes dangerous — very different from American suburbs ... more like small peasant communities. The suburbs are outside of ideology, away from the city council. I can feel free there."[2]

These solemn, yet oddly comical personages reveal much about the complex nature of the Russian psyche, recalling the chessboard netherworld of an Arthur Koestler novel where double entendre and Orwellian wordspeak is not a fiction but part of an on-going reality. As such, for all its fantastic creativity, Kaminker's art is less an art of the mind, more a forthright recreation of the everyday experience of the average Russian who does not seek an extravagant life, but a liveable one.

The sensitive, textured characters that comprise Dmitri Kaminker's *Firebird: Beyond the Fence* evolved out of his role as an assistant who made large-scale wooden models for an "official" artist specializing in huge socialist monuments. Kaminker would be given a drawing from which he would build a wooden armature, finishing the piece with clay. He soon began to realize that the wooden structures he created underneath were more interesting than the finished monuments, and it influenced the direction of his own work. Like many of our artists, Kaminker scours old junkyards and torn down homes in Leningrad recuperating old objects and found materials that "have a history" for his works. "I usually use old lumber — it keeps some of the spirit of the people who lived with it. There's some spirit of the old life."[3]

The oppressed and emblematic forms in all of these eight works have a rustic simplicity that recalls pre-revolutionary folk art traditions. They are set into a vernacular landscape interspersed with sections of a partially burnt wooden fence on which youthful graffiti inscriptions, a Russian street sign, and other eclectic details have been added. There is a constructivist laundry line, from which various ir-

regular shapes of wood hang like solid, inflexible memories, and an ironic telegraph pole that resembles the symbol of the Orthodox Russian cross from the Eastern Church's liturgical past. All of this forms a strangely intimate, fairy tale atmosphere into which he sets forlorn iconic images — totemic statues that echo Russia's propagandistic nightmare of half-truths. *Blind Man* stands transfixed on a rocker-like pedestal. His rigid, somewhat Chaplinesque trajectory is one in which hopes and expectations have been straight-jacketed by the politics of his real life situation. Ideally, he would like to touch the earth with a stick and reach the sky with his eyes, but instead he is caught in a static to and fro movement of uncomfortable introspection.

Boy on Sled (Young Hero) literally flies through the air — the very image of the Young Pioneer, a young hero who puts the ideology of the State before that of his family. The only thing that supports him is a tiny house whose interior is plastered with newspapers, a sardonic symbol of the appalling shortage of housing and the Russian family's stoic temperament — the way they will put up with short term inconvenience, while hoping for a better future.

The centrepiece of this whole fantastic village of sculptures, *Firebird on Pedestal*, personifies the traditional Russian folk tale wherein happiness can only be attained if one can catch hold of the tail feathers of the firebird. Like an oversized portrait bust, brilliantly constructed of assembled pieces of wood, its formal presentation is more like what one could see in an official bronze portrait bust from the nineteenth century, but the handling shows a sophisticated facility for the modernist idiom.

Old Hero has a solemn, god-like image of an aging Stalinist hero, who keeps his ideological illusions intact only as a safeguard against a changing world. The figure has the baroque tenor of a mocking caricature. Seated atop his wine box with a bird on his head (an allusion to his more hopeful, imaginative thoughts?), he bears the scars of past battles. Holding a crutch in one hand and a mug of beer in the other, he stares blankly off into space. As Kaminker says,"You do not tell the town hero who fought the invading Germans that he is wrong, a liar or a fool. His life, like those of other Russians is implicated in the experience of all Russians."[4] The base of this piece is an outhouse papered with propaganda, another witty comment on the day-to-day legacy of living under an ideological régime whose original *raison d'être* has vanished.

Wishful Child, the most hopeful of these assemblage portraits, depicts a small girl in the act of decorating a New Year's Tree, a beauti-

Dmitri Kaminker. *Firebird on Pedestal*, 1991. Wood and various elements.
Photo courtesy of The Toronto Sculpture Garden, Toronto.

fully constructed figuration of zigzag patterns. The lintels and beams of the architecture, the support structure of the piece on which she stands, is barely held together with rope. In front of this symbol of a more spirited future, we see the most primitive of communication symbols: a bulky Russian mail box containing a propaganda newspaper and a doorbell.

Somewhat isolated from the main elements of this installation, and situated in front of a waterfall that forms part of the Sculpture Garden's backdrop, Kaminker has constructed a long table. Its barren flatness recalls the Steppes of Russia, the wheat producing bread basket of the former U.S.S.R., and a traditional Stalinist symbol of hope. A page of propaganda is affixed to the table's surface on which a brightly coloured bowl of fruit contains symbols of abundance: bananas, oranges, grapes, a pineapple, and a bottle of Russian champagne. All carved in wood they represent the unrealized desires of all this real-life ideological tragedy, something far from the Russian peoples' daily lives but never entirely forgotten.

Unlike so many of his cultural comrades, the forty-four year old Kaminker has chosen to stay in his native Leningrad. As he continuously warns, many of Russia's émigré artists who are presently enjoying market success in the West no longer address Russian themes using the language of Russian culture, but do so with an American flair designed for effect and for a market sale.

Kaminker's works shed a ray of superstitious courage and hope amid the confusion of current post-ideological works. Like obsolete, yet gentle dreamers, these demi-gods seem to have been formed by historical forces stronger than their dreams and weaker than their thoughts. The foolish exactitude of this cruel joke pushed them into extremes of experience. The overt mythological sense in Kaminker's grandiose ménagerie reveals a truly remarkable power of imagination rooted in actual experience, not abstract delusions. These figures speak of the decay of ideology in a beautifully mythical way.

Notes

1. Karen Shopsowitz, "Dmitri Kaminker," *Toronto Star*, August 23rd, 1990, p. N16
2. Rina Greer in conversation with Dmitri Kaminker, October, 1990.
3. Karen Shopsowitz, "Dmitri Kaminker," *Toronto Star*, August 23rd, 1990, p. N16.
4. Robert Bowers, *Dmitri Kaminker*, (Toronto: Toronto Sculpture Garden Brochure), Oct. 1990, np.

20

Antony Gormley: Being A Landscape

Nature is within us. We are sick when we do not feel it. The sickness of feeling separate from the world is what is killing it. We are earth above ground, clothed by space, seen by light. The distance inherent in sight has made us treat the "outside" as different ... If we are to survive, we must balance outer action with an inner experience of matter. This is the great subjectivity and the great unity. This unity is expressed by those who live close to the earth in living ways. We must integrate our perceptions of the dynamic interpenetration of the elements with the workings of the mind and realise them in the workings of the body.[1]

In October 1989, on a flat territory of red dust and clay pans in central Australia, Antony Gormley walked back and forth until he found a site for a sculpture that would eventually become a focal point in an otherwise undefined landscape. He set up a concrete shell construction titled *A Room for the Great Australian Desert* which was comprised of a smaller square section on top and rectangular form below that could fit one person sitting in a crouching position within. While it looked like an abstract representation of the human body, it also alluded to the rigid rationalism of modern-day urban architecture. The constructed body or habitat set this off against an otherwise natural wilderness setting. The shell had four openings for bodily orifices: the ears, the mouth and the penis. While the piece's interior, seen from outside, remained an unknown quantity, its exterior became a protective and recondite symbol of the human presence within the culture of nature.

In a 1994 show titled *Air and Angels* at the Contemporary Art Society in London, England, Gormley's *Passage* was exhibited; a void formed out of the artist's body was contained within a chunk of concrete. *A Case for an Angel ii* (1990), consisted of an archetypal representation of the human body in lead with a twenty-seven foot span of wings extending almost to the gallery walls on either side. Antony Gormley commented on his intentions:

A Case for an Angel is a declaration of inspiration and imagination. It is an image of a being that might be more at home in the air, brought down to earth. On the other hand it is also an image of somebody who is fatally handicapped, who cannot pass through any door and is desperately burdened. When installed it is a barrier across the space, blocking out the light and blocking the passage of the viewer. The top of the wings are actually at eye level and describe a kind of horizon beyond which you can't see very much, and so you feel trapped and there is a sense of invitation to assert yourself in the space against it.[2]

Throughout the eighties, Gormley dealt with the human form long before it came back into vogue. His own body was and often is both the subject of these sculptures he creates through the body cast method, and the object, what we see after the process is complete. Gormley describes this process as being akin to transcendental meditation because it requires concentration, controlled breathing and immense patience while he — the subject — is being cast and before eventual release from the mould/enclosure. While in his twenties, before he had begun making sculpture, Gormley lived in India for three years. He practised vipassana meditation with the teacher Goenka. Vipassana meditation emphasizes the body's states, perceptions and feelings as a focus for "bare attention." The body acts as a site for the flow of events in the present moment, and counteracts cultural conditioning. The barriers between unconscious and conscious thought become permeable.[3]

Gormley's intention — to reawaken our own bodily sense of self when we look at his human bodily forms in their surrounding environment — is to present nature as an *embodiment* of the human form. Surrounding space, light and the materials inherent to each of his sculptures are equally part of each piece. This can be "architecture" when works are exhibited indoors, and "nature" for outdoor works. Gormley's sculptural forms are not ideal in the formalist sense, because they do not simply seek to represent a formal sensation of place and time. Our own body's sense of beingness is also part of the equation and the collectivity of sensations that goes to make up a composite reality.

As modernism evolved throughout the past century we moved from mimesis to self-expression. The individual's experience replaced the collectivity, but it was a collective anomie. Mimesis was replaced

by the monologic of the individual expression. The ritual celebration of time as being, of form as being, and of being as form subsided even further from "conscious" expression. From Rodin to Brancusi — the eulogy to the infinite subject.

Gormley's leaden human forms, such as the standing, kneeling and bowed over bodies in *Land, Sea and Air II* (1982), are seminal exposures of the human body. Their seam-cast lines expose the body in a new way: personalized with marks of manufacture, a kind of environmental signature that allows us to recognize the procreative characters of materials in the seeming act of representation. The spiritual transcendence of the body's physical form is signified by the ritual or metaphoric marks of the body as container, which can equally signify the point *before* the emergence of an individual identity or the point *after* it has been erased.

An Asian quality of spiritual transcendence first became evident in works such as *The Beginning, the Middle, the End, Out of This World* (1983-84) and *Idea* (1985). Gormley's readily recognizable lead-covered plaster casts had smaller terracotta figures placed on their heads. In *Man Asleep* (1985), the terracotta figures multiplied to become several dozen, the "conscious" ones who walk in a haphazard line beside a life-size lead hammered on plaster-cast body lying in an "unconscious" state on its side. The tiny terracotta figures presented a "dream state" that presaged some emergent, as yet unforeseen future state of being. They contrasted the solidity of the leaden figures for whom the body is a hermetic protective coating made of lead (a radiation-proof material as well) from the exterior surroundings. In a show held at the Art Gallery of New South Wales in 1989, Gormley presented 1,100 of these terracotta figures on their own, set up in two radiating hemispheres like a magnetic field. Standing in the centre of the piece, the viewer sensed the patterns of energy emanating from the figures, all of whose eyes were turned towards the spectator. The piece evoked a strange mixture of feelings. Disconcerting for the viewer, it was something of an epiphany of change for Gormley the artist, because the work would lead to much more ambitious Field projects in the near future:

> I did not want to make "sculpture" in the sense of making work that stood within the tradition of figurative or formalist sculpture, but to get away from representation by concentrating on an idea of the space a man might occupy and how to indicate that space and change it.[4]

When Gormley originally decided to move away from the body-cast lead sculptures that were his trade-mark in the eighties, it was largely a response to the cultural genocide occurring in Africa at that time. "I wanted to use my life to change my life — to start again — to start with a confrontation with the ground, and in that ground to plant possibility. I also wanted to make something that challenged my ideas of form — of the refinement of form and how that happens."[5]

In seeking to explore the notion of perpetual reproduction, mimesis and multiple authorship, bringing these to life in his sculpture, Gormley went to the Cholula Valley in Mexico to work on *Field* with the Texca family of brick-makers. A make-work project that personalized Joseph Beuys' notion of "creative capital" in a way that is both culture-specific and has global implications, *Field* presented a Western sculptor's post-industrial glimpse at permaculture in a world where planned obsolescence, production schedules and technological advancement blur our very notion of connectedness to mother earth. Baked in oil-fired kilns in made with the Texca family in their outdoor *galleria* from locally available materials, these tiny, clumpy archetypes are a collaborative work that could realize its potential "through" a collectivity of creators. In Gormley's own words,

> My friend Gabriel (Orozco) says if you don't believe in language you must believe in chaos. I feel that I tried with language and failed. I was frightened as I set out for Mexico with a great wad of dollars in my pocket to see if I could make a work that evoked the silence of the ground and the necessity of touch — the necessity of touching the other side of life, that which lives behind appearance.[6]

While the making of the figures involved endless production quotas little different from the process of making bricks — it was less standardized and demanded a tactile and instinctual response to the material being worked with, in dimensions scaled to the size of a human hand. Gradually, each of the workers evolved his or her own simplified stereotypes of the chosen form. The creative gap between intention and creation narrowed to the point that "(They) were creating instant Pollock's at the rate of one every few minutes."[7] The direct experience of working with local materials and the rhythm of production identified the work with the infinite flux of birth, life, death, decay and rebirth — transformation through time. Gabriel Orozco describes the experience in a poem titled *Being a Landscape*:

Waking up early and riding the bicycles
to the valley of the ovens and bricks.
Joining a group of thirty we began to mould the earth.
Eight hours of the morning received us with humid earth between the
hands;
earlier yet another man raised a mountain and walks it
mixing the sand and the clay with bare feet.
Below the sensitive fingers the bodies were formed.
The gazes were seeded in the clay.
More than a hundred hands persisted in this guided hallucination.
Six in the evening takes its leave of us multiplied by 80 or 100
with suspicion that each man is an illusion,
vertiginously made by a series of momentary and lonely men.

Faced by some glances we all can feel a landscape.
Each one of us is the illusion of the others,
the feeling of a multitude
is just one feeling illusorily multiplied in many mirrors.
We know the story of a man that was many men
in vain trying to be one and himself,
until the moment when he found the one who was dreaming him
and he said "I am nobody, I dreamed the world
like you dreamed your work, my Shakespeare,
and in the shapes of my dreams you are,
and like me, you are many and you are nobody."
Nobody is behind the gaze
and nobody can turn his back to the earth.[8]

Antony Gormley's *Field* is a floor level flood of 42,000 red, yellow, brown and orange people who fill the halls and press the walls at the Montréal Museum of Fine Arts. Unlike Gormley's first version of A Field, exhibited at the Art Gallery of New South Wales, this work actually impeded the viewer's entrance into the exhibition space. Claustrophobia with a difference or a population explosion of meta-sculptural archetypes, *Field* challenged many of the sacred assumptions we carry about art in the West — the perpetual refinement of form, the notion that completion realizes intention and that exclusivity defines value.

When critics of Rodin's era referred to his immortalized Balzac as a hunk of mud, the myth of the artist as an individual and formal exclusivity of modernist aesthetics carried some weight. Gormley's

Antony Gormley. *Field,* 1990-93. Terra cotta. Photo by Salvator Ala Gallery, New York. Exhibited at the Montréal Museum of Fine Arts in 1993. Photo courtesy of the artist.

Field sculptures actually are hunks of mud, a terracotta holism of hollow-eyed figurines measuring from three to nine inches in height, charged with the sensual energy of the Cholula Valley landscape from which they were made. Like the earth reflecting our consciousness back upon us, each of these figures has its own character, and was made by an individual to represent "people not yet born." Ethereal, metaphysical, even hallucinatory, they engender a feeling of perpetual recreation, one that reflects an attitude to culture that Thomas Berry has called "ecozoic" in that it embodies a biological and ahistorical relativism.[9]

The human form in sculpture, particularly representational sculptures of the body, is something we traditionally associate with the act of copious illustration — an equitable expression of a sensed reality. One might think of Rodin and Rilke in this respect ... a sculptor and a poet. Imagine Rilke writing on Rodin's desk, as he did. Was a sculptor such as Rodin, someone who felt the need to render material into forms intended to surpass the experience of life itself, ultimately less secure in his own sense of physical self than a poet such as Rilke who sensed the absolute intuitively, and did not feel compelled to work with and through the physical? As the philosopher F.H. Bradley once wrote in *Appearance and Reality*:

> A sameness greater or less with our own bodies is the basis from which we conclude to other bodies and souls ... idealize "experience," so as to make its past one reality with its present, and so as to give its history a place in the fixed temporal order. Resolve its consistency enough to view it as a series of events, which have causal connections both without and within. But, having gone so far, pause, and call a halt to your progress, or, having got to the soul, you will be hurried beyond it. And, to keep your soul, you must remain fixed in a posture of inconsistency. For, like every other "thing" in time, the soul is essentially ideal. It has transcended the given moment, and has spread out its existence beyond what is "actual" or could ever be experienced ... The soul clings to its being in time, and still reaches after the unbroken unity of content with reality.[10]

Metamorphisizing material into meta-sculptural multiples is nothing new. For their sheer numbers these figures recall the anony-

mous Buddhas of the medieval temple at San Jusan Gendo in Kyoto or the life-size terracotta warriors of China's first emperor in Xian. While Gormley's *Field* has been criticized for his so-called exploitation of Mexican workers, his intended purpose was precisely to refute the standard metaphors of authorship and hierarchical finitude that characterize Western sculpture. His desire was to reintroduce the element of ritual into the process of making art, so much so that each individual figure was ceremonially wrapped and packaged for transport and unwrapped for exhibition in a ritual manner similar to that of their creation.

By choosing a process that uses perpetual recreation and carries change within itself as an unconscious act — whose products are seemingly "conscious" human archetypes — Antony Gormley's *Field* suggests that art can be as holistic as permaculture. If it has a political or social role to play in life, it is one that involves an aesthetics of inclusion rather than exclusion. Perpetuity itself becomes a relative value: the process begets the process. Various versions of Field have also been exhibited at the Salvatore Ala Gallery in New York, the Corcoran Gallery in Washington, the San Diego Museum of Contemporary Art in La Jolla, the Malmö Konsthalle in Malmö, Sweden, the Tate Gallery in Liverpool and the Irish Museum of Modern Art in Dublin.

Gormley's 1994 *Lost Subject* show at the White Cube in London, England marks a return to the human body as libidinous, palpable, relaxed, spontaneous, subject. These works counter the distanced, generalized representation of the body archetype in sculpture. The intimate space of the body and its implicit stillness in *Lost Subject* counter the bodily representation as a public subject, a formal stereotype of the human condition, even of sculpture as an expression distinct from our inner state(s) of being. In a fax to British sculptress Alison Wilding, Gormley wrote:

> It is odd identifying with and questioning darkness. Part of what this building, insofar as a house is a body, is telling us is that the body is no longer a womb—tomb—case but capable of being a dwelling in "space," luminous space. Yet (to) insist on the "jet" — the necessity of the darkness of matter — I don't think it is (for me anyway) the Neo-Platonism of Donne's metaphysics. I see the darkness of the body as a necessary refuge from the light of reason rather than a prison of the soul. I see in it another route to love.[11]

Notes

1. Antony Gormley cited in Antony Bond, *Antony Gormley: A Field for the Art Gallery of New South Wales: A Room for the Great Australian Desert*, (Sydney: Art Gallery of New South Wales, 1989), np.

2. Lewis Biggs, Declan McGonagle and Stephen Bann, *Antony Gormley*, (London: Tate Gallery, 1993), p. 46.

3. Antony Gormley, Thomas McEvilly and Gabriel Orozco, *Field: Antony Gormley*, (Montréal: Montréal Museum of Fine Arts, 1993), p. 62.

4. Oystein Hjort, *The Silent Language of the Body: Antony Gormley's New Sculpture*, (Louisiana: MOMA Humlebaek, Denmark, 1989), p. 14.

5. Antony Gormley, Thomas McEvilly and Gabriel Orozco, *Field: Antony Gormley*, (Montréal: Montréal Museum of Fine Arts, 1993), p. 22.

6. *Ibid.*, p. 21.

7. Antony Gormley in conversation with John Grande, Montréal, May 12th 1993.

8. Gabriel Orozco, "Being a Landscape," published in *Field: Antony Gormley*, (Montréal: Montréal Museum of Fine Arts, 1993), p. 26.

9. Thomas Berry, "Art in the Ecozoic Era," *Art Journal*, Vol. 51, No. 2, (Summer 1992), p. 46.

10. F.H. Bradley, *Appearance and Reality*, (Oxford: The Clarendon Press, 1930), pp. 240, 268.

11. Antony Gormley, fax dated April 11th, 1994, to Alison Wilding. Printed in *Air and Angels* exhibition brochure, (London: Contemporary Art Society, 1994), np.

21

Which Public? Whose Art?

Public art raises important questions about structural and philosophical issues such as the individual role of the artist, the character of audiences and the relation of art to public and private spaces. In an effort to bypass the problems associated with "official" public art, some artists have sought to challenge conventional artistic practice by seeking to construct a cultural public sphere. Artists involved in these developments deal with situational events, temporary site specific or ephemeral works. Their subtle social or ecological interventions into the urban or natural landscape environment are as public as the more official versions of public art — those strained unions between art and architecture we have come to accept as part of our built environment.

Louis Jobin (1845-1928) was a sculptor whose work reflected both the "official" side of public sculpture and the vernacular character of popular folk culture in Québec. While the church was his mainstay for commissions, he also carved cigar store Indians, shop signs, mastheads and female figures of abundance for agricultural festivals. The most spectacular of his commissions was *Notre-Dame de Saguenay* (1881), a work that weighed 7,000 lbs. and stood twenty-five feet tall. Constructed of three enormous blocks of pine sheathed in leaves of lead, it was transported by schooner along the St. Lawrence up the Saguenay to the foot of Cap Trinité, where a crew of trailblazers cut a path through the wilderness, then dragged the huge sculpted blocks with horses to their present site 506 feet above the Saguenay River.

Less well-known were Jobin's ephemeral ice sculptures created for the Québec winter carnivals in the 1880s, such as *Liberty Lighting Up the World* — a 7,000 pound, sixteen-and-a-half foot replica of Bartholdi's famous *Statue of Liberty*. Auguste Rodin's *The Burghers of Calais*, completed in 1886, erected in 1895, inspired by the liberation of Calais from the English in the fourteenth century already evidences of a new spirit of individualist expression in European public sculpture (albeit modestly expressive in today's terms), but it was one that colluded with officialdom to later become a stereotypical part of the history of art.

Today's public would be more likely to remember Michael Snow's *The Audience* (1989) at Toronto's Skydome with its kitschy col-

lection of caricature-like baseball fans with hot dogs, beer bellies and binoculars painted over in gold than they ever would a Rodin sculpture. It's hardly "high art," definitely not avant-garde, but it catches the public's attention in a way that most of today's generic one percent public art projects or official monuments seldom do. The same is true of Raymond Mason's *The Illuminated Crowd* (1986) in Montréal, located in front of the Laurentian Bank and Banque Nationale de Paris Towers. A stone's throw away from one of Rodin's figures of *The Burghers of Calais* located in front of The Dominion Gallery on Sherbrooke Street, Mason's piece adopts a theme similar to that in Rodin's. Michael Brenson, former critic for *The New York Times*, described *The Illuminated Crowd* in these terms:

> Mason's human comedy has become complete; for the first time he has included the wretched as well as the blessed, the damned as well as the saved. This is the human comedy in a pure state, with nothing to dilute it, cut off from everything that would make it possible to locate and explain it.[1]

An art of the corporate avant-garde or kitsch for kitsch's sake, the subject of Michael Snow's *The Audience* and Raymond Mason's *The Illuminated Crowd* is a public abstracted from its social and historical context, portrayed as a product of the consumer culture — banal and accessible, even joyous — but without meaning or connection to a broader permacultural context. The corporations that sponsor these works choose them with a public agenda in mind — that of good citizenry — while selecting the work on an apolitical basis to ensure the status quo.

Gilbert Boyer's recently inaugurated *Mémoire ardente* (1994) was commissioned to celebrate the City of Montréal's 350th anniversary. As the City of Montréal's Commission d'initiative et de développe- ment culturel's (C.I.D.E.C.) press release states, it is an attempt to renew the aesthetic of the monument and build a memory of Montréal. Located at the extreme southern end of Place Jacques-Cartier where Nelson's monument — built before the Trafalgar Square version in London and still stands as a reminder of Montréal's British colonial past — *Mémoire ardente* consists of a cube of pink granite and a steel pole that carries the names of the private and public sponsors who contributed to Montréal's anniversary celebrations. The cube is an old symbol of the civic body, one that was used in the seventeenth-century poet George Wither's *Emblemes* (1635), depicting a cube hovering in space as a representation of *civitas*.[2]

The roots of the word "monument" stem from the Latin monere, which does not just mean to remind, but to admonish, warn, advise, instruct. If we look through the linear arrangements of drilled holes into Boyer's cube, we see the names of specific sites, streets and quarters in Montréal that are part of its civic history. As well we see verb phrases conjugated in the past tense. The piece reads as a politically correct kind of tourist sculpture, fearful of true self-expression and yet faultless. *Mémoire ardente* is as decontextualized and container-like as Boyer's *La Montagne des Jours* (1991), a series of granite disks installed on Mount Royal which had the phrases of passers-by recorded on them. An "official" view of history, *Mémoire ardente* is not about taking risks. The encapsulated context of the historic sites it mentions dissolve the contiguous meaning of that same history and present it as an idea. And yet this work is truly public in the official sense. It is a succinct example of the dilemma inherent to public sculpture — the gap between life and art. In his essay "Museums, Managers of Consciousness," Hans Haacke writes:

> In its time (the doctrine of art for art's sake) did indeed perform a liberating role. Adherents of the doctrine believe that art does not and should not reflect the squabbles of the day. Obviously they are mistaken in their assumption that products of consciousness can be created in isolation.[3]

Joseph Beuys' concept of a "Total Work of Art" used the public as a metaphor for sculpture where every detail is part and parcel of the whole — solidarity and individualism. He perceived his role as that of the activist individualist, part of an avant-gardist tradition that began more modestly in the late nineteenth century. Beuys' commitment to social change through art finds its parallels in Québec sculptor Armand Vaillancourt's work. In June 1989, for the Atelier de la Sculpture's outdoor event on Crescent Street in downtown Montréal, Vaillancourt created *Paix, Justice et Liberté*. Like Boyer's pink cube in old Montréal, the names of corporations were inscribed on it, but in this case alongside their annual profit figures and the words: "Two days of military expenditures worldwide, around 5 billion dollars, would allow the United Nations to stop the desertification of the world within 20 years." Vaillancourt's interventionist public sculpture dealt with issues of social justice, militarism and ecology from an non-official point of view.

The issue of permanence in public spaces has also been the subject of numerous temporary urban interventions by Montréal-based

artist James Carl. *Les Paumes de Terre* (1991), created for the Strathearn Centre's *Les Jardins Imprévus* city-wide show of site specific urban interventions, consisted of a set of safety earphones placed in metal boxes at Pine and Park Avenues amid the spaghetti-like intersection of roadways. This work, which Carl dutifully unlocked in the morning and locked at night, questioned the logic of urban planning and its relation to progress by simply inviting the public to experience silence. As Carl noted: "I am not much for Eden scenarios and am more concerned with generating something within the joy and catastrophe of the urban environment as I confront it."[4]

In March 1994, James Carl created yet another public art intervention, *Escalation*, in the Hiram Market section of New Brunswick, New Jersey. "Historic" Hiram Market is currently undergoing a vast redevelopment funded in part by Johnson & Johnson, the multinational medical-products manufacturer, and Rutgers University. Tony Masso describes development plans as follows:

> These projects have completely changed not only the form and focus of the city but its scale — away from small-scale buildings with shops and services at street level and above, towards huge, set-back, or enclosed structures with little face to the street.[5]

In response to the anestheticizing, ascepticizing and deindustrialization of the Hiram Market in the name of progress, Carl created *Escalation* on the exterior staircase of the old state theatre building, only recently visible because of demolition in the area. Carl stretched an eight-by-one-hundred foot length of bright red awning fabric along the exterior of the stairway that looked like an economic progress chart. In the foreground of the piece and set back from the site, Carl set up a red plexiglass grid through which one could read the work as a graph in the remnant context of the State Theatre Building. James Carl comments again:

> The current plan is to build a new art school at the end of this block of several theatres, creating an "official" cultural centre. The reality of the situation is that across the street is one of the most neglected and run down areas in the city. As the saying goes "art is the vanguard of gentrification." Here we have developers institutionalizing this role — sending out art students and the cultural community as pawns.[6]

In autumn 1993, Montréal-based artist Kathryn Walter created *Un Centre des histoires* in a building undergoing renovation on St. Laurent Boulevard. She set up her own quasi-tourist outlet, providing another point of view on the City of Montréal's development projects such as Faubourg Québec and the techno-park in old Montréal. Walter acted as tour guide, inviting those who came into the centre to explore the various documents, files, photo displays, videos and personal effects of the artist on view. This situational piece included: an archaeological display case that had tree roots, mortar from demolished buildings, railway spikes and a fax machine — a kind of morphology of progress; a continuous film with accompanying sounds of the Lachine Rapids (the natural obstacle that caused Jacques Cartier to stop in the site where Montréal was established); a zoning map of old Montréal's residential and commercial areas; and a quote from Walter Benjamin's *Illuminations*:

> His eyes are staring, his mouth is open, his wings are spread. This is how one pictures the angel of history. Where we perceive a chain of events, he sees one single catastrophe which keeps piling wreckage upon wreckage and hurls it in front of his feet. The angel would like to stay, awaken the dead, and make whole what has been smashed. But a storm is blowing from Paradise; it has got caught in his wings with such violence that the angel can no longer close them. This storm irresistibly propels him into the future to which his back is turned, while the pile of debris before him grows skyward, This storm is what we call progress.[7]

At the close of *Un Centre des histoires*, Walter held a Krzysztof Wodiczko-type staged event. A constant image of a bulldozer erasing the past — just as archaeologists encase it — was projected onto a building against the backdrop of Montréal's core city skyline in a site adjacent to the Cours Royer.

Environmentally specific responses to natural and urban environments provide an alternative notion of public sculpture, where efforts to regenerate or stimulate the landscape or city scene are considered more urgent than pure aesthetics. For many artists public art involves direct actions to improve these environments. The semantics of persuasion and "egosystems" now take a back seat to concerns about the ecosystem. As Thomas Berry states, "We now know we live in a world that is vulnerable in some absolute sense."[8] These

are not Robert Smithson's *Spiral Jetty* (1970), or Michael Heizer's *Double Negative* (1969), both maximally scaled landscape impositions of the sixties, but direct responses to the climate, vegetation, geology, other life forms and the human situation in specific micro environments. Agnes Denes' *Wheatfield* pioneered this brand of public art — temporary yet permacultural in its intent. In May 1982, Denes planted a two acre area of wheat at the foot of the World Trade Center — a block from Wall Street and facing Bartholdi's *Statue of Liberty* in New York's harbour amid the downtown congestion of Manhattan. Later harvested to make room for yet another billion dollar luxury complex development, Denes' amber field of wheat was unforgettable.

Heather McGill and John Roloff's *Isla de Umunnum* (Island of the Hummingbirds), presented near Monterrey, California, involved the creation of a hemispheric mound. The work was comprised of layered strata of oyster shells, lava rock, coal, copper and earth beside the only fresh water pond in the vicinity. It became a mysterious eye that reflected the regenerating natural environment surrounding it. An ongoing work, it is now a home for hummingbird populations and orange poppy plants.

Doug Buis is a Montréal-based artist who has been involved for some time in modest interventions within city environments which he calls *Micro-gardens*. These involve sporadic plantings of wheat, sunflowers and other species in haphazard sites throughout the city: atop signposts, in gardens, in parks, even in abandoned spaces and city lots.

Betty Beaumont's *Ocean Landmark* project (1981) is interventionist public art created for a public of underwater fish and vegetation. Created by dumping 17,000 bricks of recycled coal ash off the coast of Fire Island, New York, it will only be seen by underwater divers, yet is a public art that regards all of nature as part of the public domain. Since its inception 14 years ago, the habitat has created a small, artificial volcanic range of the Atlantic Ocean floor alive with fish and vegetation.

Mierle Laderman Ukeles' *Social Mirror* (1983) is about urban waste, recycling, landfill reclamation. The official artist-in-residence of New York City's Department of Sanitation since 1977, Ukeles, the author of *Manifesto! Maintenance Art* (1969) and *Sanitation Manifesto* (1990), put mirrored glass on New York garbage disposal trucks so that the public could see themselves reflected in this agent of waste reclamation. For another project titled *Flow City* (initiated in 1983 and ongoing until 1995), at New York's 59th Street Marine Transfer Station (the idea actually came from the workers there) — a site that loads 620 tonnes of garbage daily onto barges for delivery to Fresh Kills, the world's largest landfill site located on Staten Island — Ukeles has

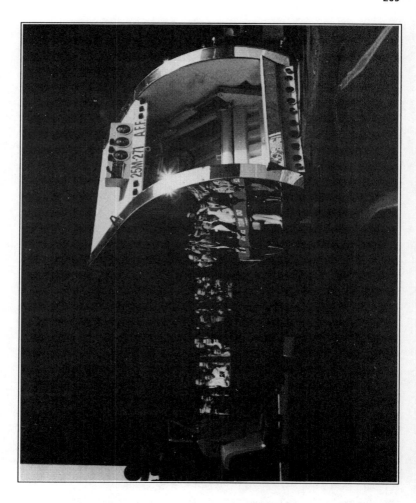

Mierle Laderman Ukeles. *The Social Mirror,* 1983. Mirror covered garbage truck with the New York City Dept. of Sanitation. Photo courtesy of Ronald Feldman Fine Arts.

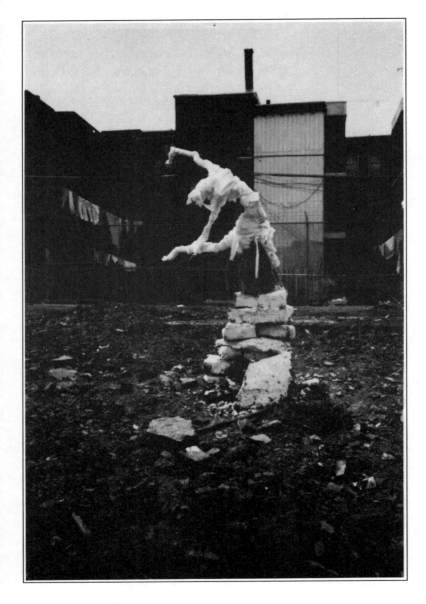

Artist unknown. *Dancer,* 1988. Title unknown. Demolition site on Clark
St., Montréal. Toilet paper, bricks, stone and wire. Photo by John Grande.

transformed the transfer station into a tourist attraction. Her work includes: "The Passage Ramp," a block long tunnel lined with wood, glass and metal refuse; "The Glass Bridge," a glassed-in observatory deck suspended over water where viewers can witness "The Violent Theatre of Dumping" that takes place on a tipping platform longer than two football fields; as well as the ritual of "The Industrial Ballet," where garbage workers cast nets over a loaded barge and guide it with ropes into the Hudson River.

Among the art works Ukeles has shown during the fourteen unpaid years as official artist for the sanitation department are an archway she built with gloves discarded by workers from twelve New York City agencies and Con Edison (exhibited in Taejon, Korea at Expo 1993), and works made of piled steel shavings from subway car wheels. Ukeles' art redefines our traditional notions of public art and establishes much needed links between the public and private spheres of life. Her work evidences the potential drama that passes largely unnoticed in the routine activities of our daily lives. An excerpt from Ukeles' "Sanitation Manifesto! Why Sanitation Can Be Used As A Model for Public Art" states:

> Sanitation is the working out of the human design to accept, confront, manage, control, even use DECAY in urban life. Sanitation is the City's first *cultural* system, not its displaced-housekeeper caste system. To do sanitation is to husband the City as home. I think it can serve as a model for democratic imagination as follows:
> Sanitation serves *everyone*; it starts from that premise; it accepts that *everyone must be served in a democracy*, and the City must be maintained in working works *everywhere*, no matter what socio-economic culture. Sanitation works *all the time*, through all seasons, no matter what the weather conditions. *Sanitation is totally interdependent with its public: locked in — the server and the served*. Sanitation, in democracy, implies the possibility of a public-social-contract operating laterally, not upstairs-downstairs, but equally between the servers and the served. This is accomplished at totality of scale; yet it deals on an incremental basis (house to house, bag to bag) and it cuts across all differences. Out of these most humble circumstances, we can begin to erect a democratic symbol of commonality.[9]

We have become estranged from our city environments, even our neighbours, and have lost the sense that spontaneous direct action can actually affect the broader evolution of our cities. The cultural component of community planning involved in the creation of public art is something we have not considered in developing the standard stereotype of the artist.

A culture of exclusion dictates to the unwilling what the shape of the future will be and causes us to fear our own judgement about who we, the public, are, and what the art is. A culture of inclusion realizes and respects the role of the artist as part of the greater community and encourages originality, innovation, self-reliance and, above all, participation. An example of this was an unsigned, ephemeral work I once saw on Clark Street in Montréal that created the figure of a dancer out of metal and toilet paper. It was a delight to behold because the intentions were genuine. Involving a principle of modest integration and surprise, it was just a detail that did not seek to dominate the space in which it stood.

If public sculpture is to have a meaningful future — one that comes from a concern for the context of contemporary life and its relation to the culture of nature — it must, like the architecture and planning of our cities, involve a modest reintegration of holistic values into design, aesthetics and public life. As Suzi Gablik, the author of *The Reenchantment of Art* writes: "Art that deals with life is hardly new, but what is at stake for artists is to deal with life in a reverential way, with a sense of purpose that lives in the larger picture of our need."[10]

Notes

1. Michael Brenson, *The Illuminated Crowd*, (New York: Pierre Matisse Gallery, 1980).
2. W.J.T. Mitchell, ed., *Art & the Public Sphere*, (Chicago: University of Chicago Press, 1992), pp. 12-13.
3. Hans Haacke cited in Suzi Gablik "Making Art as if the World Mattered," *The Amicus Journal*, Summer 1993, p. 28.
4. Correspondence from James Carl to John Grande, May 10th, 1994.
5. Tony Masso, "Historic Hiram Market: Decade Update," in *A Project by Martha Rosler: If You Lived Here; The City in Art, Theory and Social Activism*, Brian Wallis, ed., (New York: Dia Art Foundation, 1991), p. 148.
6. Correspondence from James Carl to John Grande, May 10th, 1994.
7. Walter Benjamin, *Illuminations*, (New York: Schocken Books, 1968), p. 257.
8. Thomas Berry, "Art in the Ecozoic Era," *Art Journal*, Summer 1991, p. 48.
9. Mierle Laderman Ukeles, "Sanatation Manifesto! Why Sanatation can be Used as a Model for Public Art," *The Act*, Vol. 2, No. 1, (1990), pp. 84-5.
10. Suzi Gablik, "Making Art as if the World Mattered," *The Amicus Journal*, Summer 1993, p. 28.

22

Earth Sensitive

In developing a nature-specific dialogue that is interactive, rooted in actual experience in a given place and time, with nature the essential material and ingredient of the process, artists are ultimately developing a new language of expression. The emphasis is holistic, bio-regional and mutualist. Above all, it displays a respect for our integral connectedness to the environment. The earth is a living breathing organism whose elements — climate, geography, geology, other life forms — are an inviolable part of the human creative process. The inflexible stereotypes of art history, outmoded notions of avant-gardism and modernist aesthetics in general are the legacy of an era where progress was defined in purely economic terms. The land is no longer just a subject we represent through art.

An essential freedom comes from identifying with the life process itself as art. It is one chance we have to ensure a viable art of the future. The imperial stereotypes of an art based in formal language, the segregation of humanity from nature, the platitudes that accompany the art object and nature subject have now passed into the catacombs of our museums and art galleries. Let us leave that labyrinth behind and celebrate nature whose presence is very much there, very much here. Essential for our psychological and physical sustenance, nature is here in your garden, there in your forest, can be found in a city park. A resurgence of ritual and respect for the cyclical process of life, an earth sensitive vision reaffirms nature is the art of which we are a part. The challenge is to break out of the limited conception that humanity is the centre of earth-based activity, to broaden our perspective, realize that other species, organisms, animals and plants are equally earth sensitive, the biogenitors of ecological diversity. They may even perceive the earth and us in ways we could never conceive.

From a native point of view, landscape cannot be characterized as either wilderness (i.e., a place in which human activity is not naturally present) or a scene (i.e., a representation of a site) or a framed subject that embodies an idea of nature. The line between human culture and the culture of nature are indivisible. The Métabetchouane Centre for History and Archaeology on the south

shore of Lac St.-Jean in northern Quebec, with its replica of a Hudson's Bay trading post, is a place where on July 16th, 1647, the Jesuit founder Jean Dequen, a native of Amiens in France, arrived by boat from Tadoussac.

Mike MacDonald, a self taught artist of mixed descent (Micmac, Beothuk, Irish, Portuguese, Scottish) whose nature works explore ways of healing cultural and biospecific differences, found a variety of introduced and indigenous species of plants growing in the surrounds of this historic site, a traditional native meeting place for centuries in pre-contact times. During the summer of 1996, he gathered and transplanted species of Native medicinal plants that included sweetgrass, northern sage, native onions, Iroquois ceremonial tobacco, Virginia tobacco, evening primrose, milkweed, Joe-Pyeweed, and Dyers camomile. These indigenous plants with medicinal properties were planted directly around the museum's walls to create a butterfly garden.

Naturally growing varieties of viperine, wood strawberry, and hawthorn trees introduced by European settlers centuries ago, plants that have outlasted the early settlement buildings and continued to flourish in the wild were likewise "discovered" by MacDonald whose role was more that of an ethnobotanist than artist. Rock assemblages shaped to form footprints (an allusion to Jean Dequen's original "discovery" of this site in 1647) placed in the garden enabled visitors to move through the site without damaging the plants.

MacDonald's thesis that most plants that attract butterflies have medicinal, healing properties has resulted in subsequent reconfigurations of the butterfly garden that are a source of inspiration and healing, and painlessly beautiful. MacDonald's latest butterfly garden installed amid the ruins of Our Lady of the Prairie Church at the St. Norbert Arts Centre this summer, brought living colour to this site of a former Trappist Monastery, south of Winnipeg, in Manitoba. This heart-shaped garden was replanted with blue and white flowers, the colours used in the Catholic Marian Garden tradition. The place became a work of contemplation and healing, where past Judeo-Christian traditions brought over from the Old world were brought into perspective by a native intervention. An empty plinth overlooking the garden marks the spot where a statue once stood. The 10th in a cycle of 12 related works *Patria (Homeland)* by the world renowned environmental writer, educator and composer R. Murray Shafer will be performed there.

The cycle relates the journey of two principal characters through the labyrinth of different cultures and social situations.

Located on the Pacific Flyway and the Fraser River Basin, the City of Vancouver has a particular environmental legacy and opportunity. To raise consciousness of songbird populations in city and country, and provide positive enhancement programs for songbird habitats in urban centres, artists Beth Carruthers and Nelson Gray, conceived of Vancouver's SongBird project after hearing the clear song of a robin rising above the background cacophony of industrial noise. Biologists, landscape architects, musicians, artists, planners, sustainability consultants and community groups assisted with the project, as did the Douglas College Institute of Urban Ecology and the Roundhouse Community Centre.

Environmental concerns were expressed by specialists and city dwellers in the Living City Forum (1998 & 1999), and nature walks encouraged an awareness of urban bird habitats. FLAP (the Fatal Light Awareness Program) likewise made citizens aware of how millions of birds are killed annually in North America by collisions with office and home buildings that are unnecessarily lit up at night.

A broader than usual spectrum of the public has thus become involved in re-imagining the Georgia Basin's place in the world environmental spectrum and Vancouver has become a "songbird friendly" model for other North American cities. The core annual event of the SongBird project is the Spring Dawn Chorus Festival held in May. Begun in England 13 years ago these gatherings of people who await the songbird's dawn chorus are now celebrated around the world.

The Babylon Gardens Initiative presented at the Roundhouse Community Centre, aimed at introducing to the public ways of encouraging bird populations in the city. Citizens were taught how to build feeders, nesting boxes, introduce ivy, trellises and bird baths into their home environments thus providing temporary food, habitat and water supplies for birds on balconies, rooftops, in window boxes and gardens. The Gardens of Babylon Balcony Challenge has now run for 3 years and winners are recognized for their positive bird friendly environmental interventions.

The Nest, a structure woven out of willows and dried grasses by French artist and landscape architecture student Claire Bedat with assistance from public volunteers was installed outside the Roundhouse Community Centre in the fall of 1998 to celebrate hu-

manity's connection to home, community and songbirds. As Claire
Bedat says:

> The making was in its essence a very intuitive render-
> ing, as dedicated as a bird, I used each part of my body
> to shape and build the Nest. A nest is supposedly
> round, round like life, round like the body of a bird. Un-
> consciously I was participating in the making of a shel-
> ter, a refuge, the house of my body ... Growth is often
> assimilated to change, I changed during the making of
> this project and feel emotionally empowered and
> bounded to a greater cause: preserving biodiversity on
> Earth.[1]

Alan Sonfist, a pioneer of eco-sensitive projects in the 1960s
and 1970s, for which his *Time Landscape* (1965) in Soho New York is
perhaps the best known. For this project Sonfist introduced
pre-contact plants, trees and vegetation to a site in New York. As
Sonfist states:

> One would observe, within each of the environmental
> sculptures, the struggle of life and death, as well as the
> human interaction in a historical forest. That's what the
> 19th century concepts were about. That is really what I
> am involved in, and what my thought process is trying
> to create. The natural cycles as opposed to doing an eco-
> logical model from a scientific point of view, or using
> pure history.[2]

In the Mojave Desert at the main park in La Quinta, California,
Sonfist completed a seven mile nature trail (1998) in a region of Cal-
ifornia otherwise encumbered by the introduction of non-native,
northern species of trees and plants that consume unnecessary
amounts of water. California bio-history is like bio-history any-
where, involves a layering of living species in the cyclical theatre of
nature in time: ghost flower, bee balm, blazing star, desert star,
cream cup, woolly daisy, Indian paintbrush, yellow cup, desert si-
enna, Devil's claw. The flux and flow of elements causes nature to
reinvent itself in a myriad of ways. Sonfist's project involves reas-
sessing each fragment of time, realize this nature layering takes
place in a continuum, not one fixed moment. The locals who live
near the site, seemed to favour non-natural nordic landscapes with

Alan Sonfist, Drawing of oasis area, La Quinta, California, 1998.
Photo by Alan Sonfist.

maple trees, and grass lawns. Foreign plant and tree species are planted, landscaped into our cities and suburbs because they bring an "exotic flavour" to a place. How different is this from changing the channel on your TV in an endless search for "novelty"? Artificial environments, in this case in a desert region, require heavy watering, and are a desperate attempt to reduce biocultural diversity. Since the local indigenous plant species have been introduced to the region, the initially negative response, has been replaced by an enthusiasm about how beautiful and diverse the spectrum of flower arrangements Sonfist has brought to the place actually are. Sonfist's nature trail has become a visual laboratory of environmental understanding. The work has stimulated thought and controversy as well as providing a cathartic living environment for the people who live there. Plans are on for sculptors to introduce artworks along the trail at a later date.

For the Coast Salish Squamish nation on the west coast of British Columbia whose numbers dwindled from 60,000 to a low of 150 after initial contact with the white man, the world is conceived as a forest. The community of trees that grow in a forest is like a community of people whose health and history are inextricably linked. Artist and activist Nancy Bleck and carver Aaron Nelson-Moody (Tawx'sin Yexwulla) have embarked on an intriguing project called *Cedar People*. The first stage of the project involves Nelson-Moody's carved rendition of the Society of Women in Stewardship of the Land, a "society within a society," raised from birth to act as leaders who look after the land. As Nelson-Moody states:

> There is no equivalent in non-Native society, as the women were as much medicinal doctors as they were environmental lawyers, as much libraries as they were land managers.[3]

A traditional ceremony has already been held to bless the log, and invitees witnessed the first stage of the transformation of this cedar wood into Slyn'i (cedar woman). Being the first of many such *Welcome Figure* carvings, it will be raised in a sacred site in the upper Squamish wilderness region this August. Culturally modified markings on the outside bark of ancient cedar trees can be found in such sites that indicate these places have been visited for thousands of years. Using traditional native tools, Nelson-Moody has created a twelve by three foot carving whose installation will be witnessed by the Coast Salish Squamish people and non-natives. The tradi-

tional society of women this work is dedicated to, are likewise "witnesses" who have participated through ceremony as "keepers of history." Other welcome figures will be made elsewhere, in collaboration with local carvers and participants — on site in Quebec, Germany, and Australia — locals carving traditions and motifs will be part of these initiatives.

In 1992 at Méru in the Oise region of France, Jean-Paul Ganem created his first "agricultural composition" and this was soon followed by others in the Vendée, Champagne, and Midi-Pyrénées of France and the 150 hectare Mirabel airport project in Montreal, Canada (1996). This summer, Jean-Paul Ganem has been involved in a large scale environmental sensibilization and community participation project titled *Le Jardin des Capteurs*. Created in collaboration with the Cirque du Soleil and Jour-Terre Quebec *Le Jardin des Capteurs* occupies a 2.5 hectare waste area adjacent to the Cirque du Soleil's permanent headquarters in the north of Montreal. The site referred to as the Miron Quarry, contains human waste excrement up to 100 feet in depth. Gas emission pipes (up to 400 feet below the surface), sporadically dot the surface of the land like periscopes. Operated by Gazmont Plant nearby, the gas pipe emissions provide natural gas/methane power for 10,000 homes. Ganem's art project involves youth from the St. Michel region of Montreal and volunteers from Montreal's Botanical Gardens. Thus beautified, Ganem's site intervention changes public perception of garbage and waste dumps, not only for the volunteers, but equally for those who visit the place or see it from the air. An end of the world wasteland becomes a beautiful rendition of the circus Big Top with colourful wedge-like land marks and overlapping circular motifs in varying dimensions. All this is made of living plant and flower species: red and yellow Cosmos, pink and red petunias, colza, beard-grass, wild heliotrope and buckwheat.. The colourful land markings and motifs overlap, with varying circular dimensions and shapes. An undulating path makes its way through the planting … Directional markers point to the more formidable areas of the Miron Quarry/Dump that will, over the coming years, be landscaped and transformed into a more substantial city park with a hill at its centre. Next year perennials will replace the present planting. *Le Jardin des Capteurs* introduces the notion that sites for human waste, the detritus of our urban consumer society can be recycled and beautified as sites, just as the goods and waste that end up there can be.

Approaching such initiatives from the aesthetic, and the design perspective, Belgian artist, Bob Verschueren is an artist who specializes in making vegetal art out of vegetal matter. His most impressive works include the *Wind Paintings* which are nothing less than spectacular. The *Wind Paintings* comprise lines of natural pigment that are dispersed by wind action. It was the unpredictability of the result that initially attracted Verschueren to this kind of art making. The experience came about after Verschueren quit traditional painting and found himself "no longer confronted by the limits of this horrible rectangle. The subject extended beyond any traditional aesthetic framework. A battle lost before you start one could say! One could not measure a work, one does not know what comprises the last grain of pigment, where it will go."[4]

Vershueren lays variously coloured pigments in lines along stretches of sand for his *Wind Paintings*. Nature does the rest. The action of wind on the pigment turns the land surface into the canvas for these artworks.

German artist Mario Reis makes "nature watercolours" by placing a base material in flowing water and allowing the mineral and vegetal sediment transported in the water to accumulate on its surface. Water is the paintbrush that moves and displaces the sediment and colour on these square canvases. Reis finds these configurations of silt, sand and sediment drawn from rivers all over North America in places as varied as the Yukon, British Columbia, Idaho, Ohio, New Hampshire, Nevada, Michigan, Alaska, Wyoming and Kansas to be as confounding in their variety of hues, shades, textures as any old fashioned artwork and much more challenging. Reis' likewise enacts such works in Mexico, Europe, Africa, and Japan. They are a powerful reflection on natural diversity. His approach is rigorous and truly global in scope.

The growth of an interactive approach to working with environment implies an acceptance of ourselves, as much as nature. These artists' actions carry a narrative on human history within their work, but circumvent artistic conventions of reproduction, containment and mimesis. Nature and art are less critically segregated, life takes precedence over the art. Links are established between human culture and the culture of nature. With each successive experimentation this new language of expression that involves understanding our place in nature become better understood. Elements from nature are the paint and nature is the canvas. Artists are the catalysts. There is no subject or object. This *earth sen-*

sitive language of expression is tactile, physical and plays visually with various organic and inorganic elements in a given site. The creative growth experience is interactive. As we enhance our understanding of nature's place in our society, our civilization, our personal lives, so we better understand that our society's future will inevitably involve understanding and respecting nature's processes. Nature's endemic role as *source and provider* is what will enable us to achieve sustainability for all forms of life the earth in the future.

Notes

1. Valentin Schaefer & Leanne Paris, *Songbirds in the City: A Celebration* (Douglas College Centre for Environmental Studies and Urban Ecology, 1999) pp. 38-39.
2. Alan Sonfist, cited in *Natural Reality: Artistic Positions between Nature and Reality* (Stuttgart: Daco Verlag/Ludwig Forum, 1999) p. 100.
3. Aaron Nelson-Moody, Artists statement, Vancouver, 2000, np.
4. Bob Verschueren interviewed by John Grande, Brussels, Belgium, April 2000.

23

Keith Haring: Day-Glo Environmental

Keith Haring touched life with a derisive energy. His compulsions were all-American: to bring art to the public and take it off its pedestal. His all consuming obsession was enacted in subways, on the street, soon after in some of the New York's most prestigious galleries: Tony Shafrazi, Leo Castelli, and later all over the world. Comprising some 140 works, including his large ambitious drawings, colourful sculptures and early drawings, some salvaged from New York City's subways, this show, organized by the Whitney Museum, is first full-scale North American retrospective of Keith Haring's work ever.

Raised on a diet of TV in a country with few memories and a lot of images, Mickey Mouse rather than Michelangelo was Haring's childhood mentor. After a brief period of spiritual conversion in high school, Haring turned to pop music and art for his inspiration admiring among others Pierre Alechinsky, Jackson Pollock and Stuart Davis's commercial painterly style. A biographical survey of Haring's personal belongings prepared by Richard Pendiscio, creative editor-at-large for *Interview* includes all sorts of jottings, secret notes in a language Haring himself invented as a teenager, typewritten notes, sketches and photos of a teenager trying to make sense of a crazy world. Who could imagine this small town kid would be selling paintings created in 2 hours for $15,000 at age 24? Or that he would be befriended by the likes of Brooke Shields, Madonna, Andy Warhol, and William S. Burroughs? Above all, Haring was intensely aware he was part of a new generation of Americans. "I consider myself a perfect product of the space age not only because I was born in the year that the first man was launched into space, but also because I grew up with Walt Disney cartoons."[1]

When Haring arrived in New York City from his hometown of Kutztown, Pennsylvania in 1978, street graffiti was everywhere and figurative painting were on the rise. A raft of young and talented protagonists included Andy Warhol's protégé, the more gifted but somewhat immature Jean-Michel Basquiat. Haring's first forays into taking art out on the streets in the East Village and

South Bronx — cut-up collages of newspaper headlines pasted to lampposts — led on to "tags" spray paint graffiti notations. So Haring joined the crowd and began making hieroglyphic Day-Glo or chalk drawn punk expressionist scribblings, murals and notations in the subways. Part of the game comprised endlessly changing sites and subjects. While some graffiti artists in Los Angeles have developed a language understandable only to other graffiti artists, Haring's New York style is immediately recognizable. Influenced by Hip-Hop, Punk, Puerto Rican culture and Break dancing, Haring's bright, hieroglyphic, spontaneously scripted style uses a bold, dark outlining used in cartoon drawing. The speed of his execution is usually equal to the depth of its message. During his career he painted the wall of the Necker Children's Hospital in Paris, decorated clothing, a windsurfer and surfboard, was artist-in-residence at the Montreux Jazz Festival in Switzerland, decorated a car in Dusseldorf, Germany, shaved his designs into hairstyles, decorated a Fiorucci store in Milan, body-painted Grace Jones for a performance at the Paradise Garage in New York, decorated the entire surface of a blimp outside Paris, designed four watches for Swatch USA, printed and distributed 20,000 Free South Africa posters and did the same with colouring books for children. He even created a First Day Cover lithograph to accompany a United Nations stamp issue commemorating 1990 as Stop AIDS Worldwide Year and held a sale of his work to raise funds for UNICEF's African Emergency Relief Fund in 1985.

Haring's early nihilism — the spray paint, acrylic and chalk mark figures in all shapes and sizes visitors to New York witnessed all over the place — in subways, on street murals made way for purely commercial art marketing but the causes Haring supported were all good. In a sense Haring's art celebrated distraction and delight amid the turmoil and tragedy of modern life. Chance and danger were part of the graffiti artist's bag of tricks. In a 1982 CBS TV video clip with Dan Rathers on view in the show, we see Haring grafting one of his figures onto an empty subway poster space while nervously glancing over his shoulder. A minute later a policeman arrests him.

Haring's early *Drawings for Fashion Moda at New Museum* (1980) are humorous, jazzy, eclectic, reductionist caricatures. The symbols are dumbed down cookie-cutter hierographs, human experience reduced to a *pro forma* mould. The visual language is universal, as accessible to an illiterate as to cognoscenti: the pyramid,

the tape recorder, the two figures — one black and the other white — running down converging staircases to do battle with batons and ending up at the same place. Many untitled works in this show from the 1980s for all their inventiveness and smooth execution mask a high pitched index of fear, noise, claustrophobia. Using vinyl ink on tarpaulin, materials often used in outdoor advertising the private is rendered public in an unsettling, yet exciting way. In *Untitled* (1982) we see spotted dogs jumping through a hole in someone's stomach. Cartoon-like, bold and simple the style really gets you. No one can be indifferent to it. The visual conundrums are challenging. The maze of lines that wend their way around and through images of hearts, angels, space ships, monkeys, humans and barking dogs, even the atomic symbols, are dense and compacted. Other scenes of violence and conflict, of skeletons grabbing other smaller figures, and swallowing them whole are more macabre. Prurient symbols of the abyss or expressions of creative ecstasy, Haring's art draws on the magic of consumerism and comes up with sweet nothing. The linkages are as sterile as a test tube in a modern science experiment. *Monkey Puzzle* (1988) is a circular composition with generalized monkey, human and baby figures all compacted together as if swimming in a petri dish.

The mystico-religious and scientific aspect is also evident in Haring's fascination with numerology, quantification and literal metaphor. It's a potpourri of cultural confusion and urban density. One of the best works in the show is *Untitled (Breakers)* (1987), a simple sculpture of break dancers one in red and the other one blue celebrates New York City street life. A separate installation space made of industrial chain-link fencing with a metal gate resonated with the din of disco music. On entering one sees a video of Haring himself dancing in a disco. Arranged around the place are ancient Egyptian-looking vases decorated with Haring's Pop-style hieroglyphs and a variety of smaller works. There is even a *Statue of Liberty* so densely decorated in Day-Glo the original form is visually obscured. Haring's tenets of the absolute artistic freedom of street graffiti and the Absolut Vodka commercials he made are a strange mix. Who can judge which social action is the more effective — the crass commercial or the street graffiti artist's? Both are propaganda. While Haring's art had a capital A and a small c copyright symbol right next to it the central question of whether freedom of expression imposes on the public's the right to privacy is soon forgotten when one considers the many generous acts he

Keith Haring in New York Subway, 1981. Photo by Chantal Regnault, 1981. Courtesy Keith Haring Estate.

made to benefit social causes. When Haring initiated the Pop Shop at 272 Lafayette St. in New York's Soho district in 1986 (another was opened in Tokyo in 1988), his own perfect merger between art marketing and avant-gardism the cheap, accessibly priced art objects fulfilled Haring's ultimate goal of bringing art with a message to the people at affordable prices. Numerous public murals for schools, hospitals, children's day-care centres and orphanages likewise attest to these good intentions. When diagnosed with AIDS in 1988, Haring resolved to raise funds to support public agencies for street kids, AIDS and other such causes. Before he died in 1990 at the age of 31, he established the Keith Haring Foundation to continue his charitable support of such causes in perpetuity.

The choices Keith Haring made in his brief journey from avant garde exhibitionist to cookie cutter market stylist reveal a great talent for communicating, rendering imagery immediately understandable. His art reflects a primeval desire to leave one's mark. Perhaps the most touching tribute to the enthusiasm that permeated all of Haring's life and art is the last unfinished painting he was working in 1989 before he died. With only one corner completed it still resonates with a vital energy.

Notes

1. In Germano Celant, Keith Haring, exhibition catalogue (Sydney: Museum of Contemporary Art, 1994), p. 178.

24

Patrick Dougherty: Wildness Fits

Patrick Dougherty's freeform environmental assemblages woven together out of tree branches are visual enigmas that fuse sculptural form with landscape settings. In the 1960s and 1970s, modernist land artists such as Robert Smithson, Michael Heizer, Walter de Maria, and Nobuo Sekine, manipulated nature in a site to fulfil an aesthetic agenda. Their maximally scaled landscape impositions bulldozed, dynamited, moved and displaced the land to impose an idea of art on a site. Women artists such as Ana Mendieta and Agnes Denes offered a more intuitive vision of working with the earth in that era but were less recognized. Artists' conceptions of working in and with the environment have changed greatly since then. Now Nils-Udo, Bob Verschueren, Andy Goldsworthy, David Nash, Patrick Dougherty and others invoke a respect for site and place, for the soil, vegetation, climate, the earth and specific to site and place in their art. Materials, from nature, return to nature, are nature. A vision of the land and art are linked.

Internationally recognized for his work, Dougherty has made over one hundred installations over the past fifteen years in parks, galleries, gardens, and museum spaces in Japan, Holland, England, Denmark, Austria, Mexico, Italy, and the United States. His latest exhibition at Atelier 340 in Brussels involves an on-site installation and a series of Cibachrome prints. The vernacular aspect of Dougherty's art is comparable to spoken language. It's as ephemeral as unrecorded storytelling, more alive than formal history. There is an endless innovation and changeability to Dougherty's work. The spoken word, like artmaking as process, captures the mercurial essence of life itself, escapes the boundaries of definition. Dougherty's rhythmic linear configurations draw portals, whorls, towers or tree houses in space. With an innate sense of the materials inherent properties, they weave their way through space in rhythmic poetic sequences. One witnesses a similar sensitivity to use of materials and a natural building process akin to Dougherty's in "primitive" cultures where no formal conceptions have yet been established about what a structure should be. "Primitive" dwellings closely resemble natural forms found in their geo-specific ecol-

ogies. Few of these are considered permanent and most are made
out of locally available materials.

Tree branches acquire a new meaning in Patrick Dougherty's
assemblages. He appreciates the supple tension, elasticity, tonal
and textural qualities of the materials he works with. The allusions
are to nature own forms, even if the sites are close to man-made
structures. The process is akin to drawing ever new configurations
in space with sticks. As Dougherty has stated:

> There has been a tremendous release as I have learned
> to use saplings as lines and full body motion as a kind
> of pencil. I use all the drawing conventions to make an
> interesting surface — hatchmarks and "x"-ing and rak-
> ing diagonals. I use emphasis lines and shading. I have
> learned that sometimes one small little branch can be
> employed to cool a heavy line. There is also the poten-
> tial to introduce sticks into the surface in one direction,
> thus massing the tapered lines and suggesting a kind of
> motion and directionality.[1]

Forms gradually come into being. The process involves
awareness, conception, imagination, projection, intense concentra-
tion and physical energy.

Working with nature, for Pat Dougherty, involves a crossover
view of habitat and land *where nature is also habitat within a particular
land space*. His fantastic forms mimic forms found in nature, and
look like they could have been built by animals or birds.
Dougherty's conception of scale place and space is comparable to
Japanese artist Tadashi Kawamata's but there is a wilder resonance
here. His installations are not merely an extension of the architec-
ture or site being dealt with. These works are conceived with a
great sensitivity to the creative process. It is ongoing, natural, and
holistic. Structures rise and fall, evolve gradually through a physi-
cal struggle to final completion. The strength of this work is in the
whimsical delight and liberty Dougherty takes with form. THE
PROCESS: seek out, gather, measure, clip, categorize, weave, snag,
bend and bow, piece by piece, line by line, branch by branch, sap-
ling by sapling to arrive at a structure. Dougherty explains:

> There is a natural relationship between my sculptures
> and dance. Both are about gesture, motion and the
> movement of line and force through space. This actual

construction process is not a sedate studio activity; but like dance is one that uses large motions and the entire body. The physicality of the process of making is evident in the final sculptures. Improvisation and constant reaction are the core of my process, as is a celebration of the ephemeral.[2]

There are three stages to Dougherty's artmaking process: STRUCTURE, AESTHETICS and COSMETICS. Within a half hour a brief thumb nail sketch is drawn. The project then begins. The decision over when a work is complete arrives at a natural point in time. A reawakening of natural form comes simply from observing nature. A multiplicity of structures, shapes, patterns can be found in each microcosmic section of these installations, and in the totality of a piece. Dougherty likens his work to the sacred tradition of basket weaving. The process is cyclical — like weaving or poetry — the action of binding is repeated again and again like a mantra. This is natural economy — uncontained, endless, replenishing....

Appropriating the detritus of nature created by human activity — sticks, branches, tree limbs — Dougherty`s labour and time intensive assemblages use materials that are found *on site*. The process is exacting, involving natural forms that recall nests, havens, portals, primitive shelters. The actions undertaken by Dougherty recreate a sense of space in otherwise unclaimed places. Often, natural forms are built on or around man-made architecture thus bringing the process full circle, for all materials (even architectural) ultimately derive from nature. Early human habitations and objects, the way a beaver builds its house, a bird its nest, all of these aspects of life are echoed in Dougherty's assemblages. Branches become a way of tying in the works, bringing forms and shapes together. Because they are ephemeral, these works mirror the inherent fragility of the life process.

Patrick Dougherty's artmaking involves *flowforms* that are not only sensitive to the environmental reality, as found in "primitive" cultures. They also create spatial allusions that suggest an aesthetic dimension, but only as an adjunct to the artmaking process. Our usual attitudes to nature are challenged by the new paradigms for the nature-culture equation Dougherty alludes to. Aesthetically and physically demanding, Dougherty's expression is truly one of our era. He articulates the wood like an etcher working a plate or a weaver working a basket. The dimensions, conception and execu-

tion may look spontaneous, but the effect is not so easy to achieve. Dougherty's environmental installations do not conceive of sculpture as an object, but as part of a temporal process that has a beginning and an end. The lines of branch and tree saplings are ever changing and follow a fluid course.

Bauhaus is not Our House, Dougherty's art seems to say. In works like *Points of Attachment* (1996), made of mixed hardwood for the Ringling School of Art and Design in Sarasota, Florida and *Huddle Up* (1993), woven out of willow saplings at the Yorkshire Sculpture Park in England, the forms twist and turn in, as if caught up by the wind. They are anthropomorphized, animated like tree spirits. They have natural looking openings, entrances that suggest they may have once been inhabited. We can only guess at what lies within, beneath the surface of the forms. These imaginary configurations, like clothing, skin, people or buildings, are temporary. What impresses us is precisely that like a bird's nest or a beaver hut, once lived in, they are then abandoned.

This sense of a hidden or lost history we see in these natural structures is a key to Dougherty's art. Forms, once built, may then be abandoned. The story of their construction, suggested purpose is something we know nothing about. We become voyeurs, who acquire an alternative vision of a place, and apply a possible function to each piece in our mind's eye. Following on from this, and equally part of each work, is the wear and tear of nature upon it after it has been abandoned. Other works such as *In Nature's Sway* (1998), created for the Evanston Art Center in Illinois, play on this theme with 5.49 metre high urn-like pottery forms. The urn-shapes are like ancient pottery made from another material found in nature — clay — but now woven in wood by Dougherty. A history of forms, creations, structures made by humanity is suggested. Portal-like entrances invite viewers to enter within. The dialogue evolves: the external representation of a once functional cultural object and the interior investigation as suggested by the entrances both bring us back to nature as source.

Whim Whams (1992) plays on and with the linear and monocultural arrangement of grass and hedges at the Laumeier Sculpture Park in St. Louis, Missouri. A series of 4.88 metre high hut-like forms literally flow over the grass, the hedges, the whole artificial landscape of the site. Allusion can again be made to the unseen patterns of wind, the sensitive chaos of nature's course. *In and Out of the Wilderness* (1991), an installation created at Ness Gar-

dens in Cheshire, England, inverts the landscape overlay effect seen in Whim Whams by building burrow-like openings into a hedgerow, itself sculpted in a linear and topiary way. Set into the hedge, the openings are like entrances into a hidden world, that may be natural for a gopher or a bird, but not to humans living in a post-industrial world.

Nature's sensitive chaos is evoked in a more subversive, even ironic way in the structures Dougherty has created for the interiors and exteriors of public spaces. One of these structures, *Crossing Over* (1996), a natural nest-like spiral follows the geometric spiral of a stairwell in the American Craft Museum in New York. For *Rip-Rap* (1991) Dougherty created an interweave of willow saplings amid the classical columns for the Manchester Art Gallery in northern England. The wildness of Dougherty's fabricated forms suggests a new genre or aesthetic involved with opening up a dialogue on nature and art that works with the wildness of nature instead of controlling or containing nature.

In the Middle Ages, the *hortus conclusus* or enclosed garden, brilliantly evoked in the Limbourg Brothers 15th century manuscript illustrations for *Les Très Riches Heures du Duc de Berry*, was conceived as a defence against the wildness of nature. By the 18th century, garden cultivation became an expression of control and husbandry of nature. Humanity's primordial need to survive amid nature, found expression in the cultivated garden. The arrangement and displacement of living flowers, plants and trees into neatly arranged configuration evoked a sense of security but also contained nature.

As the ongoing climactic catastrophes, chaotic irregularities in weather and temperature across the world evidence, (the destruction of 1000s of trees at Versailles in France is but one example) though humanity seeks to dominate nature, nature ultimately has the final word. "Nature has a right to remain fallow" states Dougherty. "Its the opposite of saying 'We need the woods not just for medicine, but for the spirit.' "[3] Cultivated gardens and managed parks (such as Frederick Law Olmsted's Central Park in New York and Mount Royal Park in Montreal) have long served the public as places to replenish ourselves amid nature. The nature that grows in these places has been formalized, engineered and controlled. Dougherty's innovative landscape interventions direct us to new social, environmental and aesthetic values that emphasize that untouched nature is culture in the right place. By rehabilitating

the nature-culture paradigm and consciously bringing nature to the forefront of aesthetic discourse, Patrick Dougherty's gestural environmental enigmas suggest that wildness could be integrated into the landscape aesthetic. As wild nature becomes a disappearing and increasingly rare resource, artists, landscapers, architects, even city planners could adapt aspects of natural wildness into a new found aesthetic in their work. Ever changing, visually and experientially challenging, the wilderness aesthetic is like a story whose eventual outcome one never knows.

Tree species, plant species, the subtle changeability of their shapes and patterns are related the world over, no matter what hemisphere or continent they are on. This universal relatedness of forms is an inspiration for artists like Patrick Dougherty. In *Spinoffs* (1990), Dougherty built a hut on the ground out of maple saplings at the De Cordova Museum in Lincoln, Massachusetts. A line of saplings spun upwards from this original dwelling onto the rooftop of an adjacent tower enveloping it in a whorl of branch lines. The natural form found in the "primitive" dwelling builds a continuity through an interwoven line of saplings upwards and continues onto and wraps around the turreted roof of an actual building. Ephemeral forms found in nature become the common denominator. Links are established across a chasm of cultural and ecological history from nature to "primitive" culture to contemporary.

In *Jug or Naught* (1999), a work created for the Frederick Meijer Gardens in Grand Rapids, Michigan, Dougherty alludes to pottery forms that integrate the human face from two different epochs: Ancient Roman vessels from an archaeological site in Austria and face jugs created in the Appalachian Mountains. The vessel or container is thus hybridized and becomes a universal metaphor for what is contained and what contains. This inescapable irony is at the cusp of the civilization-nature dilemma and will provide a major source of controversy for decades to come. Patrick Dougherty's intuitive recreation and tactile joy in working with materials emphasize ephemeral integration and contrast historic notions of within/ without, containment/exclusion. Materials once living and formed by an environment — climate, minerals, water, biodiversity in all its forms — become part of yet another process of transformation, from nature to art and back to nature.

The cornucopia-like twisting forms in *Little Big Man* (1994), a fantastic swirl of willow saplings (10.66m. long x 2.44m. wide) created on a pond for the Krakamarken Sculpture Park in Randers,

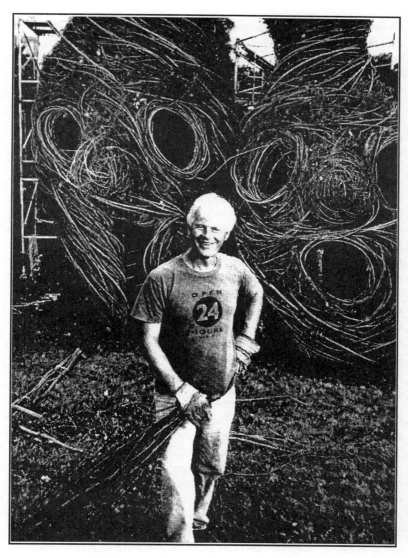

Pat Dougherty. Portrait of the Artist, *Jug or Naught*, 1999. Mixed hardwood saplings, 20' high, Frederic Meijer Gardens, Grand Rapids, MI, USA. Photo by David Ferris.

Denmark, and seen in *Holy Rope* (1992), assembled out of bamboo
and reeds in Chiba, Japan, are imaginative illusions that suggest
spiritual ascendance. Holy Rope moves upwards in a curvilinear
fashion to a height of 7.62 metres from the ground to the upper
reaches of a stately tree in the grounds of the Rinjyo-in Temple. In
Raring to Go (1988) (26.2 metres long, 13.72m. high x 91cm wide),
created in the grounds of the Birmingham Museum of Art in Ala-
bama, twisting forms literally surround and move around and
through the upper reaches of trees, a chaos of growth and form.
The scale is super-natural. Natural chaos wraps natural form.
There is a feeling that this site has been played with, that the
wrapped forms that surround the trees exist only for a time in time.
Because the scale Dougherty works with is so large, it makes us
think of the environments developers transform daily in real time
and space on a similar scale in our cities, suburbs, rural areas that
have no aesthetic of integration with site and space. The physical
scale and presence of Dougherty's art is a constant reminder that
real world environments affect our senses more profoundly than
any abstract conception of a place ever will. Dougherty's approach
challenges traditional conceptions of artmaking, both formal and
avant-gardist. He does not seek to contain meaning, or subject ma-
terials to a formal structure of learning. The discourse is chaotic,
ephemeral, self-willed and subjective; the process is exacting and
precise.

 Natural Selection (1996), created for the Copenhagen Botanical
Garden in Denmark, recalls ancient legends and folkloric tales of
the woods. For this on-site installation Dougherty wrapped hard-
wood saplings around two substantial tree trunks. Two circular
openings in Dougherty's tree-wrap look like winsome eyes. There
is a portal or entrance at ground level. We cannot see what lies in-
side, beneath the surface of this fantastic face, built with nature,
around nature, in nature. It recalls the romantic poet William
Blake's words: "In the eyes of the man of imagination, nature is
imagination." A quintessentially classical statue of a man leaning
on a pedestal stands a stone's throw away from Natural Selection.
Childhood fairy tale fantasy can be found in Dougherty's built
structures, such as *Oh, Me, Oh, My, Oh* (1996), three turreted
tower-like structures created in Houston, Texas. They curve in an
undulating dream-like fashion upwards into space.

 Patrick Dougherty began his career long before he made art.
Born in Oklahoma in 1945, a region known as "twister alley" for its

tornadoes, Patrick Dougherty undoubtedly became aware of the powerful forces nature can unleash in unforeseen ways on humanity, a humbling experience for anyone. Seen as a whole his installations are an homage to these forces of nature. As Patrick Dougherty comments:

> I believe one's childhood shapes his or her choice of materials. By using the materials one is subconsciously drawn to, one can elicit a wide range of fruitful associations. For me, it was exploring the underbrush of my hometown in North Carolina, a place where tree limbs intersect and where one can imagine in the mass of winter twigs, all kinds of shapes and speeding lines. In adulthood, the saplings, so plentiful along my driveway, become the raw materials with which to sketch out a series of large gestural forms.[4]

Nature is recycled, wrapped on and around nature's architecture (trees, landforms, hedgerows), and sometimes actual buildings or in pure space to form mythical habitations, nests, havens, portals, "primitive" shelters, towers, fantastic embodiments of chaos. Links are made with our unconscious thoughts and dreams and with nature's unending ontological history. Entirely hand built, these constructions are spontaneous, combustible, alive, immediate. They fulfil an impulse to design and work within the environment that is quintessentially holistic and human. The word *art* has its origins in the Latin word *ars* which implies skill. The word *ars* likewise comes from *ar*, meaning "to fit or join."[5] Patrick Dougherty eloquently fits and joins sticks, branches, and in so doing shapes nature into art.

Notes

1. Interview with Roberta Sokolitz, *Sculpture Magazine*, Vol.19, No.2, Washington DC, March 2000.
2. Patrick Dougherty, "Fusing Man & Nature" excerpted from *The Intimate Agenda: Inside the Creative Process*, Barbara Seidel, ed. (Aspen, Colorado: Third Eye Press, 1996) pp. 11-18.
3. Patrick Dougherty, cited in *Independent*, August 12-18 , 1998, p. 13.
4. Patrick Dougherty, Artist's statement, nd.
5. Herbert Read, *The Origins of Form in Art* (NY: Horizon Press, 1965) p. 150.

25

The Nuclear Map

In *The Neutron Picasso*, a science fiction fantasy by Michael Carin set fourteen centuries in the future after a nuclear conflict, survivors discuss what art must have meant to pre-bomb civilization:

> "Art for itself alone." Listen closely, and you can hear a lurking savagery in the phrase. It means that nothing human need be conveyed or sought, that no convention of organization need be obeyed, that anything is permitted. Well, ultimately the forepeople ermitted the Bomb, and where are we to search for the reasons why if not in the design of their consciousness?[1]

Among the artifacts preserved from this earlier pre-bomb era are two paintings by Picasso and Pollock, discovered encased in a steel crate on the ocean floor. Picasso's analytical and synthetic Cubist paintings, a breakthrough in 20th century modernist art, destroyed any lingering notions of continuous sequential representation in art, furthering the visionary schism between humanity and nature, one that was occurring in science as much as art. As one of the survivors of nuclear holocaust in *The Neutron Picasso* states, Picasso's painting is like a "keyhole glimpse of the mindset that propped the stage for the big blaze ... (They) speak like X-rays of cracked skulls splinted with madness."[2]

In the early part of this century, Ernest Rutherford worked on a new *disintegration theory of matter* while MacDonald Professor of Physics at McGill University. Rutherford demonstrated that when one element breaks apart at the atomic level, the fragments become new elements and a significant release of energy occurs. Rutherford's interest in researching radioactivity and the atom also led to the discovery of alpha and beta particles, the half-life of radioactive substances and the nucleus of the atom. By 1938, Hahn and Strassman, working in Berlin, discovered that the nucleus of a uranium atom can be split or fissioned by bombarding it with neutrons. This changed nuclear research forever. For some, this splitting of the atom represented the final splitting apart of the primal character of man — the old Adam.

The fission age was ushered in not with a whimper but a bang. It was not energy, but war, that was the engine for its development. The threat from Germany and Japan was real, and, though Canada's role in the Second World War has been well documented, our involvement in the development of the Atom bomb remains largely out of the public eye. Canada has contributed to the Manhattan Project, a race to develop an A-bomb technology that began with the Los Alamos/Alamogordo tests in New Mexico on July 16th, 1945 and followed by the Hiroshima and Nagasaki bombs. The A-bomb project was accelerated by an agreement signed by Prime Ministers Winston Churchill, Mackenzie King and President Franklin Roosevelt in Quebec City in August 1943; this historic accord stipulated that Great Britain, Canada and the United States must share resources to bring the Bomb project to fruition at the earliest time to overcome Nazi Germany.

Del Tredici's photo of Henry Moore's sculpture *The Nuclear Age* next to the Stagg Field Bleachers at the University of Chicago, is a seemingly innocuous scene of children playing, the very personification of innocence. Yet, it was in a laboratory beneath these bleachers that Enrico Fermi achieved the world's first self-sustained nuclear chain reaction in 1942, a development that paved the way for the development of the Atomic bomb. Time and again Del Tredici's photos present us with a scene, only to shatter one's initial impression because of the data, information and history associated with them. One such photo of several mounds in Hazelwood, Missouri, looks almost pastoral at first glance. The only clue to the dangerous nature of this site are the upside-down rubber boots in the foreground. Are we aware that anyone walking on this site must wear these boots — and leave them behind afterwards — lest contamination be tracked off site? The contamination in this dirt came from Canada and was used for uranium refining operations during the 1940's. The Mallinckrodt Chemical Works purified raw uranium from Port Radium in the Northwest Territories for Enrico Fermi's graphite reactor, in Chicago.

In *On Home Ground*, Del Tredici's photo of a vacuous landscape littered with radioactive uranium core-samples and waste rock at Port Radium reveals the procedure used for dealing with the thousands of tons of radioactive mill-waste in the early days. The solution was simply to dump it into the lake and the surrounding environment. Today's mining practices take more care when dealing with waste than in the early days, but methods of dealing

with waste in the long term remain unresolved. This year, while documenting the Port Radium mine-site for an exhibit in Hiroshima's A-bomb museum, whose directors had asked him to provide proof that Canadian uranium had ended up in the Hiroshima bomb, Del Tredici came across a real find: an official cement marker at the tip of Silver Point on Port Radium that had a bronze plaque with raised letters on it that read:

> The mine was reopened in 1942 by Eldorado Mining and refining Limited, a federal Crown Company, to supply uranium for the Manhattan Project (the development of the Atomic Bomb). Processing of the radium and uranium ore resulted in the establishment of a world-class refining facility at Port Hope, Ontario. Exhaustion of the uranium ore led to mine closure in 1960.[3]

In *The Road to Wigan Pier*, George Orwell explained our civilization's fixation on progress and technology, which he referred to as machine-civilization:

> The machine civilization *is here*, and it can only be criticized from the inside, because all of us are inside it ... There is no reason to think that it will destroy itself or stop functioning of its own accord. For some time past it has been fashionable to say that war is presently going to 'wreck civilization' altogether; but, though the next full-sized war will certainly be horrible enough to make all the previous ones seem a joke, it is immensely unlikely that it will put a stop to mechanical progress. We may take it that the return to a simpler, free, less mechanized way of life, however desirable it may be, is not going to happen. This is not fatalism, it is merely acceptance of facts.[4]

When Orwell wrote these words in 1932, many sensed a world war was looming, but few could have predicted that a radium mine discovered in 1930 in the bushland of Canada's north would, at the behest of the American Department of War, provide an essential nuclear explosive metal for the Manhattan Project, America's Second World War Atomic Bomb project.

In 1930, prospecting by plane in the Northwest Territories, Gilbert Labine observed a bright-coloured outcrop at the eastern end of Great Bear Lake. After landing on the lake he discovered native silver and cobalt minerals on a small island and other veins containing silver, cobalt, nickel and uranium on the mainland, in what became the Eldorado Deposit.[5] Uranium, known about for over a century, was mined only for minerals such as silver, gold, copper and cobalt. Labine's discovery was 900 miles from any road or railroad. The deposit was rich and exploitation immediate.[6]

George Blondin, a member of the Sahtu-Dene tribe that has lived on the shores of Great Bear Lake for thousands of years, recounts a traditional native story that originated several hundred years ago and has been passed down from generation to generation. It tells of native hunters returning one summer from a caribou hunt in the Barren Lands. Canoeing into Great Bear Lake, they passed in front of a cliff that natives rarely went near as it was considered bad medicine. They camped there overnight. In the middle of the night, the whole group was wakened by the frantic chanting of their own medicine man. When daylight came he told the hunters of his vision:

> I saw many people with pale skin. They dug, they worked and made a lot of noise. I saw what they were making with the rocks they were carrying out of the ground. It looked something like a log. Then I saw them put the log into a great bird. The bird flew to the far end of the earth and they dropped the log on the people who lived there. When the log fell everything caught fire and everybody died. They looked just like Indians, those people.[7]

Deline Village, at the other end of Great Bear Lake, is called the "village of widows" by local native peoples because so many men have died of cancer there. Del Tredici's photos of the Deline widow *Bella Modeste* and the newly dug grave of a Deline villager who worked with uranium and whose life was cut short by cancer, is a testimony to the harmful effects of uranium. The latter photo has a mound of earth covered in plastic. The grave is surrounded by other graves, each one with its own white picket fence. A Madonna looks on from the vantage point of her enclosed altar. The *Radium Gilbert*, a boat used in the uranium mining industry at

Great Bear Lake is a ghost-like rotting wreck now, captured by Del Tredici with paint peeling off its sides, and graffiti on the inside. The effect on the Sahtu-Dene people has been permanent. Theirs is a tale of misinformation, secrecy and neglect.

Sister Rosalie Bertell, a doctor of mathematics, member of the Grey Nuns of the Sacred Heart and author of *No Immediate Danger: Prognosis for a Radioactive Earth*, is presented in one of Del Tredici's photos lecturing at the Unitarian Church of the Messiah in Montreal. In *No Immediate Danger*, Bertell gives us some idea of the effects of radioactive isotopes on living human tissue:

> The chaotic state induced within a living cell when it is exposed to ionising radiation has been graphically described by Dr. Karl Z. Morgan as a 'madman loose in a library'. The result of cell exposure to these microscopic explosions with the resultant sudden influx of random energy and ionization may be either cell death or cell alteration ... Radiation damage can cause the cell to produce a slightly different hormone or enzyme than it was originally designed to produce, still leaving it able to reproduce other cells capable of generating this same altered hormone or enzyme. In time there may be millions of such cells.[8]

Robert Del Tredici's photo of a particle of plutonium magnified 500 times in the lung tissue of an ape evokes all the madness of the nuclear threat, but in a peacetime context and inside a living body, for the dark star in the middle of this photo shows the tracks made by alpha rays emitted from a particle of plutonium. Once inside the body, the rays penetrate 10,000 cells within their range and have a half-life of 24,400 years. Working with radioactive materials has affected the health of innumerable people, including Bjarnie Paulsen, a veteran of the clean up at Chalk River, Ontario, one of Canada's earliest nuclear mishaps. Depicted in one of Del Tredici's photos, Paulsen suffered from several rare forms of skin cancer and demanded compensation from the Canadian Pension Commission. The authorities initially denied he had participated in the clean-up. When a link between his work during the Chalk River clean-up and radiation exposure was established because of reasonable doubt and after seven tribunals, Mr. Paulsen was finally compensated.

The Nuclear Map of Canada show is an outgrowth of Robert Del
Tredici's larger body of photowork dealing with nuclear issues. The
centrepiece of this exhibition is *The Nuclear Map of Canada,* a 6' x 4' map
conceived of and co-designed by Del Tredici and Gordon Edwards,
president of the Canadian Coalition for Nuclear Responsibility. It is
covered with sites most Canadians know little about. Finding out
where they are, and what they are, somehow changes one's sense of
the nuclear industry's place in Canadian life. It demonstrates the per-
vasiveness of Canada's nuclear industry by locating and identifying
all of Canada's nuclear facilities. Del Tredici's photographs shed light
on many of the aspects of mining and refining of uranium, the Atomic
Energy of Canada's CANDU reactor technology and nuclear waste
disposal located on the map. The images presented to us in this show
are a window into this unknown world.

Robert Del Tredici was drawn to photography in the 1970s, in
part, because of that aura of mystery found in Eugene Atget's early
photographs of Paris in the 1860s, with their inexplicably sinister
and inimitable atmospheres. "I've always liked the idea of the cam-
era as a little black box that can steal parts of souls. I am attracted to
images that tell a story. I love photographing things that have not
been seen before" states Del Tredici who came to photography by
way of drawing and book illustration.[9]

Included among his early accomplishments were illustrated
versions of Cervantes' *Don Quixote* (1962), Dostoyevsky's *Crime and
Punishment* (1963) and Herman Melville's *Moby Dick* (1964-68). It
was that initial attraction to forbidden and seldom seen environ-
ments and events that led him to documentary photography. His
first book, *The People of Three Mile Island* (1980), captured the invisi-
ble effects of radiation on the lives of people living near that nu-
clear accident.

> After seeing how one slightly used power reactor could
> turn people's lives inside out, I wondered about the
> older, darker reactors that mass-produced plutonium
> for the Bomb. During six years I flew over all of Amer-
> ica's H-bomb factories. Before doing that I went to Hi-
> roshima to learn the meaning of the Bomb in human
> terms.[10]

Hiroshima was a turning point; here Del Tredici not only
heard about the effects of the Bomb on survivors but he also, in his

own words, received a blessing from survivors to go after the H-bomb factories. Del Tredici has since played a key role in making visible the unseen yet very real effects of nuclear technology on people worldwide. In 1987, the year he published *At Work in the Fields of the Bomb* (1987), Del Tredici founded the *Atomic Photographers Guild*, a collective of photographers documenting different facets of the nuclear age. The Guild, whose mandate is "to reveal all aspects of this elusive era, making it visually accessible" now has 23 members from Japan, USA, Canada, Germany, Russia, the Ukraine and Kazakhstan. More recently he has provided photographs and captions for the U.S. Department of Energy publications *Closing the Circle on the Splitting of the Atom* (1996) and *Linking Legacies* (1997), which document the first serious attempts to clean up radioactive contamination around the United States' H-bomb factories.

Two photographs effectively sum up the whole process of Del Tredici's work. One is a recent photo of a Sahtu-Dene native standing above a pile of decaying sacks on a rocky outcrop near Great Bear Lake. These same burlap sacks were once filled with uranium ore and carried by the Sahtu-Dene on their backs. Some of this uranium was sent south for use in the Manhattan Project, which led to the explosions of Hiroshima and Nagasaki. The second photo is of a bronze Buddha from Hiroshima, melted by the heat of the A-Bomb that landed on Hiroshima on August 6th 1945. One could not find a more salient symbol than this Buddha for the splitting apart of the primal character of humanity by the splitting of the atom. The Dene natives who carried sacks of ore out of the world's first uranium mine, referred to as "coolies" at the time, have never been included in any histories of uranium mining because their story is marginal to mainstream history. As a spiritual icon, the Hiroshima Buddha is rendered all the more powerful for the A-Bomb's devastation of it. The subject of war, out of which Canada's nuclear energy programme developed, has never been captured in a more succinct manner.

In another Del Tredici portrait, we see the activist Maisie Schiell questioning Atomic Energy of Canada officials at a nuclear waste conference in Winnipeg in 1986. Through a process of layering and accumulation, Del Tredici's photos gradually, subtly communicate the unspoken effects of the nuclear industry in Canada. A photo of "yellowcake" (a powdered uranium concentrate) stacked four rows high and awaiting export or another photo of the Eldo-

rado Uranium Refinery in Blind River communicate their message insidiously with a visual acuity that highlights the ordinary in an extraordinary way. Seeing an image of worker's clothes contaminated with uranium dust hanging from the ceiling at the Key Lake uranium mill in Saskatchewan, makes one ask questions. The answers are not so easy. It is this sense that the dangers associated with working in the nuclear industry exist in the details, the ordinary that pervades Del Tredici's nuclear age photos. Del Tredici's photo of a wall of white sand composed of radioactive mill waste at Elliot Lake, where more than 100 million tons of tailings have been deposited directly into the environment is equally unsettling. The cragged face of Isadore Yukon, a uranium barge pilot on Great Bear Lake is full of lines like the barren landscapes of waste Del Tredici presents in this show. These portraits create a humanistic counterpoint with his industrial photography — the aerial views of nuclear processing plants and wastelands.

The discovery of the fission process, so essential to the development of the A bomb, led to the harnessing of nuclear energy for peacetime purposes with "thermal reactors" in the post-war period. Del Tredici's photo of the CANDU reactor at Darlington, in Ontario presents a view of a man standing in front of a glaring hive of tubes. Canada's peacetime CANDU heavy water reactor produces plutonium more efficiently than any power reactor except the breeder. Uranium is fissioned in a moderator of heavy water to produce heat, steam, electricity, and plutonium. CANDU technology, unlike the American light water system, uses relatively small fuel bundles that can be moved in or out through individual tubes without shutting down the reactor. As a result, it is less easy to detect when plutonium is being removed from the reactor. The CANDU reactor enables those who have CANDU technology and would seek to produce plutonium for bombs to do so without shutting down the reactor. Though Atomic energy of Canada products have positive applications in medicine such as radio isotopes and the irradiated gold plated seeds used in various kinds of cancer treatment, the CIRIS prototype research reactor supplied to India and the plutonium extracted from it were used for India's first bomb in 1974. The collapse of communism has diminished the nuclear threat among the world's leading nations, yet it has paradoxically increased among third world countries. Pakistan's atomic test bomb in 1998, the world's first "Islamic bomb," has set the stage for an arms race in the subcontinent.

While no nuclear reactors have been sold in North America since 1978, Atomic Energy of Canada is currently negotiating new reactor projects in Turkey and China. The loan of $1.5 million for the reactor in China, is the largest ever guaranteed by the federal government.

The layering in Robert Del Tredici's photos, where each image reveals more facets of the nuclear theme, and from a perspective that we do not yet find in history books, that of cultures and peoples marginalized by mainstream historians, renders them penetrating revelations of Canada's nuclear involvement. Del Tredici fills the gaps with visual metaphors that challenge conventional notions of what is significant. His photo of the end of a nuclear disposal test shaft in Lac du Bonnet, Manitoba, is the ultimate end-game image. A ladder stands in front of a wall of granite. Drilled in a rough way into the rock are primal markings — a circle and a cross. An expository glimpse at the predicament of nuclear energy program, this cavernous test shaft prototype is used to demonstrate the concept of nuclear waste disposal 500 metres beneath the Canadian Shield.

The more insidious effects of nuclear energy, those involved in the production process and waste management, are less well known to the public. Radioactive particles and materials that last for 100's of thousands of years are left behind. Port Hope, on the north shore of Ontario, once processed radium and began processing uranium from Canada and the Congo during the Second World War and continues to process Canadian uranium. Penny Sanger, author of *Blind Faith,* an account of the nuclear industry's involvement in this region, states:

> The uranium trioxide refinery is the first stage in fuel processing. It takes the yellowcake from the mines and refines and converts it, with the addition of nitric acid and the solvent tributyl phosphate, to stages ready for conversion to the CANDU fuel uranium dioxide and uranium hexafluoride. It is this process that caused most of the chemical emission problems in Port Hope; it also gives off the sludgy raffinate wastes that contain nearly all the impurities, chemical and radioactive, from the ore ... It would have been hard, many people thought at the time, to find a place less appropriate for the construction of a uranium refinery than the deep forest and untouched meadowland of the Hope township site.[11]

Port Hope now also has a uranium hexafluoride conversion plant that produces environmental hazards in the form of fluorides emitted through the plant's stacks. The waste from these Eldorado-owned and operated plants, including their earlier radium-processing plant which ceased operations in 1953, have been dumped throughout the region with little regard for seepage, effects on wildlife and human life. The whereabouts of some of these materials are still not known, though some areas have been cleaned up. Del Tredici's photo of children playing outside St. Mary's School in Port Hope looks innocent enough. Yet this same school was the source of a stormy controversy. High concentrations of radon gas were found leaking into the school due to the dumping of radioactive waste there. The school had to be levelled and rebuilt. The polluted earth was trucked out to be deposited elsewhere.

As E.F. Schumacher, author of *Small is Beautiful: Economics as if People Mattered*, has stated:

> Of all the changes introduced by man into the household of nature, large-scale nuclear fission is undoubtedly the most dangerous and profound. As a result ionising radiation has become the most serious agent of pollution of the environment and the greatest threat to man's survival on earth. The attention of the layman, not surprisingly, has been captured by the atom bomb, although there is at least a chance that it may never be used again. The danger to humanity created by so-called peaceful uses of atomic energy may be much greater.[12]

The Ice Storm in Eastern Canada this winter awakened many of us to the problem of dependence on *all energy systems*. The problem is paradoxical. The solutions to energy use, in which the nuclear industry plays a role, involve energy alternatives and the reduction of energy consumption. Peacetime use of nuclear energy involves the maintenance of nuclear production facilities, the upkeep of these facilities, the treatment and disposal of nuclear waste, and even the future dismantling of radioactive nuclear structures and buildings. The expenses for such activities are enormous and a drawback to the creation of new nuclear energy facilities. In Ontario, a province that receives 50% of its energy supply from nuclear sources, there are major problems now surfacing in the maintenance and running of the now existing nuclear facilities.

Robert Del Tredici's black and white photographs use the conventional language of documentary photography, yet challenge our conventional associations with the photo as document. His reactor photos, for instance, of the NRX reactor at Chalk River, of Pinawa Dry Storage Fuel Equipment reactor or the face of the CANDU reactor at Darlington, Ontario, could almost, but not quite, pass for industrial promotion photos. The same could be said of Del Tredici's captured images of void-like empty spent fuel pool at Darlington, in Ontario or the full spent fuel pool at Gentilly in Quebec. His aerial photos of the Chalk River and Bruce Nuclear sites present an overview, suggest a broader context of environment within which such sites exist. We are drawn to look at them as "documents" of the nuclear industry yet these documents are tinged with an atmosphere of unreality precisely because they present an individual view of the impersonal.

Some images are more disturbing than others, such as the formidable steel maw of a shovel in the Gaertner Pit at Key Lake Mine in northern Saskatchewan, until recently the richest uranium mine in the world, where radiation levels can be 7,000 times greater than background radiation levels, or row upon row of uranium hexafluoride gas (a material that can as readily be converted into plutonium for warheads as used for nuclear energy) awaiting shipment at Port Hope, Ontario. Juxtaposed with other industrial documentary photos that capture the gadgets, cogs, pipes, pools, silos and environments of the nuclear infrastructure, Del Tredici causes us to reflect on the very nature of documentary photography. His documentary style is now a rarity. These photos have the grey, sultry atmosphere of Soviet propaganda photography or Kurosawa's films. In pursuit of all things nuclear Del Tredici follows a simple set of rules: "Play it straight, push your luck, know your rights and don't trespass." The problems encountered in documentary photography parallel those in journalistic reportage. Del Tredici's images of sights we seldom see have a global scale and scope. Document by document these photos present their case. The sheer weight of evidence suggests some sublime, universal conundrum. Each single image is part of a bigger picture. It is as if, by putting together the fragments of this jigsaw puzzle called the nuclear age, Del Tredici enables us to reflect more profoundly on the ultimate conditions of modern life, to glimpse behind the veil that has, for a long time, shielded the nuclear industry. Del Tredici's photos somehow manage to undermine our conventional associations

Gaertner Pit, Key Lake Mine, Northern Saskatchewan, Canada, 1986.
Photo courtesy of Robert del Tredici

with his subject and cause us to reflect more profoundly on the seen and unseen aspects of nuclear energy. He fits it all together, piece by piece, capturing his subject image by image, across the nuclear map of Canada.

Notes

1. Michael Carin, *The Neutron Picasso* (Toronto: Deneau, 1989) p. 63.
2. *Ibid.*, p. 53.
3. Winston Churchill, cited in *The Atomic Age Opens* (Cleveland: World Publishing, 1945) p. 18.
4. George Orwell, *The Road to Wigan Pier* (Harmondsworth: Penguin Books, 1972) p. 192.
5. Cornelius S. Hurlburt, Jr., *Minerals and Man* (New York: Random House, 1968) pp. 270-271.
6. *Ibid.*, p. 153.
7. Magnus Isacsson, Director, Uranium, National Film Board of Canada, 1990.
8. Rosalie Bertell, *No Immediate Danger: Prognosis for a Radioactive Earth* (Toronto: Women's Press, 1985) p. 27.
9. Robert Del Tredici, Artist's statement, nd, np.
10. *Ibid.*
11. Penny Sanger, *Blind Faith: The nuclear industry in one small town* (Toronto: McGraw-Hill Ryerson, 1981) p. 131.
12. E.F. Schumacher, *Small is Beautiful: Economics as if People Mattered* (New York: Harper Perennial, 1989) p. 143.

26

Transition(s)

A new language of expression developing in the West has to do with a renewed respect for nature and its processes. We see this more readily in other disciplines than art; holistic medicine, the organic food industry, earth sensitive habitats and recycling of old buildings in architecture, and bio-design. This interactive dialogue is rooted in the actual experience of site where it is and this is the key to a bioregional ethic. The inflexible stereotypes of art history — outmoded notions of avant-gardism, modernist, and even post-Modernist aesthetics — are the legacy of a civilization that defines progress exclusively in economic terms. The artworks produced on site for Transitions 2002 demonstrate that contemporary art can be earth sensitive without losing any of its cadence as part of the ongoing social dialogue. This, in part is because, nature is the art of which we are a part. On the grounds of the Maison des Gouverneurs in Sorel July, 2002 artists from Canada, the United States and Europe created unusual and surprising new works that celebrate nature's place in the creative process by using locally available materials and with a basic sensitivity to the history and geography of the place.

The unique natural and historical setting of the Maison des Gouverneurs on the chemin des Patriotes along the banks of the Richelieu River was an unusual setting for such a show, as Sorel is an industrial town that played a significant role in Quebec's history as a centre of the shipbuilding industry. Sorel is situated at the junction of two rivers — the Richelieu and St. Lawrence. The nearby Lac Saint-Pierre World Biosphere Reserve comprises a 480 square kilometre zone, and is one of only 400 such UNESCO designated sites in the world, encourages environment protection and biological diversity. As Normand Gariépy, President of the Co-opérative de solidarité de la Reserve de la Biosphere du Lac Saint-Pierre states: "The Lac Saint-Pierre region is the best kept secret in Canada. It is a real jewel of natural environments." As if by magic, the artists invited to Sorel each found specific and different locations in the immediate environment of the grounds at Maison des Gouverneurs. Each then began in their own individual way, and using locally

available natural materials, to express and create, to build and transform, thus introducing an altogether novel dimension to the otherwise austere grounds of the Maison des Gouverneurs. The American invasion of 1775 heightened awareness of Sorel`s stragtegiuc importance. Governer Haldimand acquired the seigneury of Maison des Gouverneurs for the Crown in 1781 and built the house so the commander in chief might reside in it if a war occurrreed between the United States and Canada. It was likewise the place where the first Christmas tree was raised in Canada on December 25, 1781 by General von Riedesel. At the time, the region was abundant in water fowl (Ptarmigan, wild geese and pigeons) and fish. The lands adjacent to the Maison de Gouverneurs were a large garden for growing foodstuffs and raising cattle and pigs for inhabitants at La Maison des Gouverneurs. In a letter dated 1782 Madam Riedesel comments:

> My husband has a large piece of land in behind the house that he has transformed into a garden where he planted 200 fruit trees ... Everything grows well and each night we go to the garden and harvest 150 to 200 cucumbers that I arrange into a marinade. This way of preparing them is not known to Canadians, and I take advantage of this to give them as presents, particularly to General Haldimand, who says they are excellent."[1]

It is in and around these same grounds, where foodstuffs were cultivated in the 18th century that the diverse range of artist's ephemeral creations took place. Now an empty field the site thus transformed encouraged people to rethink the ways locally available materials from nature can be used and how sensitivity and resourcefulness can transform any site and breathe life into it. It created an opportunity to reflect on the great gap between human culture and culture of nature. Events such as the Kyoto protocol, and the extreme divergence of opinion (between 3rd world and 1st world societies) on what human progress and responsibility should be, evidence how important resolving the ecological crisis worldwide has become.

The artists invited to produce outdoor installations at Sorel are part of a worldwide phenomenon, that counters the new technologies fad. Artists use processes of working with nature, while contextualizing their art, situating this in the context of the site and

using locally available materials, the majority of which are derived from the actual site.

Belgian artist Bob Verschueren is not only a veteran of vegetal art. His works are likewise daring in their use of mineral matter. Nature silently and surreptitiously invades the meaning of art in his art. His ephemeral artworks do not seek to conquer or possess a space, but in creating scenarios that are site, light and earth sensitive heighten our awareness of the actuality of a place ... Among his most ground breaking works are the *Wind Paintings* from the 1970s and 1980s which involved "painting the landscape" of empty and desolate places with crushed charcoal, iron oxide, chalk, terra verte, flour, yellow ochre, terre de Cassel, burnt and natural umber. Each time, after a specific material was laid out in a linear motif on the land, Verschueren would wait for the wind, "a hand that sublimates the art to the materials" to distribute the variously coloured pigments and materials over the land. The resulting works usually only last a few hours. The wind that created them likewise blows them away. Verschueren's Vegetal Installations play on and with ephemeral materials such as nettle and water lily leaves, sand, tree branches, moss, lettuce, twigs, stones, fire, even potato peels and the list goes on ... Verschueren's vegetal aesthetic invokes a phenomenological approach to artmaking. Each design applies natural elements to establish a relation to the architecture and landscape of a particular site — whether indoors, out in the land, or in the city.

At the Maison des Gouverneurs in Sorel, Verschueren again applied his site sensitive style to the environs, and the specifics of the site and historic architecture by creating a "flag" made of reeds gathered from sites in the region. The "flag" with the reeds inset into the trunk of a dead tree, became an emblem of sorts as it stood installed next to the visitors parking lot. It invited passers-by and people driving by to come and visit the site. Verschueren's flag represented no nation, and had no specific symbolism (Nature being in a state all its own!). Its patterning was specifically nature-based, and the whimsical humour of this traditional symbolic icon was not missed by visiting artists and public at large.

From out of the mouth of an old 19th century cannon that has been on the grounds of the old Maison des Gouverneurs for a long time, on the hillside that leads to the river, Verschueren placed tree branch sections thus establishing a nature-human history allusion, animating a de-activated space. The branches extended out of the

cannon in a mock gesture that reversed the order of history. To bring this old artifact back to life, not for wartime purposes, but simply to amuse and animate the environment, was a worthy gesture! as if it alluded to a fictional war, lost in advance between nature lovers who believed in the power of dreams, and industry's love of productivity at all costs, symbolized by the old ship yards immediately facing his installation and across the rover from the Maison des Gouverneurs.

Verschueren animated a sort of "green battle" even adding cannonballs painstakingly twined together out of twigs and branches. These finely constructed "cannon balls" — circular twinings — literally littered the hillside. The branches, cannon and cannon balls creating a surreal effect, transforming the barren hillside, to enlighten the public before, during, and after the opening ceremonies, but these vegetal armaments never flew through the air, gathering momentum, but surely and simply projected an imaginative, surreal sense of the place and of a purported "other" history. This aspect of setting nature and natural materials off against built structures and habitats is typical of Vershueren's process and practice as an artist. The juxtaposition and displacement of materials heightens our sense that the world that surrounds us may be less natural (in the sense of context) than we may think. Contexts change and nature displaces itself, just as humanity displaces nature. Basic questions remain ... Exactly whose nature is this? And whose environment? And whose art? And whose culture?

Considered a pioneer of public art that celebrates our links to the land, to permaculture, Alan Sonfist is an artist who has sought to bridge the great gap between humanity and nature by making us aware of the ancient, historic and contemporary nature, geology, landforms and living species that are part of "living history." With a reawakening of public awareness of environmental issues and of a need to regenerate our living planet Sonfist brings a much needed awareness of nature's parallel and often unrecorded history and present in contemporary life and art. As early as 1965 Sonfist advocated the buildings of monuments dedicated to the history of unpolluted air, and suggested the migration of birds should be reported as public events. Sonfist is best known for his *Natural/Cultural Landscape* Commissions which began in 1965 with *Time Landscape* in Greenwich Village, and included *Pool of Virgin Earth* in Lewiston, N.Y. (1973) not far from the Love Canal, a 7-mile Sculpture Nature Trail in La Quinta, California (1998), as well as *Natu-*

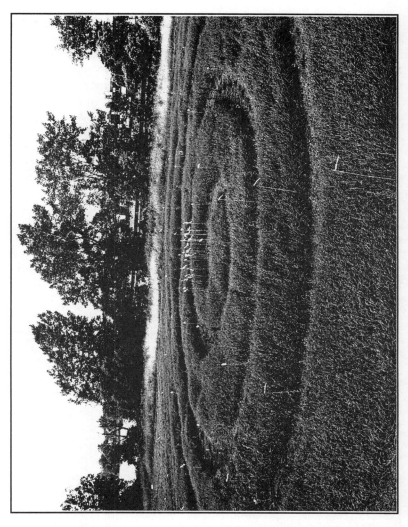

Alan Sonfist. *Indigenous Trees Reflecting the Milky Way*, 2002. Adjacent to the Maison des Gouverneurs, Sorel, Quebec, Canada. Photo by Simon Ménard.

ral/Cultural Landscapes created for the Curtis Hixon Park in Tampa in Florida (1995).

In an essay published in 1968 *titled Natural Phenomena as Public Monuments*, Sonfist emancipated public art from focussing exclusively on human history stating:

> As in war monuments that record the life and death of soldiers, the life and death of natural phenomena such as rivers, springs, and natural outcropping need to be remembered ... Public art can be a reminder that the city was once a forest or a marsh.[2]

Alan Sonfist has bequeathed his body as an artwork to the Museum of Modern Art, considering its decay an ongoing part of the natural life cycle process and, in his urban and rural artworks, he seeks to heighten public awareness of the historical geology or terrain of a place. Earth core samples, for example, become a symbol of the deeper history or geology of the land. While in Sorel, Sonfist captured the layered and complex intertwining of human and natural history that the site represents, specifically because of its being the site of the first Christmas Tree raising in Canada, but also more generally and on a broader scale, the symbol of a tree represents the ephemerality of the life cycle itself, of birth, life, death, decay and birth. As Sonfist commented during the event, "I want it to be permanent for it to be meaningful. Moving the living trees would harm them, and goes against my philosophy." Initially Sonfist conceived of his Sorel intervention and site installation as a circle of burnt tree trunks and detritus (hopefully collected from a forest fire) in the centre of a spiral of living trees. As there were no available forests that had been burnt nearby, the project was adapted, so that the centre would include a circle of red coloured plants — a symbol or birth, of blood, and regeneration. The city of Sorel-Tracy provided welcome assistance by preparing a 20 metre in diameter circle, removing the topsoil for tree planting in April. Four species of trees (including spruce and cherry) were planted at the end of April with walkway between. The pathways into the centre, formed a spiral allusion to the spiral of life and time. Each human life, each generation, each era and all of humanity's history (which parallels and is part of the ongoing bio-history of the planet earth and the cosmos in general) can be seen to be a spiral. On hearing that Sonfist intended to replace the burnt forest centre concept

with a circle of red plants symbolizing fire and regeneration, native artist Mike MacDonald, whose butterfly gardens are renowned across Canada, decided to contribute *lobelia cardinalis* plants to the event. He drove specifically from the east coast of Canada to Sorel and planting them in the centre of Sonfist's spiral not in a ceremonial way, but with humility and recognition that this act of collaboration would help in the nature healing process Sonfist's work symbolized. Immediately prior to the exhibition opening Sonfist added markers at intermittent distances all the way to the red centre of his spiral. He chose white gauze textile to hang from each marker. As they fluttered collectively in the wind, they symbolized the collective effort needed to heal the planet earth and the people, living species on it. Sonfist's gesture of healing was so appreciated by local authorities that in discussion with the Maison des Gouverneurs, the City of Sorel-Tracy agreed to rezone the site to allow the trees to remain for years after the event

As northern Alberta-based Peter von Tiesenhausen states: "I'm not trying to make a monument to anything. I want to have a dialogue with the land." Earlier works such as *Ship (in field of timothy)* (1993) a willow boat structure that referenced the journey his ancestors made to arrive in the North America are ephemeral, use locally available materials on site and suggest the theme of a passage or journey through life. During a stay at the Banff Centre for the Arts' Leighton Colony, von Tiesenhausen actually carved a boat out of ice, set a rock into it and sent it on a journey floating down the Bow River. When the work eventually melted at some point on the river, the rock dropped unseen into the river's depths. One of von Tiesenhausen's most recent projects called *Figure Journey* involved touring a collectivity of carved larger than life figural sculptures. *The Watchers*, as the sculptures are now known, have traveled approximately 30 to 35,000 kilometers through every province and territory of Canada, and have traveled by boat through the icy Northwest Passage. They have stood at the edge of the Atlantic, Pacific and Arctic Oceans. The sculpture's journey established a dialogue as people in logging towns, restaurants, gas stations, in cities or the country reacted to the figures in various ways. That journey has now ended at the same point where it began nearly five years later in Demmitt, Alberta.

For his on-site installation at Sorel, von Tiesenhausen surveyed the area and this initial inspection led to a significantly large dead elm tree beside the forest on the edge of the field once farmed

Peter von Tiesenhausen. *Ice Boat*, Bow River, Alberta. Photo courtesy of the artist.

in earlier centuries but now fallow. The inspiration for the current work came directly from observing a bird in flight attack and kill another bird in mid-air. Von Tiesenhausen went to work on the dead elm, but unfortunately a limb of the tree fell and broke his foot. With the help of student assistants Francis Mineau and Reno Bastien the work continued. An ogival cut in the grass over 20 metres long established an initial space for the installation and provided a counterpoint relief to the otherwise flat grassy field punctuated only by Sonfist's spiral in the centre of an otherwise nondescript. Cut branch and limb sections began to be employed in the making of this elongated assemblage. All of the elm was recycled and given a new purpose — as art — and some sections hung in the air, while others acted as support arches or gates. Over time, the imagery developed and gradually one could, from certain angles recognize the symbols or signs von Tiesenhausen intended. The overall sentiment in this installation is of an instinctive violence and abiding sensitivity. From a particular angle one could see the form of a boat hanging in mid-air, and from another the horned head of a bull. These stick symbols, are, like Patrick Dougherty's sculptures, a kind of drawing in three-dimensions with stick, leaf, branch and twig. von Tiesenhausen's sculpture/installations fulfill a wildness aesthetic just as the German art movement *die Brucke* sought to do with painting early in the 20th century. Peter von Tiesenhausen's forms exist in real three-dimensional space and they breathe, by space, in a natural environment.

The idea of sacrifice, of giving something back to the earth, entered into the cosmological outlook for von Tiesenhausen's work implies a cyclical process. At the end of the main vagina-shaped ground form, von Tiesenhausen recycled the remaining branch sections to create a hut/ shelter. The place provided another perspective on the piece — a point of view — and, like a sanctuary became a symbolic refuge from the current and speed of modern life. Near the forest area from which the elm was taken, von Tiesenhausen and his crew cleaned up the grounds and created an *entrance into nature*. Usually people developed a divide between nature and contemporary life, sectioning the two off from one another. With this piece, von Tiesenhausen actually breaks down the gap between nature and human culture suggesting the two are one and the same phenomenon. A path of sorts was cleared and cut tree trunk sections were placed along each side. Some were emblazoned with simple line symbols such as a cross, a vagina, arch and

bowl, recalling archaic drawing and stick language used by primitive tribes to communicate. In a way this work became a narrative on humanity's development *vis-a-vis* nature over the course of time. The central elements are visual devices but derived from, and part of, nature. The forest entrance recalls our own history as part of nature. And the hut offsets the main piece, building a balance within the overall piece by referencing an interiority, just as the more expressive branch elements are external, outwardly expressive. One could walk through this area and go on into the forest, to experience a truly interactive experience without the assistance of technology, an editing machine, or even a screen! As the author Marilyn French has stated:

> What we live in, actually, is a world in which domination has been raised to the highest power. In other words, the meaning of God in most religions in the world is 'power over', is domination, and God gave humans, in the early part of Genesis, dominion over the earth and the fish and the flesh and the fowl ... Everything that we see in the new physics, in the new science, in the new biology shows that everything is interconnected and everything affects everything else. There is nothing in nature that can move other things without being moved in return."[3]

Sonia Robertson, a Montagnais artist from northern Quebec, has taken a non-material approach to the ephemeral theme of Transitions, by making her own body part of the exchange. Robertson's approach to artmaking is closer to ritual, and seeks to break down the barriers between art and life, to remove any conceptual, social or economic constraint that the viewer and artist may place on art. This ritual has been enacted without any particular audience, tribe or collectivity in mind and outside the confining white cube of every gallery space. The human or animal spirits live on in the matter and environment that surrounds us. The energy is physical and ever changing. Very natural and geo-specific, Robertson chose a site beside the river embankment and decided to dig a circle within which indigenous plants could be transposed. Each two days a new quadrant would be planted to "fill the circle" by the end of the event. Each quadrant took two days and as part of the process Robertson ate the representative plants as part of the art piece. A sec-

tion of each plant variety was likewise kept in a bowl of water on site in the circle. Robertson recorded how each plant affected her in a diary/notebook. The overall installation symbolized the native tradition of the four corners of the earth: north, south, east and west. Sonia Robertson's did a dance performance on the final day influenced by Japanese Butoh technique. In Japanese the phrase *bu* means dance and *toh* step. Thus Butoh literally *means stamping dance.* considered strange by some, Butoh evolved into an artform in post-war Japan. It is shocking, physical, evocative, and surprising in its various manifestations, the Sankai Juku being one of the best known variants. Butoh is an attempt to recapture an ancient artform that blends ritual and creativity. Dance and theatre intertwine in unusual and often shocking performances where outer and inner worlds come together.

The Butoh dancer is said to something or someone other than him or her-self. The transformation is said to bring the body back to its natural primordial state.

Do we carry the memories of our ancestors in our bodies? Are these traces part of what we call our instinct? Seated, with her arms raised, Sonia Robertson then stood up. Her arms remained pointing upwards, Her face was tense, suggesting pain or an internal pressure. Then the bodily tension was released as if the energy were to dissipate into the skies above. Walking in and around the circle, Robertson raised her legs and then went into what looked like convulsions, her outstretched arms still symbolizing some kind of contact with universal, cosmological energies. Sonia Robertson turned to each of the four compass directions and then the dance ended.

The earth is our house, a living ecology and our art can reflect the many ways site and space (when they involve nature as co-participant) can be enhanced by an earth sensitive art expression. Chris Varady-Szabo's installations, enacted in Europe and Canada seek to reactivate "primitive space" by using basic natural materials and simple construction methods. They build a dialogue on transformation and nature's energy. By not using complicated, energy wasting, polluting techniques Varady-Szabo's interventions give participants and spectators a sense of empowerment. Recent projects include *Gondoles* organized by Axe Neo-7 in the Brewery Creek in Hull, Quebec (2000), a reed boat Varady-Szabo built that reflected his passion for primitive construction methods. At Parc Maisonneuve in Montreal (2000) Varady-Szabo's *Living*

Sculpture project comprised a 200 kilogram block of fat and bird seed conceived as a sculpture of and for birds. The birds that visited the site became a living element of the sculpture and feeding on the sculpture made them active contributors to the project. Varady-Szabo generates projects designed to heighten our awareness of the presence of nature, particularly in outdoor settings, and in all climates. Using locally available materials Varady-Szabo sculpts habitat structures and sculptures that resemble primitive shelters, mounds, or towers. "I try to give voice to natural materials, earth, branches, hay, manure ... I also experiment with the dynamic elements fire, water and air, and living elements in the form of plants and animals have increasing importance in my installations." he comments. For some time he has studied earth houses, the history of Native Amerindian building and low-tech architecture. An earlier sculpture/house at L'Ilot Fleurie in Quebec City under a highway ramp consisted of a mud and branch shelter that was eventually demolished due to the subversive nature of the structure. At La Maison des Gouverneurs, Varady-Szabo has approached the ephemeral theme by choosing a location to build a temporary earth shelter in the hillside facing the river. To begin, he made a cut in the hillside. The grass topsoil was removed in patterns and forms that recalled interfoliate designs and decorations from ancient Celtic art and carving. The removed grass cuts were placed on the hillside nearby while the digging began. After considerable digging with the help of assistants, a space opened up in the hillside and a structure made of tree trunks and branches was assembled there. On completion of the structure, the earth cuttings were put back in place and formed the roof of the piece. This sculpture/architecture that Varady-Szabo created at the Maison des Gouverneurs integrated elements found on site during digging, and the digging process was more like an archaeological dig where earth layers are uncovered beneath the visible surface. The style of building was a natural one, rather like a narrative of materials with no intention to create the perfect structure, more to integrate a relation between the individual and physical site and contrasted radically with the factories found across the river. The rationale behind this kind of building is non-linear, and views natural materials as a point of connectivity or catharsis to the human psyche and spirit in the same way that Carl Jung conceived nature as being a link between the individual and their unconscious. An old enamel sign with numbering found on site during the dig was installed on the

structure's exterior. Straw bales were brought into the interior to provide seats for visitors to rest and reflect. The project was built with a sensitivity to the role of shelter as (not only a practical place for living) a spiritual domain, a place for reconciling and reflecting on one's inner self and relation to one's place on the earth and contemplate the all pervasive forces and energies; the cosmos.

The earth is a living breathing organism whose climate, geography, geology and life forms are without a question part of the living ontology of culture. The artworks presented in Sorel-Tracy for *Transitions* challenges the belief that all activity must centre around humanity. These artists have, by simply presenting installations that approach site, materials, and with an earth sensitive and ephemeral approach, helped to broaden our perspective on what art is. Their art helps us realize that an essential freedom comes from identifying with the life process in its own place and context. Nature is chaos in the right place. If we respect its processes and adapt our civilization to include nature in the equation, we can help ensure a better life for our children and our children's children.

Notes

1. Walter S. White, *La Maison des Gouverneurs* (Sorel: Editions Beaudry & Frappier, 1980) p.31.
2. Kristine Stiles & Peter Selz, eds., *Theories and Documents of Contemporary Art* (Berkeley, CA: U. of California Press, 1996) pp. 545-547.
3. Whitney Smith & Christopher Lowry, eds. *Wild Culture: Ecology and Imagination* (Toronto: Somerville House, 1992), p. 79.

Index